Bonington, Francia & Wyld

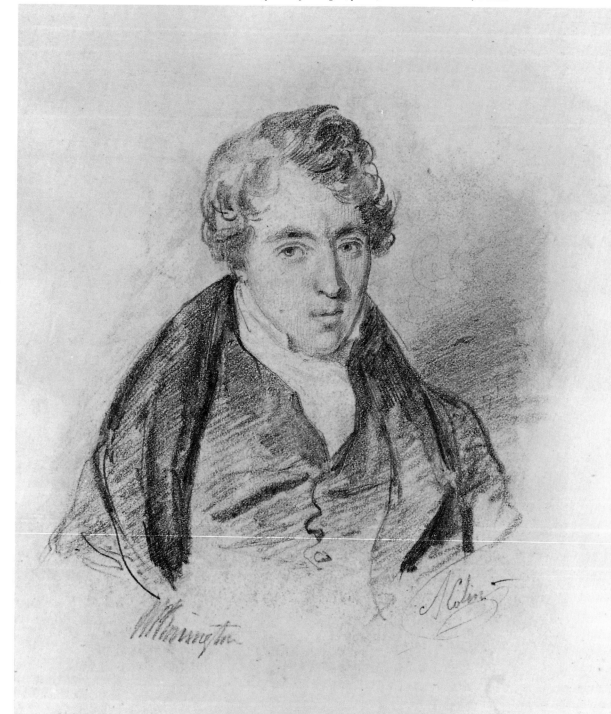

FIG. I Alexandre Colin, *portrait of Bonington*, pencil, Ashmolean Museum, Oxford

MARCIA POINTON

Bonington, Francia & Wyld

B. T. BATSFORD LTD · LONDON
IN ASSOCIATION WITH THE
VICTORIA & ALBERT MUSEUM

For the 'circle' (of Bonington) there is not much to be said: too many of them were sedulous apes.

(R. Edwards, 'Richard Parkes Bonington and his circle', *Burlington Magazine*, July 1937, p. 36.)

* * *

The outlines of Bonington's oeuvre are the least clearly defined of any nineteenth-century artist, and decisions about many aspects of his art probably should wait until Bonington and his associates have received more adequate study than has yet been given them.

(A. Staley in *Romantic Art in Britain, Paintings and Drawings 1760–1860*, Detroit Institute of Arts and the Philadelphia Museum of Art, 1969, p. 249.)

* * *

© *Marcia Pointon 1985*
First published 1985

All rights reserved. No part of this publication
may be reproduced, in any form or by any means,
without permission from the Publisher

ISBN *0 7134 1817 6* (*cased*)
 0 7134 1818 4 (*limp*)

Typeset and printed in Great Britain by
Butler & Tanner Ltd
Frome and London
for the publishers
B. T. Batsford Ltd
4 Fitzhardinge Street
London W1H 0AH

Series general editor:
John Murdoch, Deputy Keeper
of the Department of Paintings,
Victoria & Albert Museum

Contents

List of illustrations

NOTE:

Numerals printed in **bold** type in the introductory chapters are references to items in the catalogue.

Acknowledgements

I would like to thank the British Academy and the Leverhulme Trust for generous grants which enabled me to undertake research in Paris and at the Yale Center for British Art. I am grateful to the following people, all of whom have helped me in various ways: John Murdoch of the Victoria and Albert Museum, Ann Buddle and the staff of the Print Room, Bernard Adams, Jean Adhémar, Patrick Conner, David Cordingly, Cyril Frye, Robin Hamlyn, John Ingamells, Michael Ingram, William Joll, the late Mrs Hope Keith, Vivien Knight, Gertraute Lippold, Richard Lockett, Pierre Miquel, Lady Millar, John Munday, Patrick Noon, Zdeněk Pillar, Anthony Reed, Martin Royalton-Kisch, Dominique Vieville, Albert Vion, Robert Wark, Ray Watkinson, Andrew Wilton and Andrew Wyld. I owe a special debt to Marion Spencer for many illuminating conversations and to Jon and Linda Whiteley from whose knowledge of French art I have greatly profited. I should also like to thank Timothy Auger of Batsford for his patience and perseverance and all my friends and family who have been supportive and sympathetic throughout the long period of my work on Anglo-French art, of which this book is one result.

M.P., Brighton 1984

Summary chronology

1768 Foundation of the Royal Academy, London

1772 François Louis Thomas Francia baptized in Calais

1789 Storming of the Bastille in Paris

1795 Directory established

1797 Death of J. R. Cozens

1799 Francia, Girtin and 'The Brothers' meet at the home of Robert Ker Porter. J. M. W. Turner elected ARA. Buonaparte returns to France

1801 Girtin goes to Paris in poor health

1802 Peace of Amiens. British visitors flock to Paris; Girtin returns to London to die. J. M. W. Turner elected R A. Birth of Richard Parkes Bonington

1803 Birth of Thomas Shotter Boys

1805 First exhibition of Society of Painters in Water-colours. Battle of Trafalgar

1806 Birth of William Wyld

1808 Foundation of the Associated Artists in Water-Colour

1811 Francia becomes Secretary of the Associated Artists

1812 Associated Artists closes down

1815 Battle of Waterloo. Restoration of the Bourbons

1816 Francia tries unsuccessfully to become ARA

1817 Francia returns to Calais by May. Cotman's first visit to Normandy. The Bonington family moves to Calais from Nottingham. Thomas Shotter Boys apprenticed to George Cooke

1818 Bonington arrives in Paris. Cotman's second visit to Normandy

1819 Samuel Prout's first continental visit

1820 Bonington enters the atelier of Baron Gros and studies at the Ecole des Beaux Arts. Cotman's third visit to Normandy. Death of George III. Murder of the Duc de Berry

1821 Bonington's first sketching tour. Death of Napoleon

1822 Theodore and Thales Fielding open the Fielding Brothers' Drawing School

at 26, Newman Street, London, Thales and Newton Fielding go to Paris to work for d'Ostervald. Bonington leaves Gros's atelier and exhibits in the salon for the first time

1823 William Callow starts works as Theodore Fielding's assistant. Bonington goes on sketching tour of northern France and probably also Flanders. Thomas Shotter Boys completes his apprenticeship and goes to Paris

1824 Newton Fielding goes on sketching tour in Normandy; Thales tours Switzerland. Constable, Copley Fielding, Bonington and other British artists exhibit at the Salon where Copley wins a gold medal. Bonington spends much of the year in Dunkerque. Thales returns to London in October

1825 Bonington visits England with Colin and joins Isabey, Enfantin and Delacroix in London. On their return to Paris, Bonington and Delacroix share a studio. Frederick Fielding visits Paris and stays with Newton

1826 William Wyld takes up employment as Secretary to British Consul in Calais. By January Bonington has left Delacroix's studio. Bonington visits Italy accompanied by Baron Rivet

1827 Thales Fielding exhibits Delacroix's portrait in London. Bonington visits England. Wyld moves to Epernay to superintend a wine-exporting business

1828 Bonington visits London in the Spring and, in September, returns to die in London

1829 Sale at Sotheby's of Bonington's studio effects

1830 Newton Fielding and William Callow return to London from Paris owing to unsettled political situation. Death of George IV

1831 Newton Fielding and Callow back in Paris. Whigs win control of Parliament in London

1832 Passing of Reform Bill. Death of Sir Walter Scott

1833 Callow and Thomas Shotter Boys sharing a studio in Paris. Wyld visits Algiers and meets Horace Vernet,

later travels to Rome to join him.
Newton Fielding marries and settles in
England

1834 Wyld back in Paris early spring. Sale
of Lewis Brown collection of water-
colours in Paris in December

1837 Accession of Queen Victoria

1838 Opening of National Gallery, London

1839 Death of Francia in Calais. Wyld wins
gold medal at Salon

1840 Queen Victoria marries Prince Albert

1841 Wyld wins second gold medal

1842 Death of Cotman and John Varley

1846 Repeal of the corn laws

1847 The Fielding brothers abandon the
Newman Street atelier

1848 Chartists' meeting in London. Louis
Philippe abdicates

1851 Death of Theodore Fielding and
J.M.W. Turner. Great Exhibition

1852 Wyld at Balmoral sketching for royal
family

1855 Death of Copley Fielding

1859 Darwin publishes *Origin of Species*

1874 Death of Thomas Shotter Boys. Dis-
raeli succeeds Gladstone

1889 Death of William Wyld

Introduction

Bonington has long been recognized as a major talent working within what
has tended to be regarded as a minor genre. His name crops up again and
again in the annals of French and British Romanticism. Yet remarkably
little is known about his working life, his associates, friends, teachers and
pupils. The generation of 1820 was a fortunate one; it had lived through
the dangers and excitements of the Napoleonic wars; it enjoyed all the
advantages of a society where artists could make money by travelling in
search of markets in which the possibilities for exhibiting and selling were
notably more varied than for its forebears, where landscape had a following
and where royal taste was in its favour. The work of these artists might or
might not appear in the annual exhibitions in London and Paris; those
gauges of production and popularity are not particularly reliable for
Anglo-French watercolourists. It is to the provincial towns and the indivi-
dual patron that one may have to look to discover what was being pro-
duced. These artists were constantly on the move and constantly changing
jobs, or so it would seem from a twentieth-century perspective. A close look
at the working lives of many in the substratum of watercolour landscapists
of the 1820s suggests a degree of versatility and an ability and willingness
to move from one profession to another and from one place to another
which is sharply at odds with the image of the dedicated and single-minded
talent that the nineteenth century itself projected as the artistic norm.
Bonington, for one, was extremely versatile and highly mobile in his re-
sponses to the commercial environment.

The object of this book is not to produce a definitive catalogue of the
watercolours of Richard Parkes Bonington, his teacher, François Louis
Thomas Francia and one of his followers, William Wyld. Instead its aims
are twofold. On the one hand, here, for the first time, are catalogued the
entire holdings in the National Watercolour Collection of the work of these
three artists. On the other hand, by examining a group of three artists
whose lives cover the period 1772 (the date of Francia's birth) to 1889 (the
date of Wyld's death) we are able to chart changes in artistic practice, in
patronage and in the status of watercolour as an art form during the period
of its greatest popularity. In this sense the book presents a case study of
three generations of watercolourists, and we are concerned more with
charting overall changes in conditions and aspirations than in establishing
a stylistic dynasty.

Bonington is by far the best known of the group of three and has been
the subject of frequent monographic treatment. The decision not to treat
him on his own was therefore a deliberate one. To have studied Bonington
in isolation would have been to reinforce the stereotype; no artist works in

a vacuum of genius and Bonington, at least in the early part of his short life, was a travelling, jobbing landscapist particularly dependent on a network of associations and a commercial infrastructure. Moreover, acknowledging that there is a problem about defining the parameters of Bonington's *oeuvre*, it seemed to me that the best way of contributing towards the resolution of that problem was to look outwards from Bonington and try to re-establish the reputations of two of his 'lost' contemporaries. Clearly, Francia and Wyld were far from being 'sedulous apes' (see p. 4). It is hoped that through this process the notion that there is something exclusively or even peculiarly British about nineteenth-century watercolours will be questioned.

All three artists worked with equal ease in Britain and France. Two were British born but lived in France much of the time; one was French born but lived in Britain much of the time. Transcontinental travel was the norm for nineteenth-century landscapists, and a prominent and acknowledged artist like Turner should be seen within this pattern, not as an exception to it. There are many other artists who belong to what was recognized by Salon and Royal Academy critics of the 1820s as a remarkable phenomenon and has come to be known as *le Boningtonisme*:[1] they include Thomas Shotter Boys (figs. 13, 75), the Fielding Brothers (figs. 21, 28, 58), William Callow, James Holland, E.W. Cooke, John Scarlett Davis, Paul Huet (figs. 2, 70), Alexandre Colin (fig. 1), and Jules Collignon (fig. 3). The term *Boningtonisme* signifies freedom of handling in a watercolour medium combined with brilliance of colour, bold application of gouache for emphasis, a deliberate autographic stress on handling and a precise range of subject matter that includes the plein-air marine and the small-scale intimate historical fiction. The ramifications are enormous and the extended family would cover at least a part of the lives of most nineteenth-century French and British landscape artists.

The tradition of connoisseurship by which Bonington's reputation has flourished has been largely concerned with questions of authenticity and of quality, and with establishing that some objects are better and more important than others. Whilst acknowledging that from the point of view of museum directors and dealers, questions of authenticity are crucial, and whilst recognizing that some objects are intrinsically more interesting, pleasing, and competently executed than others, it is my view that concentration on these questions has not only robbed writing about watercolours of much of its vitality but, more important, it has robbed watercolour artists of their rightful position and relegated them to the sidelines of the history of art. Thus, whilst the catalogue entries will address questions of

provenance and the material state of the object, this introductory text attempts to set the work of the three artists in a wider context. Redgrave's view of the South Kensington watercolours as illustrating 'the history of (a) truly national art'[2] is thereby itself historically located, and the work of Francia, Bonington and Wyld can be seen as a significant chapter in the cultural history of Britain and France.

There has been as much emphasis laid in this study on the uncovering of new factual material (much of it culled from archives here and in France) as on the visual appreciation of particular watercolours. A serious part of the endeavour is the analysis of images, both for their content and for their execution, but there remains the paradox of Bonington as the artist whose technique was admired but whose facility was scorned. Such a contradiction is to be explained only through an understanding of the changing aesthetics of the sketch in nineteenth-century salon and exhibition circles: one of the most important issues for the history of nineteenth-century art generally. The role of Bonington as one who maintained a love of colour and *facture* in a largely hostile world is not diminished, but the continuity of a colouristic tradition even within the medium of watercolour was by no means his preserve.

Although this book is concerned with drawings and watercolours, it is important to realize that all three artists were engaged directly or indirectly with print-making. Francia's *Studies of Landscapes* ...[3] (figs. 4, 62), a sequence of fifty-nine soft-ground etchings and aquatints after his own landscapes and a selection by Gainsborough, Hoppner, Girtin, Varley and others, are described as 'imitations'. The concept of the learned 'imitation' as opposed to the copy, the choice of fellow artists and the medium, all help to situate Francia self-consciously within a tradition rooted in the eighteenth century. Bonington, on the other hand, was employed by Oster-vald to work on the huge enterprise of Baron Taylor's *Voyages pittoresques et romantiques dans l'ancienne France* (Paris 1820–78). He was of a generation that discovered the delights and immediacy of the lithographic medium.[4] Just as he organised his working life to maximize the advantages of exhibiting in London and Paris, using dealers and agents, Bonington clearly also realized that it was to his advantage to work as one of a team of artists for Ostervald and later, when he had established his own reputation, to contract out much of his own work to engravers. Wyld, similarly, collaborated with a lithographer for the production of series of popular prints of picturesque scenery.

The status and function of watercolour painting changed radically in the years between Francia's youth and Wyld's maturity. A full account would

require detailed studies of many more artists. It is, however, clear that the history of watercolour in England and France in this period is not merely the history of a changing technique, a changing aesthetic or even of a changing view of the legitimate objects of the landscapist's gaze. It is also the history of a developing business acumen within a developing capitalist economy, a readiness to exploit international travel and a widening market. With careful management Bonington and Wyld could, from every journey made, produce a range of objects which would bring in very real financial profits: watercolour drawings, finished oil paintings and engravings or lithographs. Bonington's tragically premature death robbed Europe of one of its most dazzling young talents; it also ensured for Bonington an exaggerated popularity and for Wyld a steady income. Francia outlived his pupil but by the time he died in 1839 he had also outlived his age. It is time to reassess the achievement of these three men as individuals and in relation to each other.

Notes

1. H. Lemaître, *Le Paysage Anglais à l'aquarelle 1760–1851*, Paris, 1955.
2. R. Redgrave, *Inventory of the British Watercolour Paintings in the Fine Arts Collection at South Kensington*, 1860, p. 6.
3. *Studies of Landscapes by T. Gainsborough;* *T. Hoppner, R.A., T. Girtin; Wm Owen R.A.; A. Callcot; A.S. Owen; J. Varley; J.S. Hayward and L. Francia. Imitated from the Originals by L. Francia*, 1810.
4. See A. Curtis, *L'Oeuvre gravé et lithographié de R.P. Bonington*, Paris, 1939.

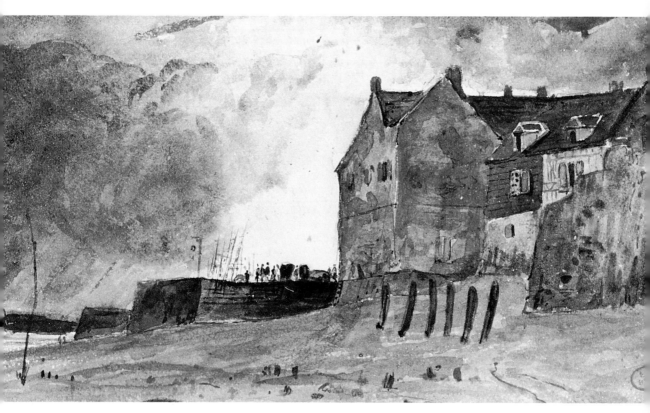

FIG. 2 Paul Huet, *Honfleur*, watercolour, Louvre,
Cabinet des Dessins, $5\frac{5}{8} \times 10\frac{3}{8}$

I Francia (1772–1839)

The British visitor to Calais seldom lingers in the town unless compelled to do so by the vagaries of cross-channel ferries, or tempted by the prospect of *supermarché* wine sales. But the traveller who does linger in the town's main square will not fail to notice Rodin's *The Burghers of Calais*, completed in 1886 but not finally erected until 1895, situated in front of the restored *hôtel de ville*. If time allows a visit to the Municipal Museum he or she will discover that the town has other celebrated citizens besides the burghers whose memory is so splendidly enshrined in bronze in the town centre. There are to be found paintings in oil and watercolour, their number sadly depleted by losses in two wars, by François Louis Thomas Francia, born in Calais in 1772, and by his son Alexandre who was born around the year 1820. A little more time and a stroll around the streets will reveal a rue Francia, named after the artist *père* who died in Calais in 1839.

Francia's life tends to divide into three sections: the period up to 1790 when he sailed for England, the period from 1790 to 1817 when he was active in London and made sketching tours to various parts of the British Isles, and the period from 1817 until his death, when he practised his art in Calais and exhibited chiefly in Paris and in northern French towns like Rouen, Dieppe and Le Havre.[1] His life was fraught with contention and conflict; J.P. Neale, a topographical draughtsman who knew Francia in his London sojourn described him as 'a conceited French refugee who used to amuse the party with his blundering absurdities',[2] and later in life he acquired a reputation for invective. The son of the Director of the Military Hospital in Calais, Francia was not of humble birth and may have prided himself on his learning. Writing to the Mayor of Calais in defence of the local Ecole de Dessin where he himself had studied before departing for London, Francia proclaimed himself the winner of all the school prizes in 1788 and the only alumnus to make a professional reputation for himself.[3] In the penultimate year of his life he engaged in a regular and venomous correspondence on a whole range of topics: the classics, archaeology, agriculture, in the pages of the *Journal de Calais*. These letters, bombastic and rhetorical in tone, were penned in response to statements made in a rival newspaper, *L'Industriel Calaisien*, by Ernst Le Beau who, after a tardy reconciliation with the artist, went on to write his obituary.[4]

It is clear, however, that Francia was capable of important and lasting friendships both with men who were his senior, like the topographer J.C. Barrow, and with young men like Bonington, who retained a connection with his first mentor.[5]

London was an inevitable attraction to a young, talented artist from northern France, not merely as a haven from the uncertain political situa-

tion at the end of the *ancien régime*, but also as a place where a young landscape artist could earn a living. Arriving in London in 1790, Francia found his way to a school in Hampstead, perhaps as a drawing master or perhaps as an instructor in his own language. It was there when, as he tells us, he could speak no English at all, that he met Joseph Charles Barrow and formed a friendship which would last until the latter's death in 1804.[6]

Barrow had recently commenced a second career as a topographical draughtsman and was himself an assistant at Henry Pars's school in the Strand. He was the son of a well-to-do businessman but a secret marriage, numerous children and a series of losses in trade and unlucky speculations (one of which was the erection of a horizontal mill at Battersea) had obliged him to abandon his career in commerce and employ his artistic talents as a teacher. He soon became a well-established topographical draughtsman, working for Horace Walpole on drawings of Strawberry Hill.[7] His drawing of Marylebone Manor, now known only from a reproduction in George Clinch's *Marylebone and St Pancras*, reveals him to have possessed a powerful sense of design with regard to street scenery.[8] His reputation today rests on his *Picturesque Views of Churches and Other Buildings*.

When Barrow established his own drawing school in Great Queen Street, Lincoln's Inn Fields, around 1792, he took on Francia as an assistant. Like Barrow, Francia was an educated man, and by 1792 a competent artist. Despite the close friendship between the two men, there were evidently some areas of disagreement which probably centred on Francia's increasing freedom of handling. Just as Dayes disapproved of his pupil Girtin, so Barrow may have disapproved of Francia. At the end of his sympathetic obituary – Barrow died in destitution after a period in the debtors' prison – Francia declares:

> As a man [Barrow] deserved more commiseration than blame; as an artist, more blame than pity ... he harboured some rooted prejudices, which were illiberal, and have withheld him from the title of a man of genius; but he wrapped himself up with mute dignity in the sombre cloak of his knowledge, and would not admit that to be talent, which was not strictly *learned*.

John Varley was also employed by Barrow and, possibly through his acquaintance, Francia soon joined the group of young artists, including Girtin and Turner, which met at Dr Monro's house in the Adelphi. There they copied landscapes by Canaletto, Gainsborough, J.R. Cozens and others from the collection of the philanthropic doctor. Francia was a founder member and secretary to the Sketching Society named The Brothers established in 1799 (**1a** and **1b**). He later exhibited with the Associated Artists (a rival organization to the Old Water-Colour Society) from their

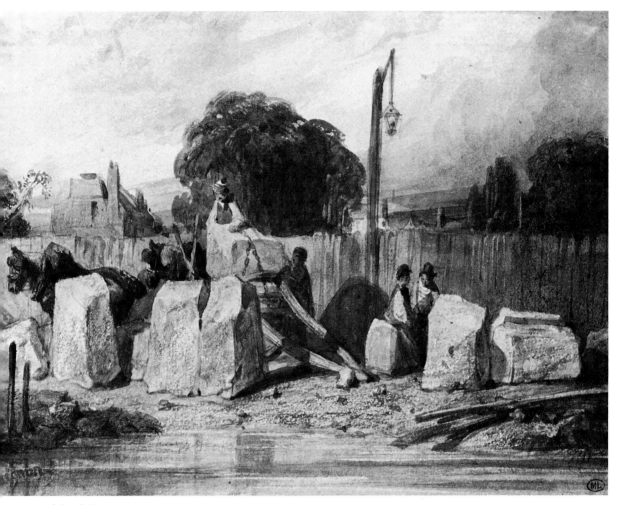

FIG. 3 Jules Collignon, *Quarrymen heaving stone*,
watercolour, Louvre, Cabinet des Dessins,
$6 \times 8\frac{3}{8}$

FIG. 4 Francia, title page to *Studies of Landscape ...*, 1810

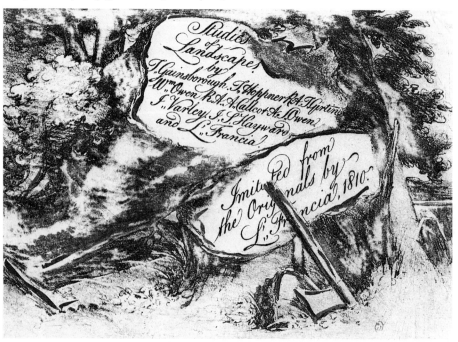

foundation in 1808. This move, a tactical error professionally, perhaps isolated him somewhat from the main body of his colleagues in the Society of Painters in Water-Colours.

The careers of Barrow, Varley and Francia demonstrate the precariousness of a way of life which comprised a combination of teaching and speculative topographical work. The history of London's drawing schools in this period has yet to be written but there is little doubt that enterprises such as Barrow's were extremely competitive. Publication was a similarly cut-throat business. The subscriber system employed by publishers of collections of engraved views was essentially speculative and, if costs turned out to be higher than anticipated, could result in disaster for artist, engraver and publisher. We can have only an imprecise idea of the costs entailed for a London-based artist in undertaking a tour of Wales or the Lake District to gather material for a comprehensive topographical work, but they must have been considerable. Even at the most basic level a tour of this kind represented a considerable investment in time and money. Barrow ended up in the debtors' prison, Varley died in destitution supported by his friends, and Francia returned to Calais in 1817 doubtless hoping for a more secure livelihood. He lived there until his death in 1839 with limited professional success among a mainly local clientele and with a growing sense of grievance. He did, however, establish his own circle of

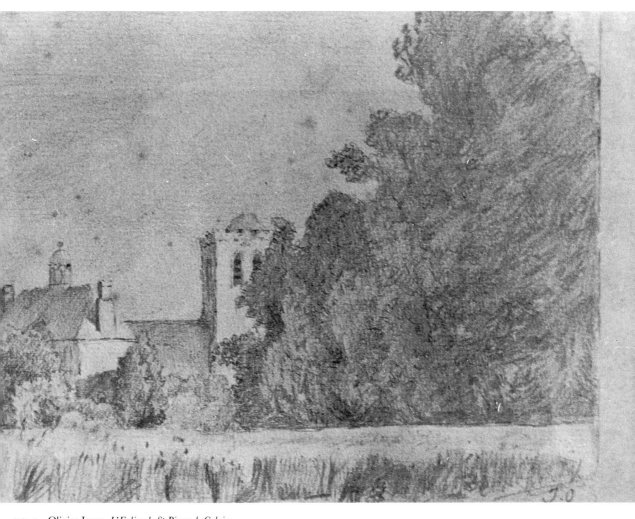

FIG. 5 Olivier Isaac, *L'Eglise de St Pierre de Calais*, pencil, Calais Museum, $5\frac{7}{8} \times 7\frac{1}{2}$

FIG. 6 Louis Tesson, *View in Algiers*, watercolour on grey paper, Calais Museum, 8⅞ × 6

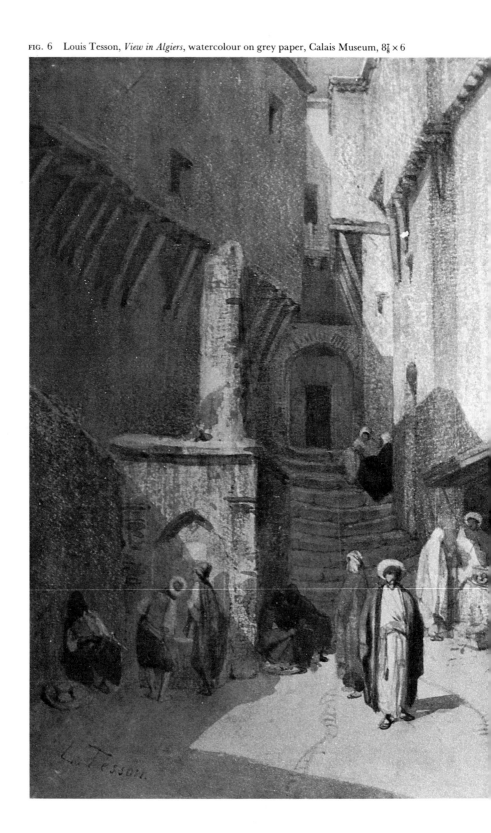

friends and admirers, students and protégés, and provided an important link between London and France. Among his pupils were Olivier Isaac (1802–68) (fig. 5) who was a keen collector of works by Francia and Bonington, Jules Collignon (fig. 3), and Louis Tesson who studied in Calais in the 1830s before proceeding to the atelier of Décamps in Paris (fig. 6).

By returning to Calais, Francia achieved what it was impossible to attain in London: a virtual monopoly of depictions of one place. He became *the* illustrator of Calais.[9] Establishing a status of this kind was precluded in England by the demands of the landscape market for the novel and the exotic. Francia's life, by contrast, arguably represents a shift from topographical reportage (although few of his earliest works survive, **6** reveals his competence in this mode)[10] through an aspiring ideal or poetic landscape mode (see **1a** and **1b**) to exercises in the picturesque (see **3** and **4**) and finally into a steady production of marine and river scenery (see **10** and **13**), which he practised for the last thirty years of his life. Of course all these modes intersect and overlap. They are discrete neither in the overall historical sense nor in Francia's individual *oeuvre*. However, it is true to say that an upward momentum is discernible in Francia's career as it is in those of other artists of this period in so far as the topographer, virtually by nature of his task, and the social context within which he practised, aspired to move from what was regarded as the most humble form of documentation into the production of works invested with imaginative response – *plein-air* drawings and works which reveal his sensibility to current aesthetic models (fig. 7).

Like his young associate Bonington and like the Fieldings, Francia endeavoured to adapt his skills to oil painting.[11] Even within the separate medium of watercolour, pressure imposed by the need to catch the attention of potential buyers at the exhibitions of the watercolour societies from 1805 led to an increasing approximation of watercolour to oil. Francia kept his work in the two media quite distinct but nevertheless the broad washes of his early work give way to the rich surface effects and the emphatic use of body colour exemplified in **15**. The unique evidence of **1** reveals the seriousness with which Francia and his peers approached the challenge of 'Historic Landscape', equipping themselves for a career in what were acknowledged to be the higher modes of the genre.

The strictures of Gainsborough and Fuseli against topographical landscape painting are well known. The former inveighed against a market that demanded portraits of gentlemen's houses, while the latter referred to 'the last branch of uninteresting subjects, that kind of landscape which is entirely occupied with the tame delineation of a given spot ... what is com-

monly called views.'[12] It is significant that the *Oxford English Dictionary* gives no examples of the use of the word 'topography' between 1646 ('The late Geographers ... call these kind of Descriptions (of small Parcels of the Earth ...) *Topographie*') and 1864 (when all history is said to be lifeless without Topography). In topography, a science and a practice, the visual is subsumed within the literary, even if the 'text' is exclusively pictorial and not accompanied by verbal explanation. This is because the topographer is one who describes or delineates a particular locality. We may now admire the formal qualities of topographical drawings and emphasize their quality as abstraction but this constitutes an historical judgement. The function of topography was the transmission of information; the topographical drawing required to be read as a strict system of signs equivalent to empirically evident facts in the world of experience. The ability and disposition of a man like Barrow to move from technology to topography should thus come as no surprise. Topography is not primarily an artistic practice in the sense in which it is most popularly understood today. The art of drawing places was, as Barrow believed, a discipline of observation, a learned skill. Hence the tension when he was confronted with the aspirations towards the imaginative in the art of his younger colleagues. The creation of diagrams and technical plans, architects' drawings and medical illustrations can still provide us with a strong sense of the proper function of the topographical drawing in documenting the physical appearance of the countryside in a pre-photographic era.

By the beginning of the nineteenth century topography had become the essential tool of geologists, geographers,[13] map-makers and industrialists. It was taken for granted as a basic and essential skill and was thus effectively invisible within the main body of artistic practice. Topography, as the OED demonstrates, ceased to be a keyword in the Age of Reason. On the other hand the vision, the processes of production and the skills of accurate transcription encouraged by topography were hugely at odds with dominant theories of the Ideal, the Sublime and the Picturesque. The insistence on an improved and idealizing art of landscape which lies behind Fuseli's comment has a long pedigree, going back to Sir Joshua Reynolds's *Discourses* and beyond. Yet artists like Paul Sandby who earned their living as topographical draughtsmen, whether in military academies or in antiquarian ventures, clearly did not see themselves as excluded by virtue of their contingent occupations from 'higher' forms of landscape art. While topography emphasized individual location, the concept of the ideal demanded that the image should have a general application and relevance. While topography required a delineation of the normal and everyday, the

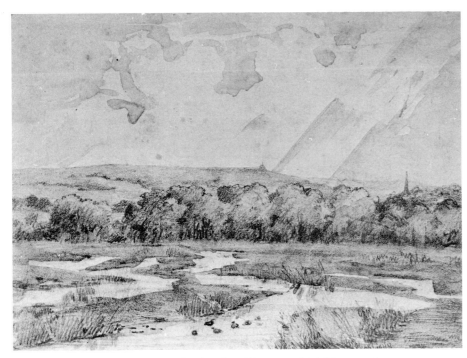

FIG. 7 Francia, *Marshy landscape*, pencil and wash on blue paper, Calais Museum, $5\frac{1}{4} \times 7$

FIG. 8 Bonington, *Landscape with timber wagon, France*, oil on canvas, the Wallace Collection, London, $22\frac{7}{8} \times 27$

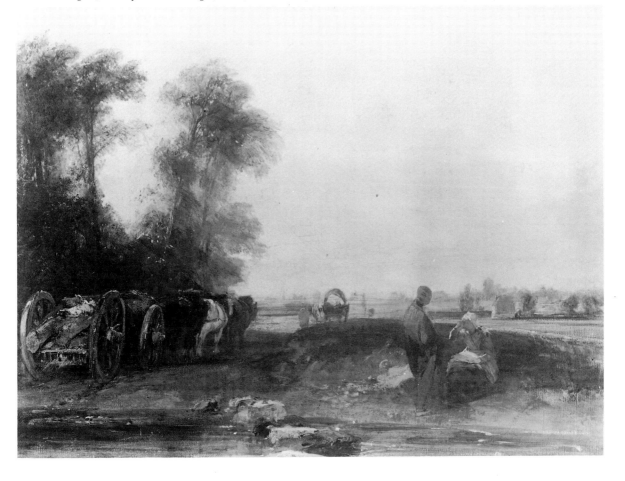

FIG. 9 Alexandre Francia, *The Port of Calais, the west jetty and the Fort Rouge*, watercolour and sepia wash, Calais Museum, 12 × 19

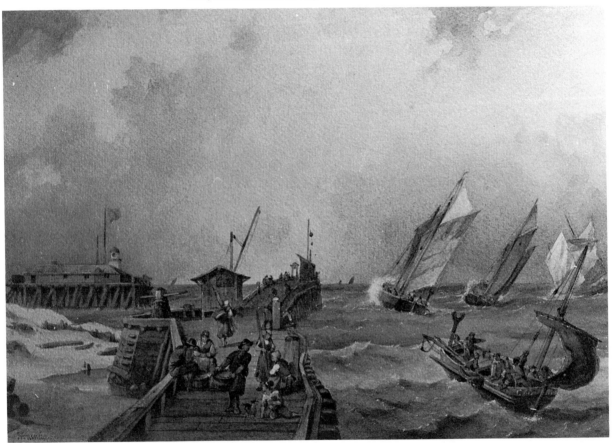

Sublime demanded the out-of-the-ordinary. As for the Beautiful, this at the very least required the removal of the rough and adventitious and the approximation of the landscape to a Claudian model. Watercolour landscape at the end of the eighteenth and beginning of the nineteenth centuries was equally responsive to this encroachment of the imaginative and the ideological upon the topographical function. Francia's art contains impulses in both directions.

There is no objective test of the truth of the topographical depiction even though we may assiduously list incorrectly drawn architraves, adjusted distances or rearranged apertures. Nor is it enough simply to say that the topographer records as accurately as possible the physical appearance of the location. Places are value-laden; their depiction even at its most descriptive involves interpretation. In an art form which privileges recognizable objects: buildings, boats, walls, constructions of other kinds over and above spaces or areas where motifs are absent, a tension is set up between the shapes as functional objects and as abstract formally apprehensible

motifs. A good example is **14**. Though not identified, this is, we may guess, a particular location, not on a feast day or some special occasion but in its everyday state. The angle of vision selected by Francia allows us to read the depiction transversely in a wing shape from the left, narrowing quickly to the centre and then widening to the extreme right where the 'objects' occupy almost the full height. Alternatively we can read it in terms of the interchangeable triangles of sky and foreground. Either way the white gates in the far distance are the focal point. Everything leads to them, including the unevenly spaced tracks in the foreground. Factually, or topographically, we have the inn (the shop sign hangs over the street), park gates, church, bridge, houses. But the visual syntax emphasizes the park gates, and would do so even without the emphatic figure of the man in greatcoat and hat whose fishing rod and stick lead us directly there. Seen thus there is an overall and harmonious development to a climax, the white gate, into which pattern are inserted a series of jarring elements: the device for fishing from the bridge, the boys themselves, the tumbledown cottage and the harshly angled horizontal prop which separates the bridge from the house at the far right. These items violently disrupt the hierarchy of design. Some, but not all, of the elements may have been necessary to the 'scientific' delineation of the particular locality but their stress within the composite whole is individual to the artist. We may wish to interpret such a design as an economic portrait of the place, emphasizing a hegemony to which the patrician entrance gates are central but also remote from the spectator. Or we may wish to concentrate upon the way in which precisely delineated objects like the stone supports of the bridge or the *pêche à carreau*, with which the boys are fishing and which is only partially seen, become removed from their functional identity by virtue of being precisely viewed. Then they are seen as peculiar shapes oddly isolated within a jigsaw of everyday experience, creating a fetishistic objectification of 'reality'.

This work is signed by Francia in bold capitals on the wall of the bridge at the left. Francia had many ways of signing his work: the handwritten signature on **6** is typical of his work of the late 1790s and early 1800s. His later work, as with **14** and **13**, which is signed on the boat's rudder, tends to claim authorship more assertively. A monogram 'LF' sometimes appears in the corners of watercolours, and especially in the series of aquatints *Studies of Landscapes* ... (1810) in which Francia reproduced his own and others' works. These monograms are carefully integrated into the overall design, tilted at an angle so that they appear to recede in the same spatial relation as the picture itself. From the early years of the nineteenth century Francia began prominently to incorporate this emboldened signature, often

with the heightened artifice of the monogram ⌊F, into the foreground of his views. Thus in **8,** for instance, the marking of the signature in paint in the left foreground is one with the overall calligraphy of the foreground, reinforcing both the strongly recessive left-hand side of the picture and the important part played by line in a work which balances flat washes with an outlining of detail in a brush-drawn line which is both precise and suggestive.

The signature is an essentially artificial and non-mimetic feature. It is a sign for something outside the aegis of the painting as representation, an intrusion into an otherwise recognizably naturalistic construct, highlighting the contradictions between convention and observation, between the empirically experienced event and the formalism of visual syntax. These are contradictions which we can identify as central to the art of the topographer. The artist's signature is more than merely a sign of authorship; it is an affirmation of convention and artifice. In an age of naturalism, evocation and personal response, it asserts notions of system and abstraction, information and calligraphy.

Francia's only surviving son, Alexandre (c. 1815–84), followed in his father's footsteps, exhibiting marine views and landscapes of inferior quality to those of his father in many European centres (fig. 9). When Francia died on 6 February 1839, aged 66, at his home in rue de la Poissonerie, one of his former pupils, the Calais-born sculptor Augustin Isaac, executed a bust of the artist. A simple but distinguished tomb was designed by the architect, Victor Vilain (1818–99), and executed in marble by the sculptor Létendart. Both the tomb and the bust have been destroyed,[14] but they are recorded in a drawing by Alexandre Francia reproduced as the frontispiece to Le Beau's commemorative *Notice* (fig. 10). It sums up the contradictory aspirations of this reputedly difficult but talented man. Francia appears in the bust with stern brow and hair romantically windswept. A laurel wreath and palette accompany the portrait. It is a worthy epitaph for an artist who claimed descent from Francesco Francia and who told friends that he had owned letters by Raphael that had been burned by his housekeeper.[15] Beneath this image is a delicately drawn view from the sand dunes at Calais, looking out towards the Fort Rouge which Francia and his pupils had so often depicted (figs. 9, 29). In the foreground his tomb stands in the unkempt grass and weeds of the upper shoreline. To move from the portrait to the view is to traverse the ambitions and achievements of this talented and little-known artist. The image embodies the paradoxical relationship between individual personality and naturalistic landscape. The conventions of commemorative portraiture are publicly invoked but the

FIG. 10 After Alexandre Francia, Bust of Louis Francia by Augustin Isaac and his tomb by Vilain, from E. Le Beau, *Notice sur Louis Francia* (1842)

manifest disjuncture between the heroic bust and the landscape is a formulation of that conflict which Constable also, until his death two years earlier in 1837, had struggled to resolve.

Notes

1. A letter from Francia to the marine painter Louis Garneray dated 9 novembre 1835 is extremely critical of the arrangements that had been made for the exhibition of his work in these various towns. MS Archives Générales du Pas de Calais, liasse 282, coll. Barbier.

2. J.L. Roget, *A History of the Old Water-Colour Society*, 1891, i, p. 99.

3. L. Francia to M. le Maire comme Président du Conseil Municipale, 30 septembre 1835. MS Archives Municipales de Calais, no cat. ref.

4. E. Le Beau, *Notice sur Louis Francia, peintre de Marins, né à Calais*, s.l., s.d. (1842). A fuller treatment of the Calais cultural scene and Francia's various activities is to be found in my book *The Bonington Circle*, Brighton: The Hendon Press, 36 Hendon Street, 1985.

5. In a letter of 1825 introducing Bonington and his companion Alexandre Colin to John Thomas Smith, Keeper of Prints and Drawings at the British Museum, Francia names them as 'two dear friends'. MS, private collection, London.

6. 'A biographical Memoir of the late Joseph Charles Barrow, Esq., F.S.A. by L.F.', *The General Chronicle and Literary Magazine*, March 1811, i, pp. 237–40.

7. W.T. Whitley, *Art In England 1800–1820*, Cambridge, 1928, i, pp. 219–20.

8. Engraved by G.I. Parkyns, George Clinch, *Marylebone and St Pancras: their history, Celebrities, Buildings and Institutions*, 1890, facing p. 8; J.T. Smith, *Nollekens and His Times* (1829), 1914, i, p. 31, n.2.

9. His large watercolour of an open-air banquet that took place in Calais in 1836 when 2,000 national guards sat down to dinner to celebrate a great musical competition and military festival is one typical product of this function. Musée de Calais, 207, formerly in the collection of the Mayor of Calais.

10. See, for instance, Francia's views in *The Antiquarian Itinerary*, 1817.

11. See, for example, *Vue de l'Ancien bout de la Jetée*, Musée de Calais, 151.

12. The Lectures of Henry Fuseli in *Lectures on Painting by the Royal Academicians*, ed. R. Wornum, 1848, p. 449.

13. See M.J. Rudwick, 'A Visual Language for Geology', *History of Science*, Sept. 1976.

14. See *Le Phare de Calais*, 7 juillet 1939. The tomb was severely weathered but Francia's grave in the Calais cemetery is now marked by a simple slab of more recent date.

15. Dossier of notes accompanying the gift of Francia drawings to the Musée Carnavalet, Paris, from the Isaac family (E 11409–11423), November 1924.

II Bonington (1802–28)

Richard Parkes Bonington's career was brief but extremely productive. Born in the village of Arnold near Nottingham in 1802, the only child of small-time artist, dealer and former jail governor Richard Bonington and his wife, Eleanor Parkes, Bonington emigrated with his parents to Calais in 1817 (fig. 11).[1] The town had long been a refuge for English aristocrats embarrassed by debts or scandals of a personal or political nature. Formerly one of the cinque ports, it maintained many English facilities and commodities. The Bonington family were no aristocrats but there were probably pressing financial reasons for their emigration. Running the risk of the severest penalties (those guilty of giving away the secrets of British technology were deported to Australia), Bonington senior smuggled machine parts out of Britain and set up a lace-making business in Calais with two compatriots, James Clark and Robert Webster.[2] The manufacture and distribution of lace remained the family business and when Richard moved to Paris to study and practise art in 1818 the family lived together selling pictures and lace from the same establishment.[3] By 1828 consumption had overtaken the young artist. He died in London at the age of 26.

The student of Bonington faces a number of problems which stem from the brevity of the artist's career. In the first place it simply is not feasible for Bonington to have been responsible for all the works that bear his name, not to mention those that are attributed to him. In the second place his precocious talent and his early death, encouraging comparisons with Keats and Chatterton, have made of him a Romantic hero (see frontispiece). This has not served the interests of scholarship and has tended to isolate Bonington from his contemporaries. In the third place there has been the problem of whether to call Bonington a French or a British artist. Francia was born in France, worked in England and returned to France. Bonington was born in England, worked in France and died in England. But Francia has, undeservedly, been virtually ignored, so the question of nationality has not in his case arisen. The debate that has centred on nationality has tended to obscure the fact that Bonington, like Francia, is essentially a Franco-British or an Anglo-French artist. The debate had special relevance in the post-war years of the late 1940s and early 1950s when watercolour was emphatically being written up as a specially British product,[4] but as recently as 1962 a reviewer remarked that the exhibition of Bonington's work at Agnew's 'removes one layer of Gallic fame from his reputation and reveals him as an essentially English artist who developed in the tradition of Girtin and Cox …'.[5] Only Lemaître recognized the complex and paradoxical position of Bonington; he is the first writer to talk not of followers or associates but of a cosmopolitanism that he rightly

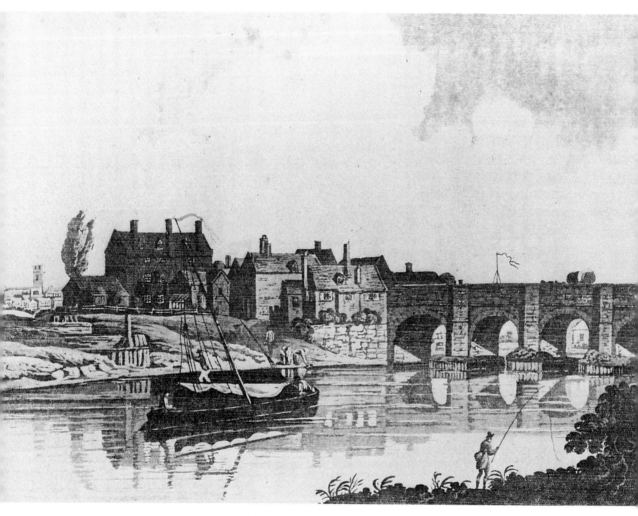

FIG. 11 After Richard Bonington, *View on the River Trent near Nottingham*, from J. Blackner, *The History of Nottingham, embracing its Antiquities, Trade, and Manufactures*, 1815

recognizes as one of the triumphs of international Romanticism.[6]

As for problems of authenticity, Hardie calculated that by the end of 1838 over 160 oil paintings, over 300 watercolours and more than 900 sketches in black and white or with a slight tint had passed under Bonington's name through the sale rooms of England and France.[7] This number must, as Hardie points out, include palpable forgeries, copies and imitations and sometimes the genuine unsigned work of painters like Francia, James Holland or Callow. We know that many artists copied Bonington's work as a technical exercise; Huet admitted having done so in 1824,[8] William Wyld's studio sale contained copies after Bonington,[9] and E.W. Cooke, who went to look at Bonington's work whenever he could,[10] and who was regarded in 1810 as possessing one of the finest collections of Bonington's watercolour drawings,[11] records making a copy after a sketch in oils by Bonington.[12]

Artists and dealers in particular flocked to purchase works by Bonington in the years immediately following his death. At his studio sale Lawrence paid over £60 for three lots, two of which reappeared in his own sale in 1830. Lord Lansdowne bought many works which remain in the possession of the family today, John Barnett (Bonington's agent) bought five lots and Seguier, keeper of the National Gallery, provoked Constable's wrath by purchasing nine lots.[13] Whitley suggests that Colnaghi was buying on behalf of Bonington's father, but since Bonington's father had organized the sale this seems unlikely.[14] There were no further major sales containing works by the artist in London until 1834, so when in 1833 Dominic Colnaghi's newly wedded wife describes him in a letter as poring delightedly over 'his Bonningtons' (*sic*) from morn till night, meals included, it must have been these works that he was relishing.[15]

The clearest testimony to the frequency of forgeries of Bonington's work soon after his death appears in the *Magazine of Fine Arts* in 1833. The writer refers to 'servile imitators', draws attention to the vigour, decision and expression in genuine drawings by Bonington[16] and concludes that 'the cupidity of dealers have been (*sic*) so great that caution and perception are now necessary in purchasing a Bonington either in oil or in watercolours'.[17] But many works which are attributed to Bonington are probably not forgeries as such but genuine works by his friends and contemporaries who have been overlooked or ignored. As well as those artists mentioned by Hardie there are the French watercolourists instructed in Calais by Francia, men like Jules Collignon (fig. 3) and Louis Tesson (fig. 6), there are other Anglo–French artists like S.W. Reynolds whom we now think of mainly as an engraver but whose watercolours were immensely admired in

Paris;[18] (fig. 12) and there are the English Boningtonists like Ambrose
Poynter and Thomas Shotter Boys (figs. 13, 75), both of whom lived and
worked in Paris for some time during their careers.

Bonington's father is known to have made copies after his son's work, for
a collection of such items was offered for sale by Sotheby's following Mrs
Bonington's death. The catalogue states that these works are marked as
copies and 'are now brought forward with the view of showing the great
mechanical talent of the copyist, and the surpassing beauty and power of
the original'.[19] On account of this Bonington senior is often held responsible
for the dire problem of authenticating Bonington drawings. But it must be
acknowledged that although there was nothing except patent inferiority[20]
to prevent Bonington senior selling his own work as his son's from 1828
until his own death, if he had done so then why should Mrs Bonington
have retained a set of such works and why should they have been presented
in this rather novel way by an auction house in 1838? We know that the
problem of forgeries was publicly recognized as early as 1833, so if Boning-
ton senior was already suspect, it would seem odd to introduce his copies,
however well marked, into a sale in 1838 that included the genuine article.

There is no simple test for identifying a work by Bonington. During his
short career Bonington's work underwent complex shifts of style and the
typical Bonington watercolour is as likely to be a forgery as the atypical.
Particular caution needs to be taken with putative studies for known en-
gravings or lithographs such as that for the *Place du Molard* (**23, 34, 35**).
Not only Bonington but all contributors to volumes of picturesque tours
were subject to piracy of this kind.[21] Views of the same location by Bon-
ington, Callow and Boys can be acutely difficult to disentangle, especially
as many of those views have become classic images familiar to any traveller
to Paris, Rouen or Venice.[22] For instance, *Paris from the Tuileries*, a view by
Callow in a sketchbook in the Victoria and Albert Museum, has been
identified as a preliminary study executed by Callow for Boys in 1831. It
is exceedingly close to a Bonington watercolour of 1828. In the British
Museum there is a tracing by Boys of Callow's sketch and in 1833 Boys
completed a watercolour of this subject.[23]

Of all Bonington's friends and followers, Boys's work (fig. 13) is at times
the closest to Bonington's and watercolours in museums and galleries have
been constantly attributed and reattributed to one or the other artist.[24] But
Boys is always more concerned with the motif, more preoccupied with what
is in front of him than Bonington (fig. 75).[25] Bonington often did not sign
his work and, although John Ingamells has published a useful illustrated
guide to signatures,[26] it has to be borne in mind that signatures can easily

FIG. 12 S.W. Reynolds, *View of a park*, watercolour, gouache, sepia and gum, reproduced by courtesy
of the Trustees of the British Museum, London, 13 × 18⅞

be forged. They can also be misread; just to take one example as an
illustration of the problem, we may cite an album of miscellaneous draw-
ings sold at Christie's on 15 January 1935 from the estate of Lady Powell.
These drawings were in a Boningtonian manner and were signed RDB for
Rosetta d'Arblay Wood, the mother of Lady Powell. Broken up, such an
album could produce profits for an unscrupulous dealer with an unwary
public.

There is a 'rightness' about a genuine Bonington, however much one
may dislike the term. This is enshrined in the artist's sense of construction
and design and in his instinctive mastery of detail (see **21** and **26**). A
watercolour that is vaguely atmospheric is unlikely to be by Bonington,
and the same is true of subjects with strident or sentimental narrative
detail. Oil sketches present fewer problems. Although Bonington rarely
signed his work in this medium, images like *Les Salinières* (fig. 14) and
Landscape in the National Gallery of Scotland are executed with great
variations in impasto and vibrancy of handling in relatively sober colour
range. The ground is often allowed to show between dragged brush strokes
and everything is exquisitely controlled without any loss of spontaneity.
Thus, in *Les Salinières*, wet into wet paint assists in clarifying the structure
of the dunes in the foreground. The smoke at the right and the figures to
the extreme left are minute but essential components in the overall com-
position and the thick bristle marks in the heavy impasto of the sky have

FIG. 13 Thomas Shotter Boys, *Dordrecht*, watercolour, bodycolour and gum, Victoria & Albert Museum, $7\frac{3}{8} \times 11\frac{1}{4}$

FIG. 14 Bonington, *Les Salinières, Trouville*, oil on board, National Galleries of Scotland, Edinburgh, 9×14

an intentional and controlled creative function in the overall structure.

Only provenance provides an approximate test of authenticity. Works that were exhibited during Bonington's lifetime (if they can be securely identified), works that appeared in recorded sales during the artist's life or immediately following his death and works that belonged to friends of the artist may be approached with relative confidence. All else should be regarded with caution, though the quality of some imitations is as high as one would expect from the close-knit relationships within this community of artists, and in these cases the questions of identity, authorship and authenticity should not be regarded as primary.

As an aspiring young artist Bonington was lucky to find himself in Calais where he soon attracted the notice of Francia (fig. 15). Nobody could have been better placed to promote the boy's interests and Francia soon sent his young friend to Dunkerque where the mayor, M. Morel, a cultivated and wealthy ship-owner, became his first patron.[27] From Dunkerque Bonington moved on to Paris with an introduction to Delacroix which he scarcely needed, since the two young men encountered each other in the Grand Galérie of the Louvre (figs. 16, 68) where they were both studying from the old masters.[28] From now on the Bonington family was based in Paris but the artist kept closely in touch with Francia and frequently returned to Calais, Dieppe and Dunkerque.

In the spring of 1825 Bonington visited London in the company of Alexandre Colin, joining up with Delacroix, Isabey and Eugène Enfantin after their arrival. Delacroix and Bonington made drawings of the Meyrick collection of medieval armour, visited Westminster Hall and Hampton Court and went to the theatre. The practical details of their visit were overseen by the Fielding brothers who had an atelier in Newman Street but who had also been working in Paris in the early 1820s. On his return to Paris Bonington shared a studio with Delacroix and later, in December 1825, with Frederick Tayler (1802–89) who was to become a distinguished and long-serving President of the Society of Painters in Water-Colour.

In April 1826, living life at a frenetic pace that was possibly symptomatic of his impending illness, Bonington made a rapid tour of northern Italy in the company of Baron Charles Rivet. They travelled via Geneva and the Simplon Pass (**20, 23**), stopping briefly in Milan (fig. 67) and then making for Venice via Brescia and Verona (**21**), arriving towards the end of the month (figs. 26, 27). By the end of May Bonington and his companion were on their way home via Padua, Ferrara, Bologna and Florence. The abundance of sketches that Bonington executed provided him with material

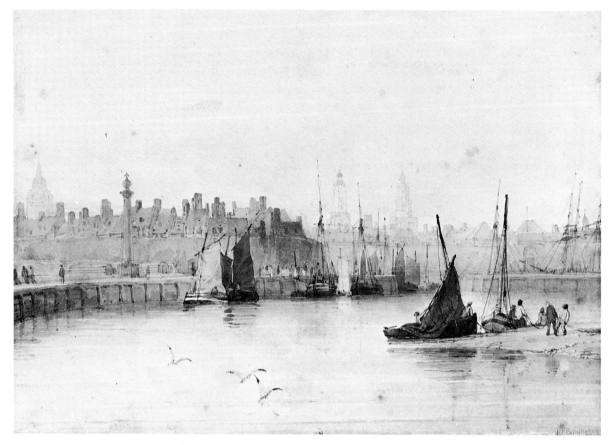

FIG. 15 Bonington, *View of Calais from La Rade*,
 watercolour, *c.* 1818, Bibliothèque Nationale,
 Paris, 7⅜ × 10¾, phot. Bibl. Nat. Paris

for exhibition pieces for the Salon and the Royal Academy in 1827 and 1828.

The historical accident that led to Bonington coming of age in Paris rather than in London was extremely fortunate as regards his career. He was at hand when Baron Taylor was looking for illustrators for his *Voyages Pittoresques et Romantiques dans l'ancienne France*[29] and he was able to enjoy the new spirit of patronage and sympathy for the arts under the Restoration. The value of *plein-air* sketching had been established by Pierre-Henri de Valenciennes in his *Elémens de Perspective Pratique* of 1800 and, although French academic practice and the prize offered at the salon for *paysage historique* for the first time in 1817 reaffirmed the status of idealized classical landscape, there was considerable scope and a very real recognition for the nascent naturalism of artists like Georges Michel. Bonington made frequent sketching tours; his friend, Alexandre Colin, accompanied him to Dunkerque in 1824 and left a unique pictorial record of times spent in work and at leisure (figs. 17, 18). The Salon of 1824 at which Constable, Copley Fielding (fig. 21), Samuel Austin (fig. 20) and other English landscape artists made a considerable impact, was a high point in a process that had been going on for some years and would continue to develop. Nevertheless, as a watercolourist, Bonington had little serious competition in Paris. The pupils of Valenciennes practised *plein-air* oil sketching and the use of the *croquis* was well established but Bonington was able to exploit the tradition for washed drawings inherited from Moreau l'Aîné and continued in the work of Claude Thiénon (1772–1846) and Antoine-Louis Goblain (b. 1779) and invest it with a new and astonishing brilliance of colour and effect.

Had Bonington been in London, Turner would surely have proved his greatest rival and he would have been drawn into the most fiercely competitive market in Europe for topography. But in Baron Gros, under whom he studied in Paris from 1820 to 1822, Bonington found a master who encouraged traditional skills of draughtsmanship and control whilst recognizing and practising a painting technique characterized by *facture* and colour. Bonington is often said to have transported ready-made to Paris the English technique of Girtin and Cotman but it is worth pointing out that his deeply disciplined sense of form and his control of design and structure are distinctive in the English watercolour school and must derive at least in part from the rigorous Beaux-Arts training that he received in Paris. Bonington was certainly original enough to translate the skills acquired in the Ecole de la Bosse to his own exploration of landscape motifs. At the same time his foreign nationality undoubtedly protected him from the constraining effects of the French academic system. It would probably have been

FIG. 16 Anonymous artist, students copying in the Louvre, oil, whereabouts unknown, early nineteenth century

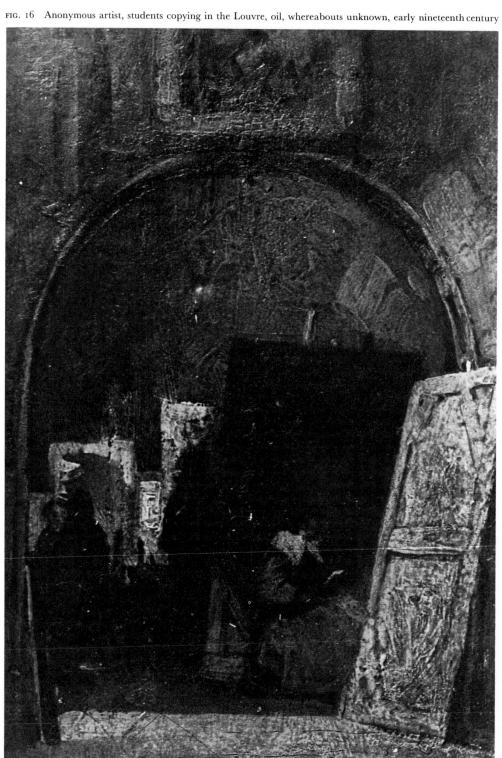

FIG. 17 Alexandre Colin, *Bonington sketching from a rowing boat*, pencil and sepia, inscribed *en mer*
 Bonington, Musée Carnavalet, Paris, $4\frac{3}{8} \times 4\frac{3}{8}$, photo Bulloz

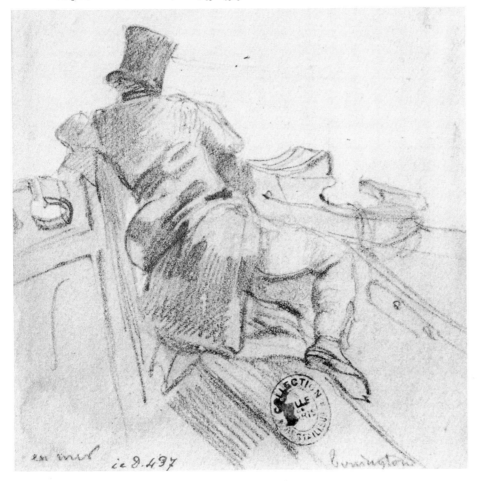

less easy for Gros to have acknowledged the unconventional talent of
a young Frenchman. As it was, Gros, having seen some of Bonington's
watercolours in a dealer's window, was inspired to declare to his students:
'You don't pay enough attention to colour, gentlemen. Colour . . . is poetry,
charm, life and nothing can be a work of art without life', and to tell
Bonington, 'You have found your path, follow it!'[30]

Bonington's facility in producing small, richly coloured watercolours,
brilliant in technique, loose in handling and yet highly finished, corres-
ponded very precisely to the taste of French collectors who had never lost
their delight in the sensuous surfaces of Watteau and Lancret and who
were intent on building up cabinets in the expansive and optimistic years
of the early 1820s (**22**). His work appealed both to the survivors of the
ancien régime, men like the Comte de Narbonne, Comte Demidoff, the Comte
de Pourtalès-Gorgier, M. de Barroilhet and the Duc de Feltre, and to mem-

bers of the more recently wealthy commercial classes like Amable Paul
Coutan and John Lewis Brown.[31] A watercolour like *A Fair in Normandy*
(fig. 22) is not only richly coloured but also, with its sinuous line of receding
figures in a lush landscape, borrows from the compositional versatility of
Watteau.

Bonington was an astute businessman with an eye for the market; he
possessed a talent for being in the right place at the right time. He was not
the first artist, English or French, to chart the Normandy coast. He had
been preceded by Cotman, Francia and others. But he was nevertheless
early in his depictions of the valley of the Seine and of its course through
Rouen to Le Havre. Sea-bathing became fashionable in France in the
1820s, partly through the encouragement of the Duchesse de Berry, who
gave her name to a sea-bathing establishment at Dieppe. She was also a
keen patron of contemporary art.[32] Bonington's views answered a demand
for peaceful, picturesque views of the French coastline and French monu-
ments after years of threatened coastal invasion, warfare and civil unrest.
They also provided a pictorial affirmation of the city-dweller's developing
taste for sea air, boating and marine pleasures of all sorts (figs. 23, 24).

When he visited Venice in 1826 Bonington was following in the footsteps
of Samuel Prout, who had been to Venice in 1824 and who exhibited a
Venetian work at the Academy two years later in 1826. Turner had made
his first visit to Venice in 1819, and Corot in 1825. But Turner did not
depict the city in oil and did not exhibit any of his views of Venice until
very much later, and Corot disliked Venice and painted only one view
which does not compare with his Roman scenes. Bonington, however, lost
no time in exhibiting Venetian oils at the salon in the autumn of 1827, at
the *supplément* in the spring of 1828 and at the Royal Academy in 1827 and
1828 (fig. 66). His success with these works and with the many Venetian
watercolours he had on the market (figs. 26, 27) may actually have
prompted Turner to return to the city in 1828.

In the light of his commercial aptitude, it is ironic that Bonington is
often described as a 'pure painter'. There is no doubt that his astonishing
facility with the brush, the kinds of variation in wash and texture of which
he was capable, and his ability to move from crisp drawn outline through
dragged dry body colour to the most faultless wash all within the same
small area of paper is exceptional (see, for example, fig. 25). His sense of
form and construction and his ability to establish distances and suggest
landmarks is impressive. There is certainly a historical point to be made
here. This was a period of rapid development in techniques and materials;
watercolour painting was no longer a straightforward process. At the very

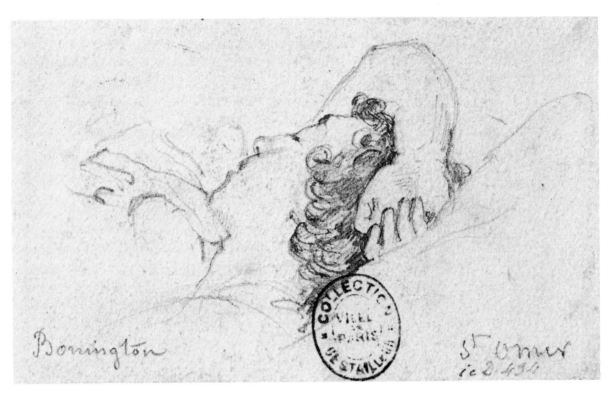

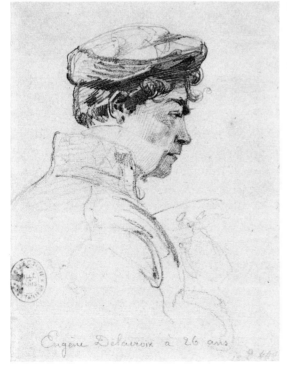

FIG. 18 Alexandre Colin, *Bonington asleep*, pencil, inscribed *St Omer*, Musée Carnavalet, Paris, $2\frac{3}{8} \times 3\frac{5}{8}$, photo Bulloz

FIG. 19 Alexandre Colin, *portrait of Delacroix, aged 26*, pencil, Musée Carnavalet, Paris, $6\frac{3}{4} \times 3\frac{7}{8}$, photo Bulloz

end of the eighteenth century Edward Dayes, Girtin's first teacher, declared that 'one great inconvenience the student labors under, arises from the too great quantity of colours put into his hands; an evil so encouraged by the drawing-master and color-man, that it is not uncommon to give two or three dozen colors in a box, a thing quite unnecessary.'[33] Within twenty years or so Bonington's generation was scumbling a mass of colours, floating colour into colour and using a range of pigments that would have caused the fastidious old topographers to turn in their graves. By 1847 Ackerman was offering a box containing forty-five cakes of pigment, palettes, slab, pencils (brushes), ultramarine saucer, chalks, etc., for £3-13-6, as well as four different sketching pencils (brown and black for foregrounds, grey for middle distance, neutral for distance), vellum hot-pressed drawing paper, Whatman's satin paper and a mass of other commodities.[34]

The dominant concepts of modernism and the avant garde have always ensured that Bonington's *facture* received attention but this was in isolation from any considerations of economic or social context. The questions of content and iconography have never properly been considered. Thus for Roger Fry, Bonington was immensely more gifted than Delacroix 'as a painter in the strictly limited sense of the word. His gift indeed was prodigious. No English artist ever started his career with such an equipment as regards sheer manual dexterity and the instinct for discovering how to interpret his images in conformity with his technique. Since Rubens, indeed, one may doubt if any such sheer specific gift had been seen.'[35] In 1937, at the time of the Burlington Fine Arts Club exhibition, Bonington was similarly admired for his brilliant sketching, in other words for those qualities that approximated most closely to what was admired in the work of the Impressionists and their successors.[36]

If 'pure painter' implies unconscious painter, Bonington is certainly not that. His choice and treatment of subject – from the famous Bridge of St Maurice crossed by countless grand tourists on their way to Italy and treated by Bonington in such a way as to stress the timeless and the pastoral (**20**) to the gem-like pseudo-historical idyll enacted in *The meeting* (**22**) – reveal an artist absolutely fully cognizant of his market and how to exploit it. As in the *Corso Santa Anastasia, Verona* (**21**), Bonington frequently coins views that have since become standard picture-postcard images. He knew precisely where to stand and how little to show. The antiquarian impedimenta of his predecessors and the encumbrances of authentic 'realism' adopted by near-contemporaries and fully developed by travellers like J.F. Lewis and John Ruskin were not an issue for him. Nor was he tempted to pay pedantic attention to local dress and ethnic detail; he knew precisely

FIG. 20 Samuel Austin, *In the channel*, pencil and watercolour with gum arabic, Whitworth Art Gallery, University of Manchester, $5\frac{5}{8} \times 8\frac{7}{8}$

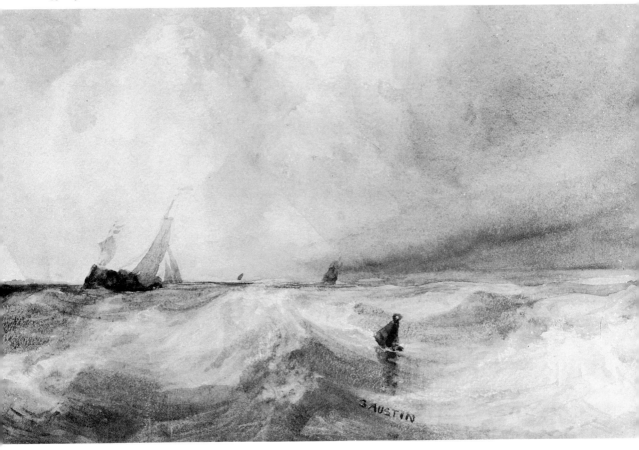

where to stop. The *Corso Sant'Anastasia, Verona* suggests the daily existence of a commercial, Roman Catholic community without penetrating its surface.

Bonington died in 1828 at the age of 26. The most artistically productive episodes of his life were well documented by his biographers in 1924 and subsequent commentators and historians have reinforced and added to this body of information.[37] Nevertheless, the identities of some of those named individuals who succoured the sick artist during the last months of his life have remained obscure or hazy and doubts have persisted about the precise sequence of events leading up to the death of this talented young man. An anatomization of the last eighteen months of the artist's life reveals the structures, commercial and social, which Bonington had helped to create and, within which he worked. These structures, worthy of historical examination on their own account, were moreover a major factor in determining Bonington's reputation after his death.

When Bonington arrived back in Paris in June 1826 after his visit to

Italy he settled once again into his studio at 11 rue des Martyrs. He apparently lived at this address but continued to use the house in the rue des Mauvaises Paroles, which he shared with his parents, as a business address.[38] By May 1827 he had moved to a studio in rue St Lazare where his parents joined him in 1828. He had by this time many commissions, especially for Venetian pictures, and undoubtedly needed more space than was available at the cheerful but crowded *immeuble* on the rue des Martyrs.[39] He appears to have established by this time an effective network of retail outlets in the city. Mme Hulin of rue de la Paix, before whose window Gros had lingered in admiration of his young English student's watercolours, dealt in modern art of the new school: Delacroix, Bonington, Géricault and others, with a special emphasis on watercolour and lithograph. The Marchand de Nouveautés Collot had in stock at the time of his sale in 1852 three canvases of marine and landscape subjects by Bonington, and Giroux and company stocked works by Bonington, Thomas Shotter Boys, the Fielding brothers and Constable.[40] After Bonington's death, artists like William Callow, Boys and the Fieldings – all of whom worked in Paris as well as in London – supplied the market. Works ranged from relatively large townscapes (fig. 75) to tiny studies of landscape and game (fig. 28).

In the spring of 1827 Bonington again visited England, probably arriving in London in advance of the opening on 4 May of the Royal Academy exhibition where his work was on show in that venue for the first time.[41] The visit has been much disputed because no first-hand evidence survives. Cunningham quotes a letter which was sent to him by Mrs Forster, daughter of the sculptor Thomas Banks, and wife of the Anglican chaplain to the British Embassy in Paris. 'When Bonington visited England', she says, 'I gave him a letter of introduction to Sir Thomas Lawrence, but he returned to Paris without having delivered it. On my enquiry why he had not waited on the President, he replied, – "I don't think myself worthy of being introduced to him yet, but after another year of hard study I may be more deserving of the honour." '[42] When he returned to London the following spring Bonington took advantage of this introduction and made the acquaintance of the President of the Royal Academy.[43]

There seems no reason to doubt the authenticity of this account. It would have been the most natural thing in the world for Mrs Forster, whose home was a centre for artists in Paris and who extended hospitality to Thomas Shotter Boys, William Callow and Ambrose Poynter (who eventually married one of the Forster daughters), to give Bonington a letter of introduction to the President of the Academy on the occasion of the

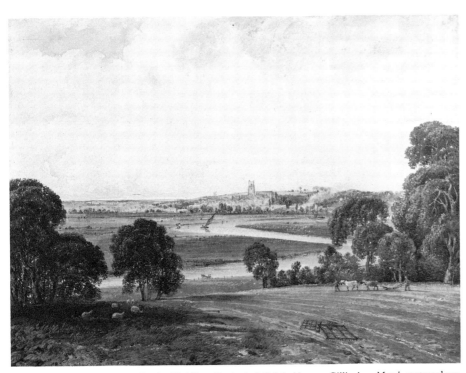

FIG. 21 Anthony Van Dyck Copley Fielding, *Beccles in Suffolk looking over Gillingham Marsh*, watercolour, 1819, Victoria & Albert Museum, $9\frac{3}{8} \times 11\frac{7}{8}$

FIG. 22 Bonington, *A fair in Normandy*, watercolour, Museum of Fine Art, Budapest, $7\frac{3}{4} \times 10\frac{3}{4}$

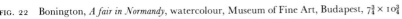

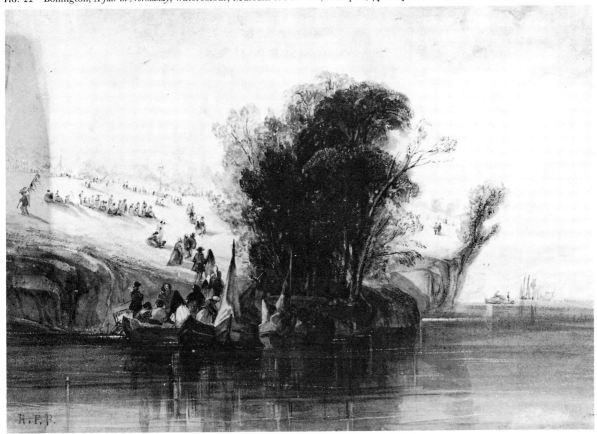

young Anglo-French artist's first showing there.[44] The account is reinforced by Bonington's letter to Dominic Colnaghi of October 1827 telling the dealer that he is sending a small painting (*A Street in Verona*, fig. 65) via Mr Pickersgill[45] 'in the hope of completing the order you honor'd me with, when in England last'.[46] It is improbable that after a gap of nearly two years and an eleven-week journey to Italy Bonington would still be trying to complete orders given him by an English dealer in 1825. Therefore we may deduce that this reference is to a recent visit and the most likely time is April 1827.

Bonington's connections with the Colnaghis suggest that he was, at least by 1827, attracting attention from the vigorous and active proponents of modern art in London. Dominic was the eldest son of Paul Colnaghi who had worked as an agent for the sale and purchase of prints and drawings in Paris and who possessed an extensive knowledge of the art trade in Europe. It was Paul Colnaghi who vouchsafed for the credit of Arrowsmith in 1824.[47] His business at 14 Pall Mall East had become, by 1825, a well-known centre frequented by connoisseurs, men of letters and politicians.[48] His eldest son, Dominic, became a partner in the firm in 1826. It is interesting to note that Dominic was well acquainted with Constable at least from 1821 and probably from much earlier. Indeed, Constable, who disliked Bonington's work, told James Carpenter, the publisher, in March 1830, that he had recently been in Dominic Colnaghi's shop when a great collector (whom Constable is unable to name) came in and desired Colnaghi 'to take back everything he possessed of Bonington's in exchange'.[49] Bonington may have begun to do business with the Colnaghis as a result of a contact with Paul Colnaghi in Paris. But it is equally likely that he made it his business to visit the Colnaghis' shop when he was in London in 1825. The fact that Dominic was the original owner of the Meyrick armour which Delacroix and Bonington sketched in 1825 at Meyrick's house lends weight to this suggestion.

There remains the problem of what Bonington did in England during this visit in the spring of 1827 and whether any credibility should be given to the account that he visited England to recover from a fit of depression caused by the death of one of the Forster daughters.[50] The eldest daughter, Emma, would have been twenty-seven at the time; she married Ambrose Poynter in 1832 and lived on until 1848. The second daughter, Clara, married and emigrated before 1827. The third daughter, Lavinia Joanna, was, like Bonington, consumptive, and she would have been eighteen at the time. She died in 1829. The youngest child, Julia, who would have been seventeen, married Bonington's friend, the sculptor Baron Henri

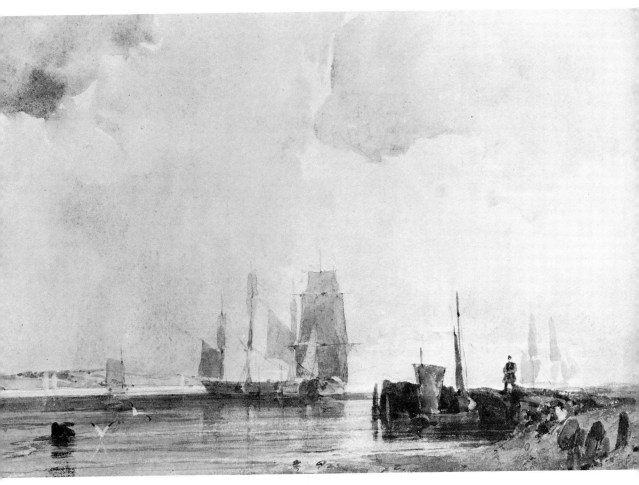

FIG. 23 Bonington, *Sailing vessels in an estuary*,
watercolour over pencil with touches of
bodycolour, Yale Center for British Art,
Paul Mellon Collection, $5\frac{3}{4} \times 9$

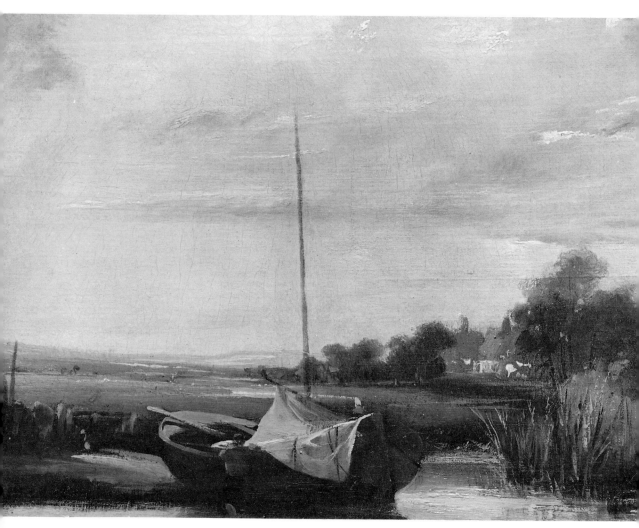

FIG. 24 Bonington, *A river in France*, oil on can-
vas, private collection, $8\frac{1}{2} \times 11\frac{1}{2}$, photo
Sidney W. Newbery

Triqueti.[51] Edward Forster, father of the girls, was a man of many talents. By the time he took over the chaplaincy in 1818[52] he had spent some seventeen years editing finely illustrated books in England and two years engaged in similar enterprises in Paris. He was extremely conscientious in his duties as chaplain until he died early in 1828.[53] His home was precisely the sort of environment to have attracted Bonington. However, no daughter of the Forster family died in 1827. Either Lavinia or Julia might have been the object of Bonington's affections and a rejection by either young woman or, possibly, distress over Lavinia's illness may have contributed to Bonington's decision to visit England in the spring of 1827. However, this is mostly speculation; the chief reason for the visit – especially since there was no need to go as far as England to distance himself from Paris – must have been business.

If we accept that Bonington was in England in the spring of 1827, then it is necessary to reconsider certain issues over dating. Two views on the Seine[54] are painted on card made in England[55] and, although paper and other artist's materials were imported into France, so that this card could have been purchased by Bonington in Paris, rather than in London in 1825, it could equally well have been purchased in London in 1827, thus giving a later date to these works. *Landscape with Timber Wagon, France* (fig. 8) has usually been dated *c.* 1824-5[56] but the treatment of the trees in this view is very reminiscent of Turner and the subject and colour range are close to Constable. Bonington would have seen Constable's work in the Salon in 1824 and in the Royal Academy in 1825 but the oil painting *Landscape with Timber Wagon* ... reveals such a marked study of the English landscape tradition that it may be dated to some time after the spring of 1827 when Bonington would have had further opportunity of looking at the works of Constable, Turner, Callcott and other landscape painters whose work was prominent in the Royal Academy that year.

Two writers allege that Bonington visited his place of birth in 1827 and, although this is nowhere confirmed, there seems little reason why such a story should have been invented without at least some foundation in truth. The suggestion that Bonington visited his old friend Tom Hulse whom he had known as a boy before the Bonington family emigrated to Calais in 1817 is quite plausible.[57] The Hulse family continued to run their silversmith's business as freeholders in Hulse's Yard, Nottingham until long after the artist's death.[58] At the time of the artist's death in 1828, his cousin Miss Parkes was living with his parents. We do not know when Miss Parkes arrived in France but one possible reason for a visit to Nottingham on the part of Bonington could have been to conduct his cousin back to Paris. A

person named R. Parkes exhibited portraits and landscapes at the Birmingham Society of Arts in 1829 and 1830.[59] If Bonington's cousin had followed the family profession (his father had also practised as an artist) then her visit to France may not have been exclusively social.

Having collected orders from Dominic Colnaghi, Mr William Carpenter and John Barnett, who evidently acted as Bonington's agent in London, the artist returned to Paris by the beginning of July.[60] The Carpenter family, whom Bonington met either in 1825 or in 1827, had excellent connections in the London art world. James Carpenter was a distinguished dealer of Old Bond Street who published specialist works of art. He produced and sold the Fieldings' books and John Burnet's study of colour.[61] It is possible that the Fieldings provided Bonington and Delacroix with an introduction to James Carpenter through which they would have acquired access to all the up-to-date English manuals. After Bonington's death Carpenter became one of the leading publishers of lithographs after the artist's work. Working with James Carpenter was his son, William, who possessed exceptional determination, tenacity and scholarship. He immersed himself so successfully in the fine art business that he acquired a reputation as an able connoisseur which led to his appointment as Keeper of Prints and Drawings at the British Museum in 1845.[62]

William Carpenter and his wife, Margaret, a portrait painter of distinction,[63] became good friends to Bonington; Margaret Carpenter's portrait sketch of the artist was used as a basis for J.P. Quilley's mezzotint that appears as the frontispiece to J.D. Harding's collection of lithographs after Bonington's work, published in 1829. She wished to exhibit at the Salon and the first part of Bonington's letter of 21 October 1827 is concerned with details about dates of submission and arrangements for transport.[64] The Salon of 1827 contained many contributions from English artists; as well as a portrait by Mrs Carpenter there were works by Bonington, Constable's *The Cornfield*, two landscapes and a frame of watercolours by Newton Fielding, engravings by Thomas Shotter Boys and Abraham Raimbach, who showed the immensely popular mezzotint after Wilkie's *The Rent Day*. Francis Stephanoff exhibited a subject painting and William Daniell sent in three views of India and three of Windsor and Eton, two of which are specified as watercolours. At the first *Supplément* Sir Thomas Lawrence displayed his portraits of the Duchesse de Berry and Master Lambton.

The presence of the English in such force at the 1827 Salon irritated the critics; Auguste Jal declared that the jury had been justified in admitting Constable and Lawrence in 1824 but that this time they had gone too far.[65] For every work that appeared in the Salon there were many that never

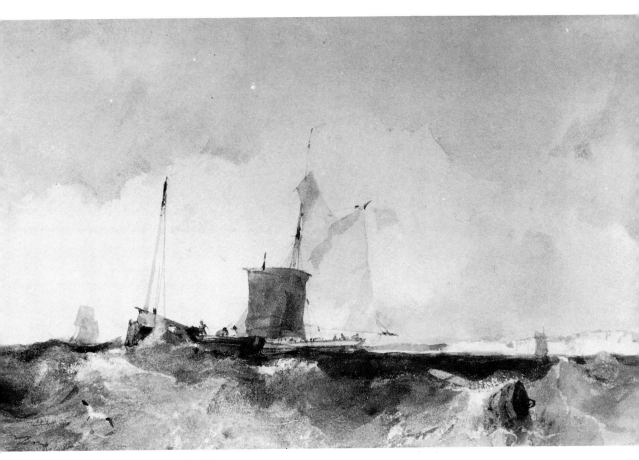

FIG. 25 Bonington, *A choppy sea off the English coast*,
 watercolour, Museum of Fine Art,
 Budapest, $5\frac{1}{2} \times 9\frac{1}{8}$

got beyond circulation among the artistic community and many more that appeared before the public via dealers like Mme Hulin and through the pages of the Keepsakes. Thus the English contribution to the 1827 Salon should be taken as an indication of an extensive phenomenon and one which presupposes the existence of an efficient network, a system for importing and exporting fragile works of art, transmitting information, sending instructions. In his letter to William Carpenter, Bonington tells Mrs Carpenter to send her picture for the Salon to M. Lagache at the Hotel Dessein, Calais, and from there it will be forwarded to Bonington in Paris. If the Hotel Dessein, which tops the list of hotels in the guidebook to Le Nord (1878), was the location of the meeting which James Roberts reported had taken place in a hotel in Calais between himself, Delacroix and Bonington at the end of 1825,[66] we may reasonably speculate also that Bonington had established by 1827 a reliable agency of some kind in Calais. The continuing residence of his teacher, Francia, in the town must also have been an advantage.

In London, Bonington's professional interests were served by John Barnett of 29 Tottenham Street. Having brought his exhibition pictures to London in March or April 1828 and having taken the opportunity of calling on Sir Thomas Lawrence with a folder of drawings,[67] Bonington was back in Paris by the beginning of May and writing to Barnett forlornly asking for news and saying 'everything with me is fol-lol neither good nor bad'.[68] He was by this time very sick and had been obliged to cancel a sketching holiday that should have taken place in Normandy on his way home in the company of his friend Paul Huet. Bonington had to withdraw from the arrangement and Huet, when he got back to Paris, was able only to shake his friend's hand and say goodbye.[69]

Friends, both English and French, rallied round. Doctor Carrier, brother of the artist's friend, Joseph Carrier (1800–78) who had studied alongside Bonington at Baron Gros's atelier, attended the patient.[70] An Englishman, identified only as 'Mr Henderson', but who was undoubtedly the younger son of the amateur artist and discerning patron of Turner and Girtin, John Henderson, took Bonington every day for a walk in the Bois de Boulogne.[71] Despite his illness, or because of it, the artist continued to work at a frenetic pace. There are a number of drawings which bear annotations claiming for them unique status as the last production of R.P. Bonington; the apocryphal nature of these inscriptions render the task of separating myth from fact the more pressing.

It must have been difficult for those trying to care for the stricken artist to deter him from using up what little energy remained to him. A recently

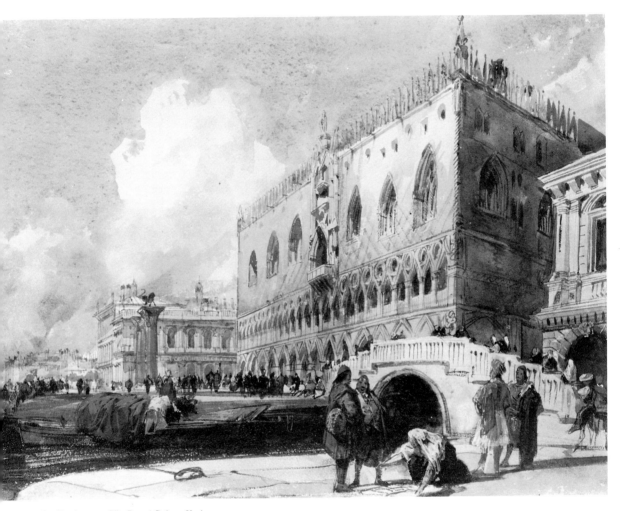

FIG. 26 Bonington, *The Doges' Palace, Venice*,
 watercolour, Wallace Collection,
 London, $7\frac{7}{8} \times 10\frac{3}{4}$

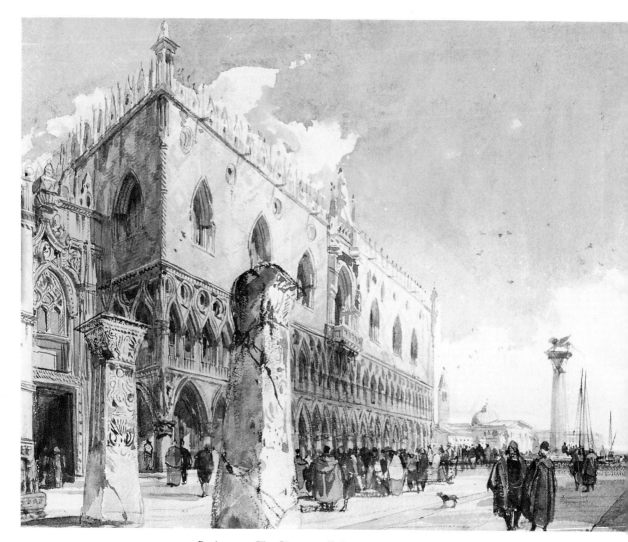

FIG. 27 Bonington, *The Piazzetta, Venice,* water-
colour, Wallace Collection, London, $7 \times 8\frac{7}{8}$

published letter written by Thomas Shotter Boys to Barnett on behalf of
Bonington and evidently to be seen by him is a poignant mixture of the
protective ('Mr Bonington is not yet allowed to touch either pen or pencil')
and the mendacious ('I am deuced glad to say our old friend is getting
better as fast as he can'). Messages are sent wishing Barnett all joy and
happiness on the occasion of his marriage and a request for Barnett to deal
with a proposal for the engraving in London of *Henri III of France* from the
Royal Academy exhibition.[72]

Boys was very intimate with Bonington and the sad decline of a friend
so talented and inspiring, witnessed at such close quarters in the early
summer of 1828, remained with Boys as a painful memory. The following
year, after calling on Dominic Colnaghi, Boys wrote: 'I am sorry you were
not at home when I called as I had brought down a drawing or two of
Bonington's to shew you. I say shew you as I really cannot find it in my
heart to part with one of them.'[73]

The assurances that his friend was recovering were, as Boys must have
known when he made them, ill-founded. On 21 July Bonington himself
was able to scrawl a note to his old artist friend Pierre-Julien Gaudefroy
(b. 1804), but the letter tells painfully of his physical weakness and his
desperate determination to adapt his surroundings in order to allow him
to continue working. Gaudefroy is urgently asked not to forget to bring the
old armchair and to make sure that it is high enough to support his head.[74]
By August his plight was acknowledged to be desperate, even by his closest
relatives. A plan to send him to winter in the south of France was aban-
doned and by 6 September Bonington, accompanied by his parents, was
on his way to London again. From Abbeville a letter was sent to John
Barnett, dictated by the artist but written by his mother, asking Barnett to
arrange accommodation for them.[75] In the event, Barnett took the Boning-
ton family into his own house. Before leaving Paris, Bonington had time
only to scribble a note in an uncertain hand, full of deletions, assuring
Alexandre Colin, 'je serai de retour un jour'.[76] The true state of affairs is
revealed in Mrs Bonington's postscript to the letter dictated by her son in
Abbeville: 'Such is the state of our dear child that the great power above
only can save him thro means perhaps permitted by his goodness.'[77]

The Bonington family, travelling by slow stages, reached London by
mid-September. The object of their visit, according to the artist's biogra-
phers, was to consult a quack doctor who specialized in tuberculosis cases.
There was very little time left to the artist but he was able to visit his old
friend W.J. Cooke and his family; a poignant record survives to tell us of
that occasion. John Saddler, who was an apprentice with the Cookes at the

FIG. 28 Newton Fielding, *River scene with a sluice gate, sailing punts and figures*, watercolour and gum arabic, 1834, Victoria & Albert Museum, $2\frac{7}{8} \times 5\frac{3}{8}$

time, recalled the event:

> I was a pupil of William John Cooke, the engraver, and close friend of Bonington and had been a month with him when Bonington came to dinner. I have some curious reminiscences of the day. It happened that my master was, at the instigation of his brother-in-law, Thomas Shotter Boys, making experiments for a permanent brown ink over which colour could be washed. One of the materials was walnut juice extracted from the outside shells – and boiled down to expel the watery particles – and Bonington after dinner, while reclining on two or three chairs, made sundry sketches with pen and brush, with the juice, and expressed his intention when he was better he should try the material further, adding his approbation of the colour – permanency had not been tried. They were brought into the study to be thrown into the paper basket, but I took care of them, with Mr Cooke's permission, and I have them now ... They are simply curious ... as the very last things Bonington produced – he died after that visit.[78]

Bonington died on 23 September 1828 at John Barnett's home. He left no will but his father organized his affairs from Paris early in 1829, writing to Dominic Colnaghi, Samuel Prout and Clarkson Stanfield seeking the best possible terms for an exhibition and sale of his son's studio effects.[79] This took place at Sotheby's on 29 and 30 June 1829 (see Appendix 3). Bonington was buried at St James' Chapel, Pentonville, and after his parents' death his body was removed and reinterred, without a monument, alongside theirs at Kensal Green Cemetery. Bonington's was an honourable

funeral; Sir Thomas Lawrence and Henry Howard attended as representatives of the Royal Academy and G.F. Robson and Augustus Pugin on behalf of the Water Colour Society. News of the artist's death quickly reached Paris where it was announced in the *Journal des Artistes* only five days later.[80] In England the accolade began modestly with a notice in the *Annual Biography and Obituary* in 1829 and swelled to extravagance as the century progressed until the hard-working and unassuming young Anglo-French artist was transformed into a Romantic British hero:

> But Bonington sleeps not under the shadow of the dark cypresses in Père Lachaise: the dawn of his morning opened up beneath an English sky, his sun went down, ere it was day, amid the heavy golden tints of an English autumnal atmosphere.[81]

Notes

1. See C.E. Hughes, 'Notes on Bonington's Parents', *The Walpole Society*, 1913-14, iii, p. 109; and A. Dubuisson and C.E. Hughes, *Richard Parkes Bonington: his Life and Work*, 1924, p. 20.

2. Although, because of the very nature of the act, it is not possible to prove Bonington's breaking of the law in this way, it seems likely that Foreign Office Memorandum FO/27/199, Public Record Office, London, refers to Bonington, Clark and Webster. See also N. Mulard, *Calais au temps de la Dentelle*, Calais, 1963; and R.B. Calton, *Annals and Legends of Calais*, 1852, p. 163.

3. Bonington Senior's name first appears in the *Almanach du Commerce de Paris, des départements de la France, et des principales villes du monde* (the *Bottin*) in 1821, as 'fabricant de tulles uni et brodé', rue des Moulins, 22. By 1825, Bonington, 'fabricant de tulles' and Bonington, 'peintre' are both advertising from rue des Mauvaises Paroles, 16.

4. For example by Laurence Binyon, *English Watercolours*, 1946.

5. A. Brookner, review of Bonington exhibition, *Burlington Magazine*, 1962, p. 129.

6. H. Lemaître, *Le Paysage anglais à l'aquarelle 1760-1851*, Paris, 1955, p. 330.

7. M. Hardie, *Watercolour Painting in Britain*, 1967, ii, p. 179.

8. *Paul Huet (1803-1869) d'après ses Notes, sa Correspondance, ses Contemporains. Documents recueillis par son fils et précédés d'une Notice Biographique...*, Paris, 1911, p. 21.

9. Paris, atelier 30 May 1890, Hotel Drouot 30-31 mai 1890, lot 135.

10. For example, see his unpublished diary, private collection, transcript by J. Munday, National Maritime Museum, Greenwich,

Sunday 25 August 1833: 'called on Mr. Bonnington (*sic*) and saw the fine Exhn. of his son's drawings & c. Home at 7'.

11. *Library of the Fine Arts*, iii, 1832, p. 208.

12. Diary, Friday 16 January 1835.

13. Sotheby's 29-30 June 1829, annotated sale catalogue, Victoria & Albert Museum, London, see Appendix 3.

14. W. Whitley, *Art in England 1821-37*, Cambridge, 1930, p. 168.

15. History of Colnaghi's 1760-1960, unpublished, researched by Mrs Manning, information kindly communicated by Ms Griselda Grimond of P. & D. Colnaghi & Co. Ltd, London.

16. *Magazine of Fine Arts*, ii, 1833, p. 33.

17. Ibid, p. 148.

18. *Paul Huet (1803-1869)* ..., op. cit., p. 95; L. Dimier, 'L'Estampe anglaise d'il y a cent ans', *Le Monde Moderne*, mai 1896, no. 17 vol iii, p. 70.

19. See Appendix 3.

20. The writer in *Notes and Queries*, series iv, vol. viii, Jan-June 1871, p. 502, who had seen these works by Bonington Senior, pronounced them easy to recognize as inferior copies.

21. In the Yale Center for British Art at New Haven there is a volume of watercolours and two hand-touched lithographs, copies after views by Baron Taylor.

22. The commercially produced picture postcard of the Colleoni Monument, Venice, is, for example, an almost exact replica of Bonington's watercolour in the Louvre.

23. See J. Reynolds, *William Callow, RWS*, 1980, p. 12.

24. See M. Hardie, *op. cit.*, p. 183 for some examples.

25. J. Roundell, *Thomas Shotter Boys, 1803–1874*, 1974, pp. 25–9, makes some acute observations on this subject.

26. J. Ingamells, *Richard Parkes Bonington*, 1979, p. 68.

27. The source is Dubuisson and Hughes, op. cit., pp. 24–5, but it is reinforced by information on the Morel family in the *Almanach de Dunkerque*, 1814, p. 56 and in a dossier of notes written by the Calaisien P.A. Isaac and given by him to the Musée Carnavalet in 1924.

28. Delacroix's account of the meeting, written some forty-two years after the event is contained in his letter to Théophile Thoré of 30 Novembre 1861, *Correspondance Générale d'Eugène Delacroix*, Paris 1935–8. The dossier of notes on Francia left to the Musée Carnavalet by P.A. Isaac states that Bonington went to Paris with an introduction from Francia to Delacroix.

29. The engraver Ostervald first employed the Fieldings in 1821 or early 1822 on this project; Bonington contributed to the second volume, published in 1825.

30. Jean Gigoux, *Causeries sur les Artistes de mon Temps*, Paris, 1885, pp. 249–50, and P.A.L. in *Notes and Queries*, 4th series, vii, June 1871, pp. 502–3.

31. Comte de Narbonne, 24–25 mars 1851, Hotel des ventes mobilières, rue des Jeuneurs, 42; Comte Demidoff, 13–16 janvier 1863, Hotel Drouot; Comte de Pourtalès-Gorgier, 27 mars 1865 et jours suivants en son Hotel, rue Trouchet, no. 7; M. de Barroilhet, 12 avril 1866, Hotel Drouot; Duc de Feltre, 6–9 mai 1867 Hotel Drouot; vente Coutan 19 avril 1830, Hotel Drouot; ventes Brown, 27 décembre 1834, 17–18 avril 1837, 23–24 mai 1837, Hotel de MM. les commissaires priseurs, Place de la Bourse, 2; all in Paris.

32. Vicomte de Reiset, *Marie-Caroline Duchesse de Berry 1816–1830*, Paris, 1906; Pierre-François Frissard, *Plan de Dieppe et de ses Environs*, Dieppe, 1827, pp. 65–6.

33. *The Works of the Late Edward Dayes . . .* (1805), 1971, p. 298.

34. Ackerman's Superfine Watercolours, General List, printed at the end of T.H. Fielding, *The Knowledge & Restoration of Old Paintings: the modes of judging between copies and originals*, 1847.

35. R. Fry, 'Bonington and French Art', *Burlington Magazine*, 1927, p. 273.

36. *R.P. Bonington and his circle*, Burlington Fine Arts Club, London 1937, p. 13.

37. See n. 1 and also J. Ingamells, op. cit., and M. Spencer, 'Richard Parkes Bonington (1802–1828), A Reassessment of the Character and Development of his Art', unpublished Ph.D. thesis, University of Nottingham, 1963.

38. The rue des Martyrs address appears on his letter of October 1827 to Dominic Colnaghi, transcribed in Dubuisson and Hughes, op. cit., pp. 78–9.

39. He exhibited at the Royal Academy from the rue St Lazare but his name appears in the *Almanach du Commerce de Paris* for 1827 under 16 rue des Mauvaises Paroles.

40. Vente Collot 29 mai 1852, Hôtel des ventes, rue des Jeuneurs, 42; *Galérie des Tableaux Anciens et Modernes, miniatures, lavis, dessins et gravures, de M. Alph. Giroux et Compie*, Paris, dans les salons de l'exposition, rue Coq-Saint-Honoré, no. 7, Paris, s.d.

41. *Scene on the French Coast* (373); Dubuisson and Hughes mistakenly cite three works, op. cit. p. 77.

42. A. Cunningham, *The Lives of the Most Eminent British Painters, Sculptors and Architects*, 1829–32, v, 308.

43. Sir Thomas Lawrence to Mrs Forster, 8 September 1828, in *Annals of Thomas Banks, sculptor, Royal Academician*, ed. C.F. Bell, Cambridge, 1938, p. 207.

44. *Annals of Thomas Banks . . .*, p. 211.

45. Henry William Pickersgill, RA (1782–1875).

46. Bonington to Dominic Colnaghi, October 1827, transcribed in Dubuisson and Hughes, op. cit. pp. 78–9, original unlocated.

47. See *John Constable's Correspondence*, iv, 'Patrons, Dealers and Fellow Artists', ed. R.B. Beckett, 1966, Suffolk Records Society, x, pp. 152–4.

48. *Dictionary of National Biography*.

49. *John Constable's Correspondence*, iv, op. cit. pp. 141–2.

50. *Library of the Fine Arts*, iii, March 1832, p. 207; *Revue Britannique*, 1833, pp. 63–4 (a reprint of the English article).

51. *Annals of Thomas Banks . . .*, p. 210. The marriages of Emma and Julia are recorded in the Embassy Chapel records, Guildhall Library MS 10891.

52. Public Record Office, FO 802, 168.

53. *Dictionary of National Biography*; MS letter, Lambeth Palace Library.

54. Spencer, op. cit. 255 and 258.

55. See *La Peinture romantique et les Pré-Raphaélites*, Petit Palais, Paris, janvier-avril 1972, no. 23.

56. Wallace Collection, London; see J. Ingamells, op. cit. pl iv.

57. The boyhood friendship is described by Dubuisson and Hughes, op. cit.

58. Nottingham census returns, Nottingham Public Library.

59. Birmingham Society of Arts, 1829, *Portrait of a Gentleman* (41); 1830, *View near Aston* (351).

60. John Barnett worked from 29 Tottenham Street which, as Patrick Noon points out, was listed in *Pigot's Commercial Directory* for 1827–8 as belonging to John Dixon, copperplate printer. Barnett was probably a

junior member of this firm until his marriage to Dixon's daughter. See P. Noon, 'Bonington and Boys: some unpublished documents', *Burlington Magazine*, May 1981, p. 294, n. 2.

61. See Theodore Fielding to James Carpenter, 7 September 1829, MS Institut Néerlandais, Paris; John Burnet's *A Practical Treatise on Painting in three parts: Composition, Chiaroscuro and Colouring*, a copy of which Delacroix is known to have owned, was published in 1827.

62. *Dictionary of National Biography.*

63. She enjoyed a reputation as 'the best woman portrait painter of her time', W. Whitley, *Art in England, 1821–37*, Cambridge, 1930, p. 162.

64. See n. 46.

65. A. Jal, *Esquisses, croquis, pochades ou tout ce qu'on voudra sur le salon de 1827*, Paris, 1828, p. 17.

66. James Roberts, MS notes on Bonington in the form of a draft letter following the publication of Allan Cunningham's *The Lives of the Most Eminent British Painters . . .*, op. cit. in 1837, Paris, Bibliothèque Nationale, Estampes, Rés.; A. Joanne, *Itinéraire Général de la France, Le Nord*, Paris, 1878.

67. *Annals of Thomas Banks . . .*, op. cit. pp. 209–10; W. Burger (pseud. T. Thoré), 'L'Ecole Anglaise' in C. Blanc ed. *Histoire des Peintres de Toutes les Ecoles*, Paris, 1872, pp. 12–13; Dubuisson and Hughes are unreliable in their account of this visit.

68. Bonington to John Barnett, 5 May 1828, MS. Anderdon catalogue, Royal Academy, London; transcript Whitley papers, British Museum, Dept. of Prints and Drawings.

69. *Paul Huet (1803–1869) d'après ses notes . . .*, op. cit. p. 96, p. 102; Dubuisson and Hughes say that Bonington and Huet set off but got no further than Mantes and had to return to Paris, op. cit. p. 81.

70. Carrier, médecin, is listed in the *Almanach des Adresses des Principaux habitants de Paris pour l'année 1824*, living rue Marché St Honoré, 22.

71. Dubuisson and Hughes, op. cit. p. 81, quoting T. Thoré. John Henderson, who lived next door to Dr Monro in Adelphi Terrace, had two sons: John Henderson Junior (1797–1878) who was, by 1828, resident in Bloomsbury and well established as an archaeologist, antiquarian and collector of, among other things, watercolours, and Charles Cooper Henderson (1803–77) who is known to have taken lessons from Samuel Prout and to have travelled abroad sketching as a young man.

72. T.S. Boys to J. Barnett, Paris 10 July (1828), MS. Osborne Collection, Beinecke Rare Book Library, Yale University, printed in full by Patrick Noon, op. cit.

73. T.S. Boys to D. Colnaghi, 1829, transcript, Henry E. Huntington Library, San Marino, California.

74. R.P. Bonington to Gaudefroy, 21 July 1828 (postal stamp), MS. Bibliothèque Nationale, Paris, Estampes, Rés., facsimile reproduction Dubuisson and Hughes, opp. p. 81.

75. Bonington to J. Barnett, Abbeville, 6 September 1828, Maggs Brothers, cat. no. 449, 1924, no. 34; transcribed Dubuisson and Hughes, p. 82.

76. Bonington to Alexandre Colin, *ce mardi soir* (watermark 1826) MS. Institut Néerlandais, Paris, 7719; transcript Bibliothèque Nationale, Paris.

77. See n. 75.

78. John Saddler to Messrs Shepherd Bros., quoted in Dubuisson and Hughes, p. 84.

79. See correspondence printed in Dubuisson and Hughes, pp. 86–9.

80. *Journal des Artistes*, XIII, 28 septembre 1828, p. 206.

81. *Art Journal*, ns. IV, 1858, p. 137.

FIG. 29 Wyld, *Calais Pier and the Fort Rouge*,
pencil, wash and gouache, Whitworth
Art Gallery, University of Manchester,
$5\frac{1}{4} \times 6\frac{1}{2}$

III Wyld (1806–89)

William Wyld's work has been omitted from recent exhibitions of Oriental-ism.[1] Watercolours of North Africa and the Middle East by Charles Gleyre and Holman Hunt from 1834 onwards recently occupied a room at the Royal Academy but there was no example of the prior work in both oil and watercolour executed by William Wyld in North Africa in 1833. Clearly such shows cannot hope to be comprehensive but the absence of Wyld is significant, for it conveniently demonstrates how an English artist who retained his nationality but lived all his working life in France, exhi-biting at the salon in the French section but nevertheless writing perfect English and visiting Balmoral at Queen Victoria's invitation, can be obli-terated within the historiography of art history and connoisseurship, with its dependence on nationality and schools. Wyld's work appears regularly at the London dealers, at Agnew's, Colnaghi's, Spinks and elsewhere. Yet virtually nothing is on record about the artist's life and career. He is even not infrequently confused with William Wilde (1826–1901), the Nottingham-born watercolourist.

Ruskin has nothing to say of Wyld, and Martin Hardie clearly felt he was *de facto* a Frenchman and therefore beyond the scope of a book on English watercolour painting. His sentence on Wyld is uncharacteristically tentative: 'He is said to have played a large part in the development of water-colour painting in France. It was Bonington, and not Francia, whose influence is most apparent in Wyld's work.' Hardie also states, erroneously, that Wyld was Bonington's executor.[2] Bonington, in fact, died intestate and Wyld claimed actually never to have met him.[3] French art historians and writers have shown an equal lack of interest, despite the fact that Wyld was a salon gold medallist. It was left to P.G. Hamerton, himself an expatriate Englishman, to interview Wyld for *Portfolio*, the magazine of the arts that he edited in the last decade of the century, and to prepare an introduction to Wyld's studio sale held in Paris in 1890.[4]

William Wyld is arguably Bonington's most interesting successor, not in the sense that he slavishly imitates the other man's work but in the sense that he acquired from a study of Bonington's work a sharpness of eye, a dexterity of handling and an individual sense of location which he exploited to the full in the markets of England and France. A pencil drawing like *Calais Pier and Le Fort Rouge* (fig. 29) in the Whitworth Art Gallery exhibits the same sharp, stabby manner with a blunted pencil that is so character-istic of many of Bonington's drawings[5] (fig. 63). Yet in design it is diffuse in the manner of Francia (fig. 30), balanced in organization with its typical buoy in the left-hand corner, and the composition spreading out along a wide horizon, with the details noted in the stylish shorthand of the

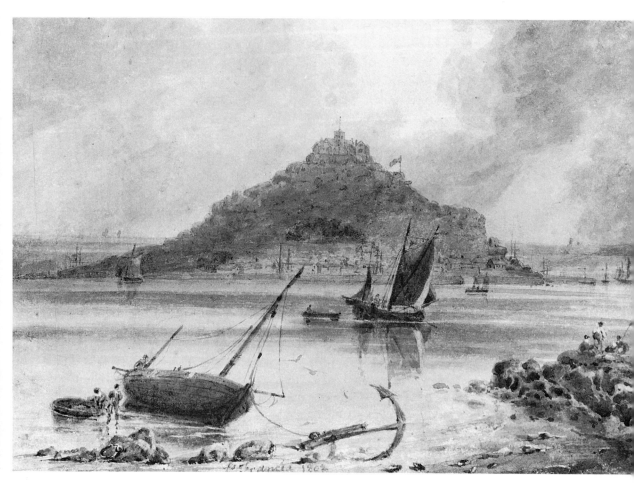

FIG. 30 Francia, *Mont St Michel*, watercolour,
1802, by courtesy of Birmingham
Museums and Art Gallery, $6\frac{3}{8} \times 9\frac{3}{8}$

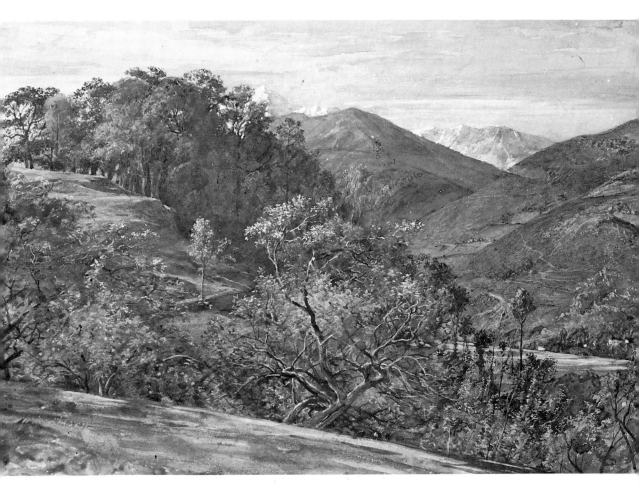

FIG. 31 Wyld, *A mountain view*, watercolour, City
of Manchester Art Galleries, $18\frac{1}{2} \times 11\frac{1}{2}$

habituated *plein-air*ist. His views of Venice replicate Bonington's but have an added preoccupation with local colour which is more reminiscent of Boys (figs. 27, 36). However, he also developed his own grand manner of watercolour painting with heavily worked surfaces, large areas of body colour and a high degree of detail. Indeed, works such as **28** and *A Mountain View* (fig. 31) in the Manchester City Art Gallery,[6] reveal an almost obsessive attention to botanical detail which anticipates Ruskinian landscape of the mid-century.

Thanks largely to Hamerton, it is possible to piece together the outline of Wyld's long career. This is of considerable interest, not least for the way in which he moved from diplomacy to business and from business to art. The skills and connections he acquired were put to good use and he travelled easily around Europe enjoying distinguished patronage. Wyld's world was very different from Francia's but his success was to a large extent due to his ability to tap markets that had been anticipated by Francia and established by Bonington. Wyld was thus essentially an entrepreneur, a man of the Second Empire and the age of Queen Victoria. Francia's teacher, Barrow, had moved without difficulty between technology and topography. For Francia, in his turn, it was imperative to establish the independence of landscape as an imaginative and individualistic genre. Now Wyld could, like Barrow, develop his artistic career from amateur to professional status. From the late eighteen-thirties he had no problem reintegrating technology and landscape; technology and industry informed the content of his work. Warehouses, machinery and industrialized townscapes took their place alongside views of Venice and Prague (see **27** and **30**). Moreover Wyld knew how to work within a market where business interests, agencies and salesmanship were as important as the older patterns of aristocratic patronage.

William Wyld was born in 1806, the son of a family of London businessmen. As a result of a family connection with the statesman, George Canning, Wyld found a position in the diplomatic service at an early age and was sent to work for the British Consul in Calais.[7] He may well have succeeded Francia who, if his own account is to be believed, took a job as Secretary to the British Consul for a period after his return to his native town in 1817.[8] According to one account Wyld worked there for four years,[9] and he himself says that he began work for the Consul in 1823.[10] However, his name first appears in Foreign Office records in November 1826, and disappears again in May 1827.[11] In any case, Canning's death in August 1827 brought to a sudden close Wyld's hopes of swift promotion in the diplomatic service and he returned to live with an uncle in London

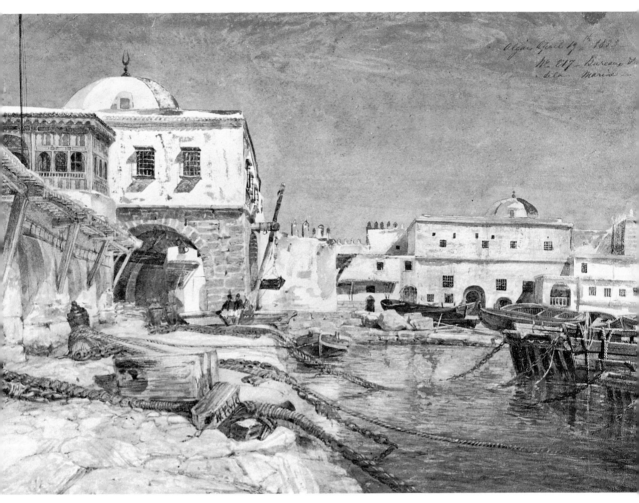

FIG. 32 Wyld, *Bureau et Magasin de la Marine, Algiers*, watercolour and gouache, 1833, Whitworth Art Gallery, University of Manchester, 11 × 16¼

FIG. 33 Wyld, *A reclining Arab*, pencil and watercolour, Fondation Custodia (Coll. F. Lugt), Institut Néerlandais, Paris, $3\frac{3}{8} \times 3\frac{5}{8}$

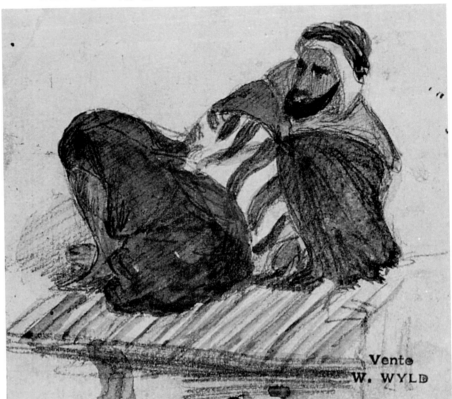

while awaiting an opening in business. It seems that Wyld was, by this time, already painting seriously, but he was not permitted by his family to regard such work as a full-time career. Much later in his life he said that he knew Bonington's father in Calais and he took lessons in watercolour from Francia.[12] He must, therefore, have been familiar not only with Francia's work but also with that of his many pupils.

The Consulate at Calais provided opportunities for an aspiring artist. Diplomacy and the art trade have often been mutually beneficial, as the careers of artists like Rubens and Van Dyck most amply demonstrate. The period immediately following peace with France was a peculiarly delicate one for Anglo-continental diplomacy. Nevertheless, the art trade, benefiting from the spoils of Napoleon's Conquests, continued in familiar channels. A letter from the English Consul at Calais, Sam Marshall, to the Comte de Forbin of 31 October 1822 assures him that an unnamed painting has been forwarded. At the same time the Consul is preoccupied with the arrest of John Bowring, a British subject 'suspected of being charged with dispatches or letters for the Revolution in England'.[13]

FIG. 34 Wyld, *An oriental bazaar*, pen, ink and wash, Whitworth Art Gallery, University of Manchester, $5\frac{1}{8} \times 4\frac{5}{8}$

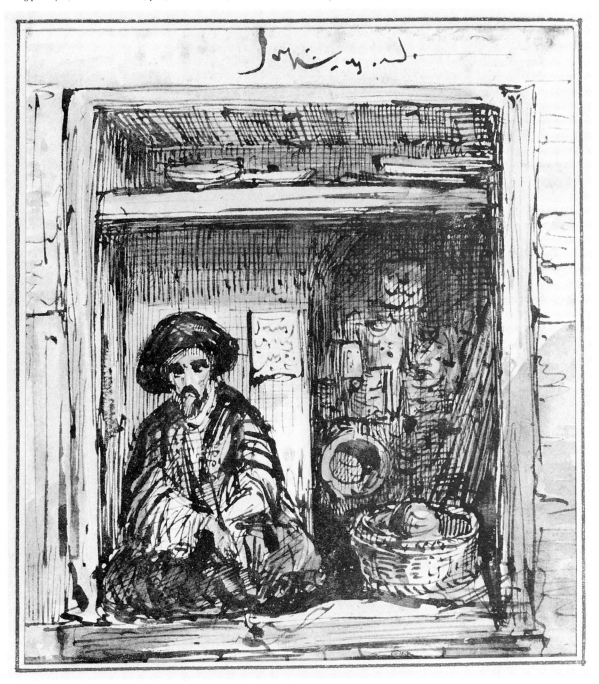

We get a vivid picture of Wyld's work as Secretary, sailing in the winter of 1826-7 between Calais and Dover with dispatches from Lord Granville to Canning. Sometimes the boats had to row most of the way. The most interesting letter from our point of view is one in which Sam Marshall explains to Lord Granville that the second dispatch arrived after the boat had sailed with the first and that he had therefore been obliged to send a second boat. 'The dispatches were given in charge to W. Wyld & M. Lewis Brown ...'[14] The latter must be the Bordeaux wine merchant, John Lewis Brown, who plied his trade between France and England. He was, presumably, well known and trusted by the British Consulate. He was also owner of the most comprehensive and distinguished collection of Bonington watercolours, many of which are now in the Wallace Collection, London.[15] (figs. 26, 27, 67).

Wyld thus encountered a man with precisely the kind of taste in art most helpful to him at this time as well as exactly the sort of business connections he needed. Probably with the help of Brown, Wyld succeeded in having himself appointed to set up and direct the branch of a London-based wine-importing business in Epernay. Before he took up his new post Wyld and a friend spent several months on a sketching tour of France, travelling by diligence.[16] On the road between Dieppe and Rouen they found themselves sharing a coach with Horace Vernet who, true to his reputation for conviviality, invited them to his house in Paris and entertained them very lavishly.

In all Wyld lived for six years in Epernay, working in the wine trade, but also making frequent visits to Paris to look at pictures in the Louvre and the Luxembourg and sketching whenever he got the chance. He made a number of friends among the influential families in Champagne; they were to be very useful to him when he began to depend solely on artistic production as a means of livelihood.

In 1833 Wyld's younger brother was old enough to take over his position in Epernay, and Wyld felt free to devote himself to his art. Accordingly he travelled to Algiers where he remained for six months collecting material which he published in collaboration with Lessore as a sequence of lithographs in 1835, *Voyage Pittoresque dans La Régence d'Alger pendant l'Année 1833*. Isabey had visited Algiers in 1830 as an official painter with the French navy and Delacroix had accompanied the Comte de Mornay to Morocco and Algeria in 1832. But unlike Isabey and Delacroix, Wyld seems to have had an immediate and very clear idea of the commercial viability of such a journey, providing as it did images that would extend the picturesque tours popularized by Baron Taylor into the newly fashionable lands of the Orient.

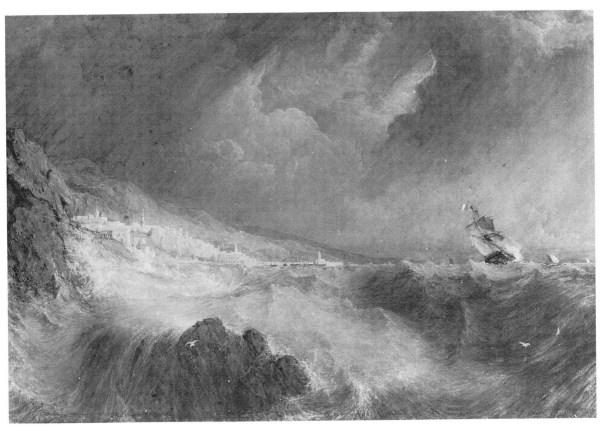

FIG. 35 Wyld, *View of Algiers*, watercolour and
gouache, Musée Boucher de Perthes,
Abbeville, 50 × 73

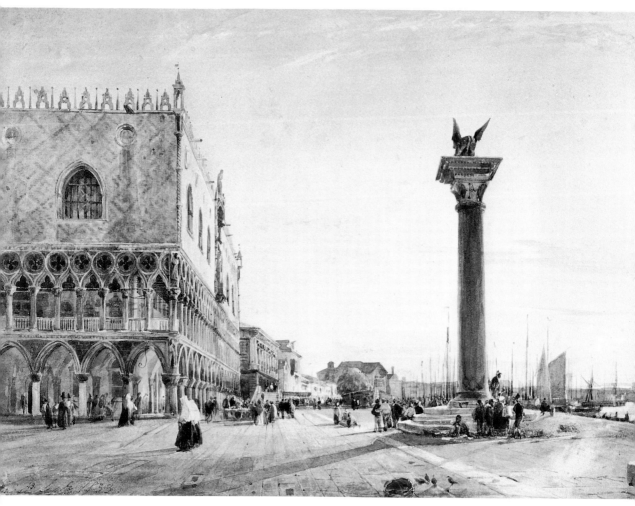

FIG. 36 Wyld, *The Doges' Palace, Venice*, water-
colour and bodycolour, Whitworth Art
Gallery, University of Manchester,
$11\frac{1}{2} \times 16\frac{3}{4}$

Wyld's Algerian views exemplify the disjuncture between topographical reportage and the process of myth-making. In the transformation from on-the-spot images to popular lithographs or grand salon paintings (fig. 35) we can discern important shifts and modifications. There is a process of distancing and generalization on the one hand and a deliberate adjustment of content and detail on the other, both going on simultaneously. Wyld's gouache study of the *Bureau et Magazin de la Marine, Algiers*, in the Whitworth Art Gallery, University of Manchester (**32**),[17] features some of those tell-tale absences identified by Linda Nochlin as characteristic of Imperialist imagery of the Orient: the absence of scenes of work and industry, the apparent absence of art strategy, of that which reminds the viewer of the 'bringing into being of the work', the absence of history suggesting a world without change.[18] There exist independent sketches of Arab figures by Wyld which he used at later stages[19] (figs. 33, 34, 76) but the initial view is virtually uninhabited; the only sign of life is two distant figures inert upon a bench.

By coincidence Wyld was able to meet up again with Vernet in Algeria. The latter, who was taking a break from his duties as director of the French Academy in Rome, took Wyld back to Italy with him. By the time he returned to Paris in 1834 he had drawings and watercolours sufficient to ensure a constant flow of scenes of Algiers, Venice, Rome and other parts of the Mediterranean for many years to come (figs. 37, 38). As with his view of Algiers, (fig. 35) these scenes are rendered unalien, distanced and safe by the controlling gaze of the artist. In the 1850s his views of European cities were commanding high prices and finding their way into most of the major collections of contemporary French art, both public and private.[20] He visited Britain regularly and contributed to the Society of Painters in Water-Colour from 1848. His work was purchased by several Manchester businessmen: Thomas Horsfall, John Pender and Samuel Mendel (figs. 31, 36, 43).

The formula Wyld had developed for the representation of cities from their perimeters, seen in a hazy light which reinforced the grandeur and made selectivity of detail possible without loss of clarity (**29, 30**), was ideally suited to the ethos of the northern industrial city as experienced by the dominant commercial class. His two views of Manchester from Higher Broughton are particularly noteworthy from this point of view. The first, in Manchester City Art Gallery, dated 1835 (fig. 39), is essentially an English rustic panorama with distant chimneys punctuating the horizon but not seriously intruding upon the peaceful rural idyll of the foreground. The second, in the Royal Library, Windsor, dated 1852, is an impressive

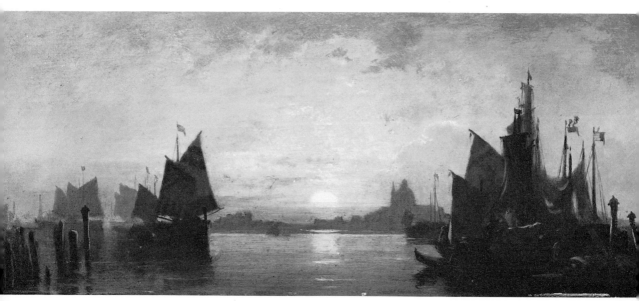

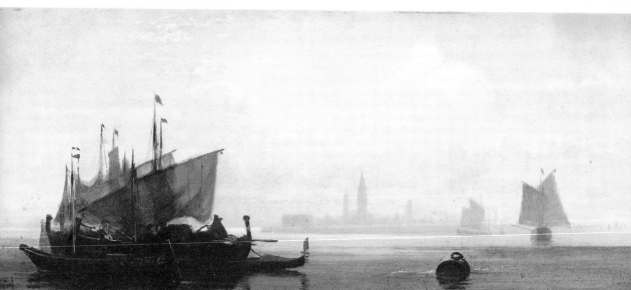

FIG. 37 Wyld, *Venice: evening*, oil on panel,
Sheffield City Art Galleries, $5\frac{1}{4} \times 13\frac{1}{2}$

FIG. 38 Wyld, *Venice: morning*, oil on panel,
Sheffield City Art Galleries, $5\frac{1}{4} \times 13\frac{1}{2}$

spectacle dominated by heavily smoking chimneys and long dark shadows (fig. 40).[21] Industry is the focus of interest here, and it is a clear reminder that the educated foreigner's tour of Britain had increasingly been directed towards the manufacturing north. Travellers like the German architect, Karl Friedrich Schinkel, and the French writer, Hippolyte Taine, who travelled around England after 1850, were as much concerned with technology and industry as with antiquity and landscape. For the royal family Wyld produced exquisitely detailed but large-scale watercolours which not only recorded the appearance of major public edifices but also narrated events of political significance. In the Royal Library are large, highly finished watercolours of *St George's Hall, Liverpool*, dated 1852 and presumably associated with the Queen's visit there in October 1851, *The Crystal Palace in Hyde Park*, also dated 1852, and *The Ball at the Guildhall, London, July 9th 1851*, dated 1851.[22]

The secret of Wyld's success, as of many of his contemporaries, lay in his capacity for transforming the small-scale, private watercolour into a significant public object without losing the qualities of intimacy usually associated with the medium (fig. 41). These were private objects made public by virtue of subject matter and treatment. The content was immediately classifiable on a sliding scale according to the importance of the buildings depicted and their social, historical or governmental significance. It was an art that was essentially political in so far as it was produced at the behest of the royal family on the one had and commercial interests on the other, and was finely calculated to please a taste for the interpretation of private and public values. Thus St Cloud (fig. 41) is presented in such a way that the viewer, though he or she discerns the palace very clearly, has to traverse the Seine with its barges and pleasure craft, the strolling public on the bank and the hedged gardens, to attain that vision. Wyld's Windsor watercolours can thus be seen as a part of the carefully orchestrated and politically effective royal private life, a sequence of images that reinforced royal conviction and could be called upon in the interests of the publicity machine when needed.

Wyld was in England in 1851, probably for the Great Exhibition. The following year he visited Balmoral and the considerable number of his watercolours in Queen Victoria's albums suggests he was a favourite. As well as the usual scenes around the castle, Wyld recorded the erection of the 'Carn Elach Chuimkneachan' in a watercolour inscribed 'One cheer more! ... Balmoral 12 October 1852' (fig. 42). The event on Craig Gowan was also recorded in *Leaves from Journals of our Life in the Highlands*, with a plate after one of Wyld's drawings.[23] The Queen worked her visiting artists

FIG. 39 Wyld, *Manchester from the cliff, Higher Broughton*, watercolour, 1835, City of Manchester City Art Galleries, $26\frac{1}{2} \times 46\frac{1}{4}$

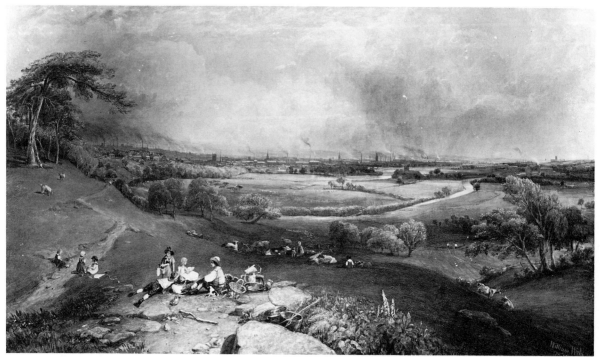

hard and Wyld was no exception. Writing home, he commented, 'My hands are full of work and she is wishing for something fresh every day.'[24]

Wyld's work is easy to recognize. It is invariably signed *WWyld* in pigment, usually at the base of the picture. His watercolours fall into several categories: the small loosely worked watercolours, which tend to be almost monochromatic and are reminiscent of J.R. Cozens, date from the thirties and early forties. *The Pont du Gard* in Manchester City Art Gallery is a good example of this manner (fig. 43).[25] These works may well have been done on the spot. Then there are the highly finished townscapes such as **29** and **30**, and the richly foliated and heavily worked studio landscapes like no. **28**. These are evidently elaborated in the studio from small sketches done on the spot, and date from the mid-thirties to the mid-fifties. There are the more substantial exhibition pieces like **31**, which are similar to the finished townscape but on a larger scale and tending to more elaborate surface detail. In addition there are topographical studies of imperial architecture executed with a degree of precision and a hardness that suggests the use of photographs. These constitute a superior kind of picture-postcard record, and consequently found their way into royal albums. Views of Brussels done in 1852 and now in the Royal Library, Windsor, exemplify this manner very well (fig. 44).[26] There are the pen-and-ink and sepia

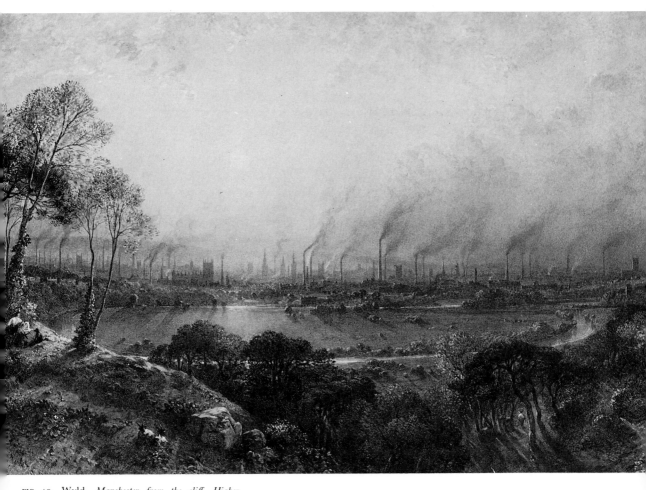

FIG. 40 Wyld, *Manchester from the cliff, Higher Broughton*, watercolour, gouache and gum arabic, 1852, the Royal Library, Windsor, $12\frac{1}{2} \times 15\frac{1}{4}$

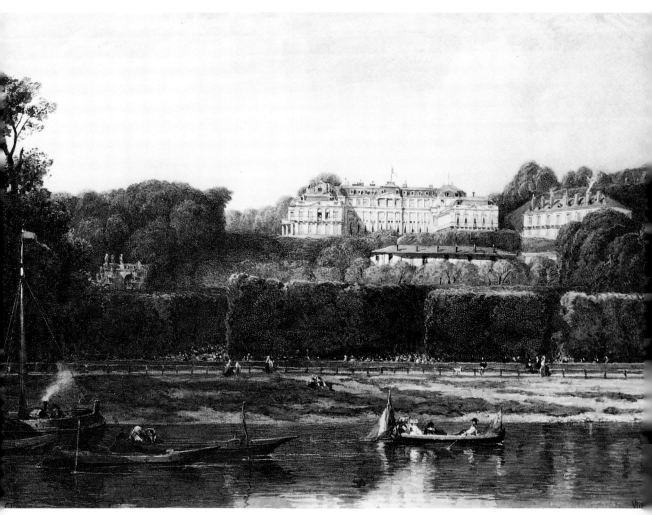

FIG. 41 Wyld, *St Cloud from the Seine*, watercolour
and bodycolour, 1885. Copyright
reserved. Reproduced by gracious
permission of Her Majesty the Queen.
$12\frac{3}{4} \times 18\frac{3}{8}$

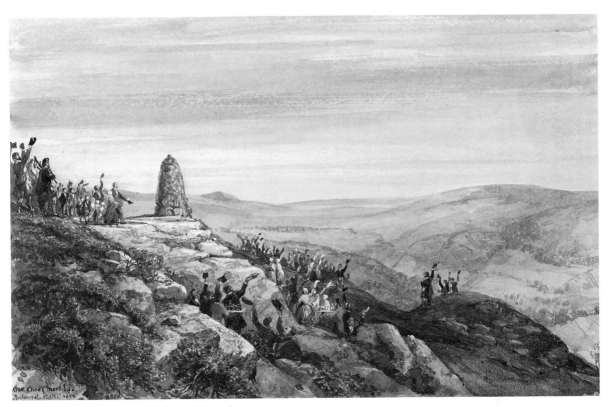

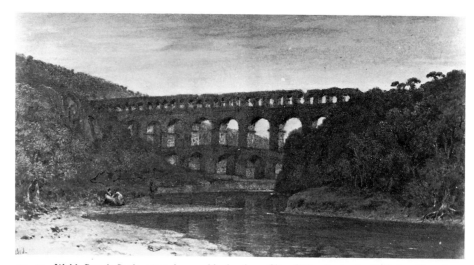

FIG. 43 Wyld, *Pont du Gard*, watercolour and bodycolour, City of Manchester Art Galleries, $6\frac{3}{8} \times 12\frac{3}{8}$

FIG. 44 Wyld, *The Royal Palace, Brussels*, watercolour, bodycolour and gum arabic. Copyright reserved. Reproduced by gracious permission of Her Majesty the Queen. $8\frac{3}{4} \times 13\frac{1}{8}$

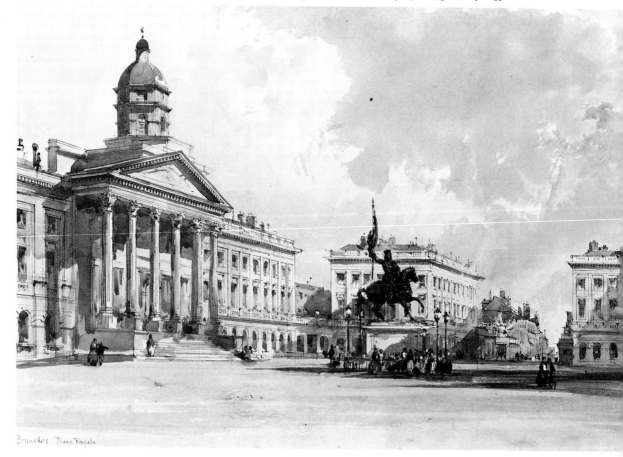

drawings which, for all their freedom of handling, often have the feel of seventeenth-century topography about them. The swiftly executed pen-and-ink study of the fortress at Algiers is an example of this manner (fig. 45).[27] Such drawings were probably used as a preparatory stage towards the production of lithography. Wyld also worked in oil with similar motifs and on a large scale.[28]

We are left with the impression of a highly organized and well-educated gentleman artist who had transformed the topographical townscape into a peculiarly confident genre of mid-nineteenth-century imperialist art. He had profited from expanding markets and ease of travel. Though Francia had not lacked privilege by birth, his life as an artist had certainly not been easy. Bonington's lower-middle-class manufacturing background seems to have endowed him with an impressive versatility, tenacity and opportunism. No wonder people have speculated so often on what he might have achieved had he lived. But Wyld seems to have possessed an effortless assurance and a near-familiarity with his patrons that ensured for him not only a secure livelihood but also a comfortable standard of living. He knew the market and provided the product. Writing on 13 May 1854 from Club Chambers in Regent Street to a potential purchaser, the Revd E.L. Magson, he suggests that the gentleman call on him during his stay in town and Wyld will be 'gratified in shewing you my folios containing many sketches & studies from nature in most parts of Europe'.[29] Hamerton's memoir sums up an achievement whose blandness should not be allowed to disguise its intrinsic historical and artistic interest:

> It will be remembered that Mr. Wyld is not a rustic landscape-painter, but chiefly a painter of continental cities. The kind of subject which best suits his taste and genius includes palatial architecture, rich foliage, and water, seen in beautiful weather.[30]

Wyld's self-congratulatory tone and the suggestion that he has a considerable stock of drawings effortlessly maintained at a level to satisfy the demands of middle-class clients cast him in a less than sympathetic light. It is tempting to judge Wyld's townscape art to be lacking a moral core in an age which produced Charles Dickens and Matthew Arnold. But the technical excellence of Wyld's art served to minimize the effort of understanding. Diverting attention from the actual state of industrialized cities in the north, it enshrined in technically adventurous depictions a belief in European continuity. That belief is a part of the anguished faith in hegemony underlying the writings of Wyld's manifestly serious contemporaries: Carlyle, Arnold and Ruskin.

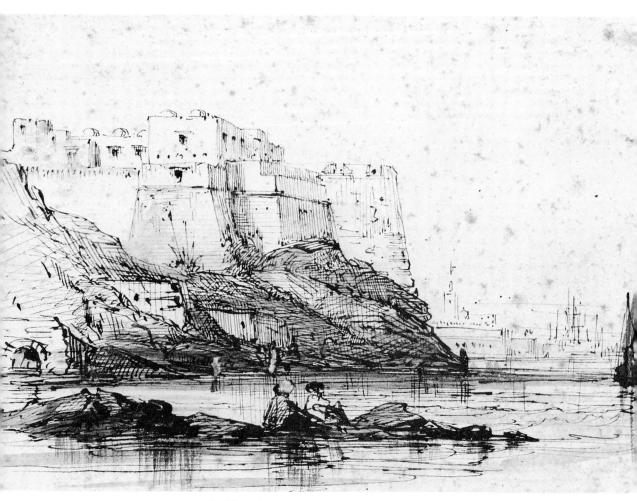

FIG. 45 Wyld, *A fortress in Algiers*, pen, sepia,
ink and wash, Whitworth Art Gallery,
University of Manchester, $3\frac{5}{8} \times 5\frac{1}{2}$

Notes

1. *Orientalism: the Near East in French Painting 1800–1880*, Memorial Art Gallery of the University of Rochester, Rochester, New York, 1982; *The Orientalists: Delacroix to Matisse, European Painters in North Africa and the Near East*, Royal Academy, 1984.

2. M. Hardie, *Watercolour Painting in Britain*, 1967, ii, p. 145. The error derives from A. Dubuisson and C.E. Hughes, *Richard Parkes Bonington: his Life and Work*, 1924, p. 84.

3. P.G. Hamerton, 'A Sketchbook by Bonington at the British Museum', *Portfolio*, XII, 1881, pp. 68–9.

4. 'W. Wyld's Sketches in Italy', *Portfolio*, VIII, 1877, Vente W. Wyld, Paris, atelier 30 mai, Hotel Drouot, 30–31 mai 1890.

5. D/65/1926 (1121), pencil, wash and gouache on grey paper, $5\frac{1}{4} \times 6\frac{1}{2}$ in.

6 Horsfall Collection, 1918, 458, watercolour, $18\frac{1}{4} \times 11\frac{1}{2}$ in.

7. All information concerning Wyld's biography is derived from his interview with P.G. Hamerton in *Portfolio*, VIII, 1877, unless otherwise stated.

8. He designates himself thus in the Royal Academy catalogue for 1817.

9. P.G. Hamerton, introduction to Wyld's studio sale, see n. 4.

10. P.G. Hamerton, 'A Sketchbook by Bonington . . .', op. cit., p. 68.

11. Public Record Office, FO 452/1. Copies of letters from the Consul at Calais, March 1822–August 1832. Henceforth FO 452/1.

12. P.G. Hamerton, introduction to Wyld's studio sale, see n. 4.; P.G. Hamerton, 'A sketchbook by Bonington . . .', op. cit., p. 68.

13. FO 452/1.

14. Ibid.

15. Lewis Brown's collection was sold in Paris 27 December 1834 (50 Boningtons), 17, 18 April 1837 (53 Boningtons); 23–24 May 1837 (52 Boningtons).

16. This, in itself, suggests a degree of affluence; many artists walked.

17. D10–1920, inscribed top right in ink *Algiers April 19th 1833 no. 217 Bureau & Magazin de la Marine*, $11 \times 161/4$ in.

18. L. Nochlin, 'The Imaginary Orient', *Art in America*, May 1983, pp. 122–3.

19. e.g. Three studies on one mount, pencil and watercolour. Paris, Institut Néerlandais, 7727.

20. For example, Théophile Gautier owned four of Wyld's watercolours and Etienne Arago, Director of the Luxembourg, owned at least one. In 1869 Wyld was paid 3,500 francs by the government for his *View of Mont St Michael from Avranches* (unlocated, study in the Louvre). This was destined for the Luxembourg. Other works purchased by the government found their way to provincial museums. The Musée de Douai was given Wyld's *Vue du Port de Genes prise des hauters d'Albano* (destroyed 1914–18 war) and the Musée d'Abbeville received a marine view.

21. Manchester City Art Gallery, 1919.9, $26\frac{1}{2} \times 46\frac{1}{4}$ in; Royal Library, Windsor, 20223, Souv. Alb. V. p. 48. 31.8 × 38.2 cm.

22. 20219, Souv. Alb. V. p.45, $12\frac{5}{8} \times 18\frac{7}{8}$ in; 19930, Souv. Alb. V. p.47, 30.8 × 49.2 cm; 20218, Souv. Alb. V. p.45, 29.2 × 42.8 cm.

23. 19483, Souv. Alb. XII, p. 13a, 22 × 35 cm; engr. J.A Stephensen in *Leaves . . .*, p. 88.

24. W. Wyld to 'My dear Suzan', 25 Sept. 1852, MS, The Royal Library, Windsor, Vic. Addl. MSS.

25. 1918. 604, watercolour, $26\frac{1}{2} \times 46\frac{1}{4}$ in. This, like many of the works in the Manchester City Art Gallery, comes from Horsfall's collection.

26. e.g. 13753–13758.

27. Whitworth Art Gallery, University of Manchester, D.52/1926 (1130), $3\frac{5}{8} \times 5\frac{1}{2}$ in.

28. See, for example, two views of Venice in The Graves Art Gallery, Sheffield.

29. W. Wyld to Revd E.L. Magson, DD, 13 May 1854, MS, The Historical Society of Pennsylvania.

30. P.G. Hamerton, 'W. Wyld's Sketches in Italy', *Portfolio*, VIII, 1877, p. 143.

Catalogue raisonné of works by Francia, Bonington and Wyld in the Victoria & Albert Museum

Catalogue

Only those items belonging to the catalogue and numbered in **bold** type are held by the Victoria & Albert Museum; for purposes of comparison, however, figs 46–76 appear in juxtaposition with these.

Francia's work is followed by that of Bonington and, finally, by that of Wyld. Within each section works are arranged in chronological order, with those works that cannot be dated with any degree of certainty at the end of the section.

There is one oil painting by Bonington in the Dept of Prints and Drawings and Paintings; this has been included (**24**) since the homogeneity of Bonington's work necessitates discussion of his work in all media, not just in watercolour.

Some works by imitators and pupils that have found their way into the collection are included, as they provide a useful index to the problems of authenticating watercolours by these artists. They are to be found together at the end of the catalogue.

Sizes are given in inches and centimetres, height before width.

Francia

1a & 1b
Landscape composition moonlight and Landscape composition moonlight (reverse)

Watercolour on white paper; 9 × 14½ (22.9 × 37.3)
Inscribed on reverse in brown ink in Francia's hand:

> This drawing was made on Monday May the 20th 1799 at the room of Robert Ker Porter of no 16 Great Newport Street Leicester Square, in the painting room, that formerly was Sir Joshua Reynolds's; & since has been Dr Samuel Johnson's; & for the first time on the above day convened a small and select society of Young Painters under the title (as I give it) of the Brothers; met for the purpose of establishing by practice a school of Historical Landscape, the subjects being original designs from poetick passages.
>
> Lˢ Francia

The society consists of
Worthington
J. Cˢ Denham, Treas^r
R^t K^r Porter
Tˢ Girtin
Tˢ Underwood
G^e Samuel
and Lˢ Francia, Secret^y

477–1883

CONDITION: Badly damaged at the edges, surface scratched at the right and vertical fold marks at the left. Slight foxing in centre

PROV: Acquired by the Museum in 1883 from Mrs Edwards of 26 Golden Square for the sum of £15. This drawing must always have been something of a curiosity owing to its inscription. There is no record of its history prior to 1883 but one possibility may be that Mrs Edwards was a descendant by marriage of Edward Edwards, watercolourist, landscape artist and author of *Anecdotes of Painters* published posthumously in 1808. Edwards makes no mention of the Brothers but he does include Girtin, who was a member, in the *Anecdotes* (p. 279)

LIT: Almost every study of watercolour painting refers to this drawing or the circumstances surrounding its production. These are the most important items of

bibliography: W. Thornbury, *The Life of J.M.W. Turner R.A.*, revised ed. 1877, facsimile, Ward Lock reprints, 1970, pp. 66–7; J.L. Roget, *A History of the 'Old Watercolour' Society*, 1891, i, pp. 98–101; H.M. Cundall, *A History of British Watercolour Painting*, 1908, pp. 43–5; Dr Guillemard, 'Girtin's Sketching Club', *Connoisseur*, LXIII, 1922, pp. 189–195; Jack Hartshorn, 'Notes sur le séjour de Louis Francia en Angleterre: "The Girtin's Sketching Club"' (*sic*), *Bulletin historique et artistique du Calaisis*, no. 14, pp. 23–25 n.d.; T. Girtin and D. Loshak, *The Art of Thomas Girtin*, 1954, pp. 37–8; Martin Hardie, *Watercolour Painting in Britain*, 1967, ii, pp. 9–10; Jean Hamilton, *The Sketching Society 1799-1851*, Victoria and Albert Museum, 1971 (in this, *Landscape composition moonlight* is wrongly cited as 477-1863)

Landscape composition moonlight is an example of a watercolour that has survived by virtue of its status as a piece of historical documentation. It has a crudeness and naïvety which would normally have excluded it from most collections and its physical condition is such that it may even, at some stage during its life, have been screwed up or at least crumpled up and discarded. To deal first with the pictorial image, though this cannot be detached from the history of the sketching club, the origin of which is so fascinatingly recorded on the reverse, it may be said that technique and subject matter are both worthy of attention. The watercolour is executed in dark monochrome using the basic watercolour technique advocated by Edward Dayes in which the white of the paper is allowed to stand as the lightest tone in the work's range, here appearing in the moon and in its reflection in the water (E. Dayes, *Essays on Painting, instructions for Drawing and Coloring Landscapes; and Professional Sketches of Modern Artists* in *The Works of the late Edward Dayes*, 1805). The subject must, if the inscription on the reverse is to be believed, be based upon a specific passage of poetry. There is no very clear indication as to a text, but the tower or castle which can be seen on the headland to the left of this otherwise uninhabited scene may provide a clue. Milton must certainly have been regarded

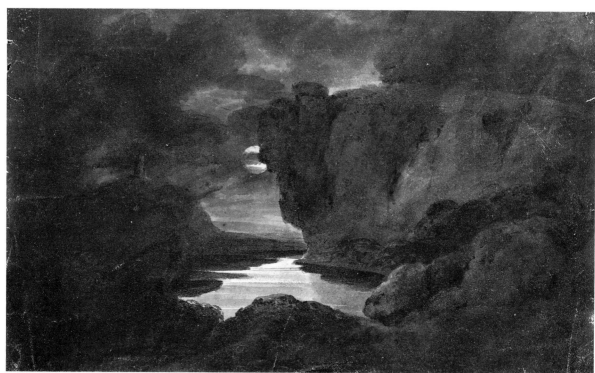

ib

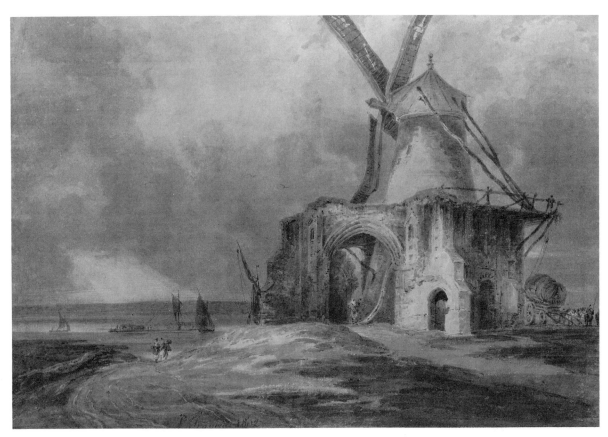

FIG. 46 (for comparison with CAT. **1a** and **1b**)
Francia, *St Benet's Abbey*, *Norfolk*, water-
colour, 1802, Cecil Higgins Museum and
Art Gallery, Bedford, $11\frac{1}{4} \times 16\frac{1}{4}$

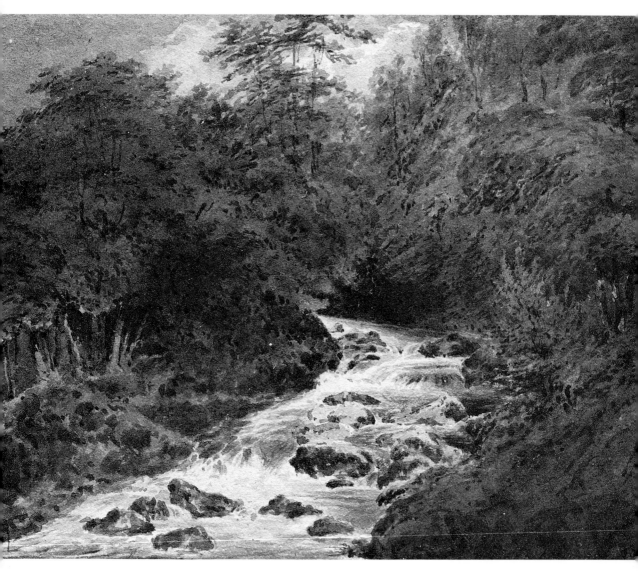

FIG. 47 Francia, *A Mountain Stream*, watercolour,
1801, Yale Center for British Art, Paul
Mellon Collection, $5\frac{11}{16} \times 7\frac{3}{4}$

as a very proper source for epic pastoral scenes; and *L'Allegro* was the source of one of the texts set for the Sketching Society (possibly a continuation of the Sketching Club) one evening when Cotman attended (J. Hamilton, op. cit., p. 7). *Il Penseroso* furnishes a passage which might well be the basis of Francia's *Landscape composition moonlight*:

> Or let my lamp at midnight hour,
> Be seen in some high lonely tow'r,
> Where I may oft outwatch the Bear,
> With thrice great Hermes, or unsphere,
> The spirit of Plato to unfold
> What worlds or what vast regions hold
> The immortal mind that hath forsook
> Her mansion in this fleshly nook.
> (*Milton Poetical Works*, ed. Douglas Bush, Oxford and London 1966, 'Il Penseroso', lines 85–92)

Francia does not seem to have been much at home in the genre of historic landscape. Apart from *Orlando and Oliver* exhibited at the Royal Academy in 1796 (367, unlocated), all his exhibited works appear to have been based on nature rather than on literature and to have been picturesque rather than poetic. By 1799, Francia was 27 and might have been expected to have achieved something rather more refined in execution than *Landscape composition moonlight*. Very early works by Francia are not plentiful, but a comparison between this watercolour and *A Mountain stream* (fig. 47) and *St Benet's Abbey, Norfolk* (fig. 46), signed and dated 1801 and 1802 respectively, suggests that either Francia suddenly blossomed forth as an artist between 1799 and 1801 or that *Landscape composition moonlight* is atypical. I incline to the latter view; the works dated 1801 and 1802, whilst falling far short of the level of accomplishment that one has come to expect in Francia's watercolours of the eighteen-twenties, manifest a confidence of touch, a relative sophistication of approach to composition and lighting and a range of handling which suggest that Francia must have thoroughly learned the lessons of Varley and Girtin over some considerable period of time.

Other drawings executed by Francia at the club and signed are now in the Henry E. Huntington Art Gallery, San Marino, California, along with the society's minute book (62–78). These drawings are characterized by the same dull execution and sombre monochromatic colour. It is always possible, *Landscape composition moonlight* being unsigned, that Francia wrote his inscription as secretary on the back of one of the other Brothers' drawings. Those of their works that have survived at the Huntington Gallery are executed in a similar manner.

The inscription on the reverse of *Landscape composition moonlight* has exercised many scholars and connoisseurs of watercolour painting. The sketching club is frequently referred to as 'Girtin's sketching club', even though the inscription implies that Francia is the founder. The procedures and aims of the Brothers are described by Thornbury and reiterated by Roget (Thornbury, op. cit. pp. 66–7, and Roget op. cit i, 98–101). Thornbury, who over the years has been proved unreliable on a number of counts, gives three names in addition to those given by Francia in his manuscript list of founder members. They are A.W. Callcott, P.S. Murray and John Sell Cotman. It seems likely that Thornbury confused the Brothers with the later club of which Cotman was the founder.

During the 1920s the minute book of the club came to light and this provided some extra information (Guillemard, op. cit., pp. 189–195). The basic known facts are as follows: the first meeting took place on 20 May 1799, after which they were probably irregular until 9 September 1799 when the minute book was first used. The regulations were straightforward and quite strict. The club was to meet weekly at the house of each member in turn; its special aim was landscape composition as described by Francia; the members met at six o'clock over tea or coffee, and worked until 10 o'clock when they ate a plain supper together, leaving around midnight. The host for the evening supplied strained paper, colours and pencils, and all sketches became his property at the end of the evening. There was a fine of half-a-crown for non-attendance without a satisfactory cause and a fine of a shilling for making any objection to a subject chosen. One can well imagine that the severity of these rules was one possible cause of the early demise of the club. The laws specified meetings to

be held on Saturdays, but actually the first three seem to have taken place on Mondays and it was not until 28 September 1799 that Saturday became the regular meeting day. The last meeting in the minute book is given as 11 January 1800, at which date all the members were in regular attendance. Guillemard suggests that the Brothers may simply have acquired a new secretary and a new minute book, but Hamilton's view is that Cotman's Sketching Society, which came into existence in 1802, was possibly a continuation of the Brothers rather than a new club. At all events, the group was evidently very close-knit whilst it continued to meet, their watercolours rigorously adhering to the required subject and expected form of interpretation. Their choice of texts included Ossian, Cowper and John Cunningham.

The members of the club as named by Francia were all practising watercolourists. It is perhaps symptomatic of the watershed that this sort of activity at this time created that three of the individuals named went abroad more or less permanently. Francia and Underwood pursued their careers in France (Cundall, op. cit., p. 45) and Ker Porter in Russia.

Two of the artists mentioned merit special attention. It may well be significant that the first meeting of the club was held at the home of Robert Ker Porter. The Porter family moved to 16 Great Newport Street (a house redolent in historical associations, as Francia points out) some time in the late 1790s. Robert Ker Porter was a flamboyant character of many and varied gifts, beginning professional life as a painter of religious pictures and progressing through theatrical scene-painting to the creation of the celebrated panorama of the siege of Seringapatam in 1800, enlisting as Captain in the Westminster Militia in 1803 and finally establishing himself as painter to the Czar of Russia in 1804.

An important influence in the Porter household was that of Robert's sister Jane, 1776–1850, who became celebrated as a novelist after the publication in 1803 of her novel *Thaddeus of Warsaw*. The hero of this novel, having arrived penniless in London, survives by the industrious execution of watercolour landscapes of Germany (done from memory) which he sells to a dealer in Great Newport Street. Samuel Carter Hall is supposed to have called Jane Porter 'Il Penseroso' (which, if true, might lend authority to my suggested source for 477–1883) and one writer (without giving any source) states that it was Jane Porter who selected the passages to be illustrated (*Dictionary of National Biography* and Hartshorn, op. cit., p. 25). It seems more than probable that the Porters – the brother with his penchant for the theatrical and his experience in the tradition established by de Loutherbourg, and the cultivated literary sister – were prime movers behind the foundation of the sketching club recorded on the reverse of *Landscape composition moonlight*.

The other name that deserves special mention is that of John Charles Denham. Denham was an amateur of no very great distinction but he was evidently the sort of man who worked hard at his friendships with artists professional and amateur and who enjoyed accumulating ephemera and souvenirs. It is thanks to these two characteristics that there has survived a remarkable album owned by Denham and containing examples not only of his own work but also of that of several members of the sketching club, as well as of a wide variety of artists active in England in the first half of the century (The Denham Album, Beinecke Rare Book and Manuscript Library, Yale University). Denham collected an early Turner executed at Dr Monro's, sketches by Girtin and Callcott, a landscape by Lawrence, a Sandby, a de Loutherbourg, a Hearne and two Francias (one of them a view of Cumberland). A sketch by Jane Porter reveals that this literary lady was also adept with pencil and brush. A drawing and a letter to Denham from Robert Ker Porter in Caracas in 1835 indicates the firmness of the bonds of friendship sealed over drawings and supper at 16 Great Newport Street in 1799.

ARTISTS LISTED BY FRANCIA AS
FOUNDER MEMBERS OF THE BROTHERS

J.G. Worthington, active 1795–1804, amateur landscape painter who exhibited 11 views at the RA

John Charles Denham, active 1768–1858, amateur artist, exhibited 63 works at the RA

Robert Ker Porter (later Sir Robert),
 1777–1842

Thomas Girtin, 1775–1802, celebrated
 watercolourist

Thomas Richard Underwood, 1765–1836,
 one of Dr Monro's protégés, exhibited at
 the RA until 1802 then visited Italy. He
 was arrested on his return through
 France in 1803 and, after his release,
 remained there, having been granted
 permission to practise as a landscape
 painter.

George Samuel, active 1785, died 1824,
 very prolific landscape painter working
 in watercolour and oil.

2
The shipwrecked mariner

Watercolour on coarse absorbent paper
laid down; $4\frac{1}{2} \times 12\frac{2}{8}$ (10.3 × 30.9)
625–1877
(See also colour plate between pp. 96 and
97)

CONDITION: In good condition, slight
diagonal scratch in the sky at right

PROV: Lot 273 in Samuel Redgrave's sale,
Christie's 23–24 March 1877, bought by
the Museum for £6, entered the collection
26 March 1877

EXH: *Drawings in Watercolours by Artists born
anterior to 1800 and now deceased*, Burlington
Fine Arts Club, 1871 (213); *British
Watercolours 1750–1850*, International
Exhibitions Foundation, 1966–7 (39)

Francia's simple and arresting shipwreck
scene must belong to around 1799; it is
close in treatment and concept to *Landscape
composition moonlight* (**1**) on the back of
which appears the record of the meeting of
the Brothers and the declaration of their
intention to depict landscape designs from
poetic passages. The paint is applied in
great sweeping washes in parallel bands.

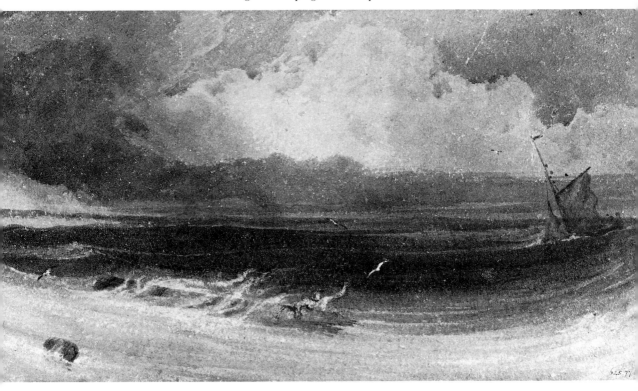

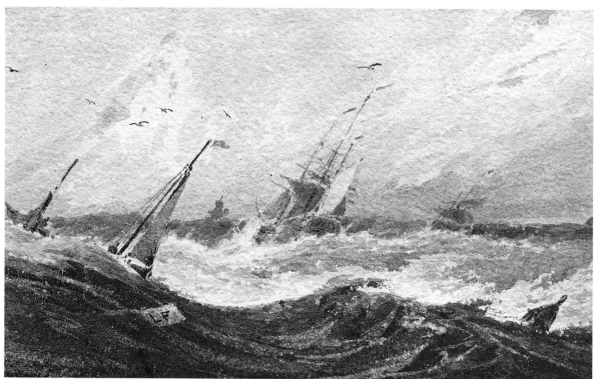

FIG. 48 (for comparison with CAT. **2**) Francia,
Boats on a stormy sea, watercolour, Yale
Center for British Art, Paul Mellon
Collection, $4\frac{1}{4} \times 7\frac{1}{8}$

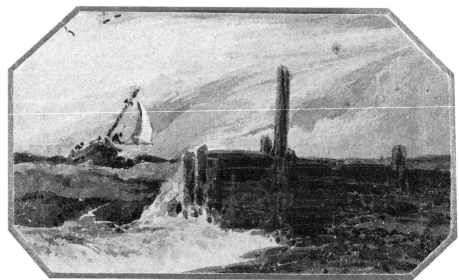

FIG. 49 (for comparison with CAT. **2**) Francia, *Nearing port in a stormy
sea*, brush with brown ink touched with bodycolour on grey
paper, Yale Center for British Art, Paul Mellon Collection,
$4\frac{1}{2} \times 7\frac{1}{4}$

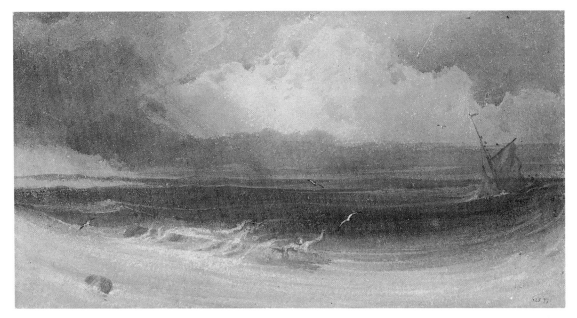

Catalogue 2 Francia, *The shipwrecked mariner*

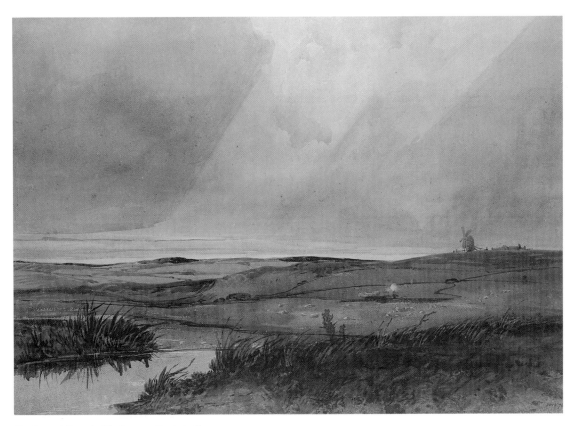

Catalogue 4 Francia, *Heath scene with windmill*

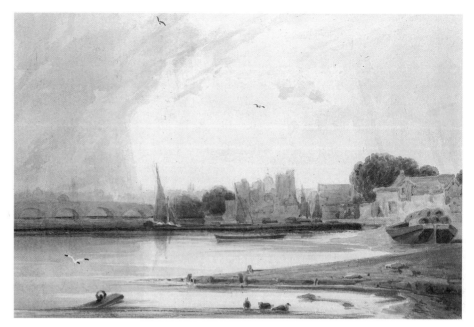

Catalogue 9 Francia, *Lambeth Palace and Westminster Bridge*

Catalogue 17 Bonington, *The church of St Gilles, Abbeville*

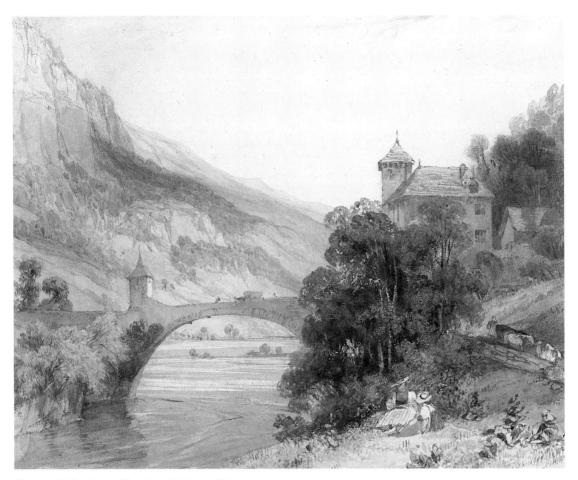

Catalogue 20 Bonington, *The bridge of St Maurice d'Agaune, Switzerland*

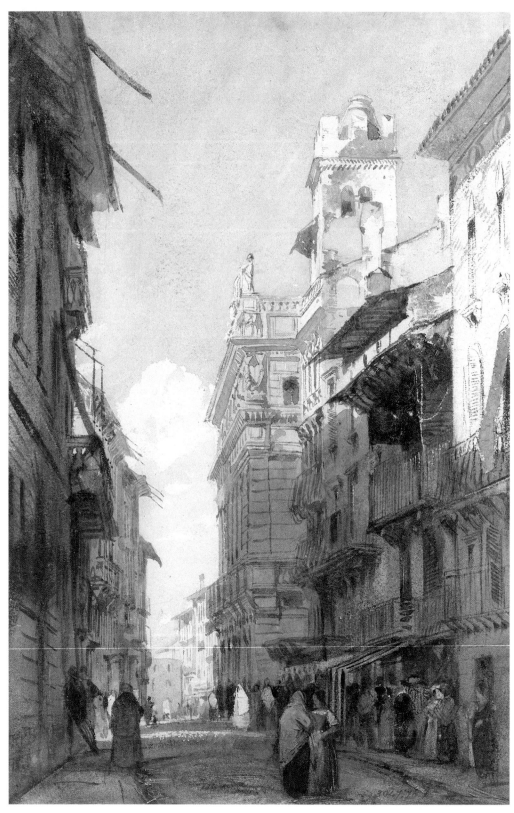

Catalogue 21 Bonington, *The Corso Sant'Anastasia, Verona, with a view of the Palace of Prince Maffei*

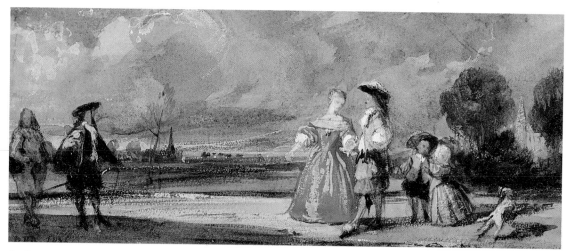

Catalogue 22 Bonington, *The meeting*

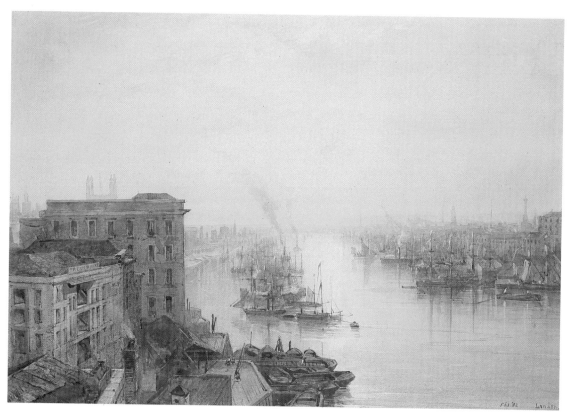

Catalogue 27 Wyld, *The Pool from Adelaide Hotel, London Bridge*

Catalogue 28 Wyld, *The Falls of Tivoli*

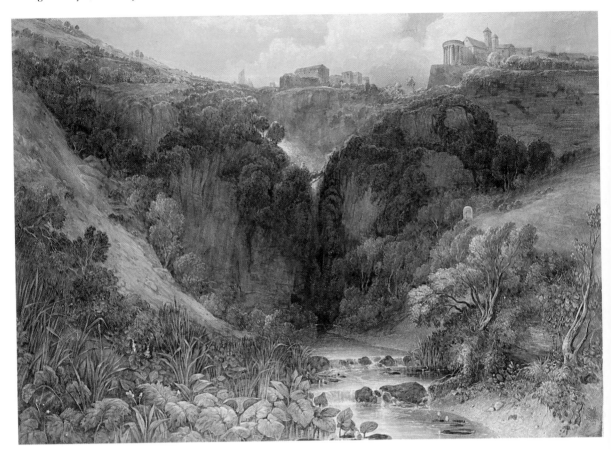

Catalogue 29 Wyld, *View of Dresden by sunset*

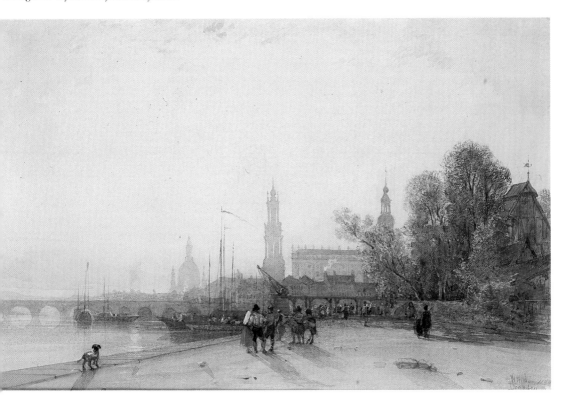

Catalogue 30 Wyld, *A view of Prague*

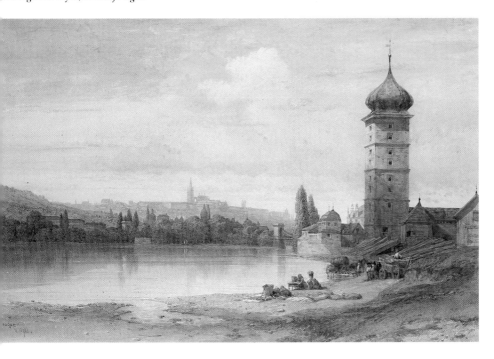

Catalogue 33 A pupil of Francia, *A Deal or Hastings lugger and boats*

The waves, seagulls and other light areas are scraped off and the entire rendering has retained an air of vigour and animation through the white flecks which remain as a result of the extremely coarse paper surface. The composition is striking in its economy; although there are many similar views of rough seas painted in similar concave bands of colour with lights energetically and boldly scraped out, they tend to be more detailed than *The shipwrecked mariner*. *Boats on a stormy sea* in the Yale Center, formerly in the collection of Thomas Girtin, has the same schematic composition and rich blue-black foreground, but here the impact is weakened by the six partially visible boats as well as by details like the spar, on which the artist has signed his initials, and the buoy in the right foreground (Yale Center for British Art, B 1975.3.835) (fig. 48).

The flattened vortex of the composition in *The shipwrecked mariner* as well as the treatment of light (bright foreground, light patch on the horizon and a jagged area of light in the sky), suggest that the young Turner may well have learned something from Francia. The innovative qualities of Francia as a watercolourist can be appreciated further by looking at a number of seascapes in the Yale Center which are painted on stiff grey card with the corners cut off (e.g. B.1977.14.5816) (fig. 49). The composition and treatment remains conventional by comparison with Turner, but the interest in the effects to be gained by painting on dark-toned paper or card and the experimentation with format for sea-scapes with no solid foreground is very bold for the end of the eighteenth century

or the very beginning of the nineteenth.

The shipwreck became one of the most popular subjects in the repertoire of nineteenth-century artists (see T.S.R. Boase, 'Shipwrecks in English Romantic Painting', *Journal of the Warburg and Courtauld Institutes*, XIII). Francia's mariner clinging to a spar and waving his arm in the hope of being seen by the occupants of an approaching fishing boat, may be based on William Falconer's popular poem *Shipwreck* (1762 revised) or on the passage describing the storm at sea in Thomson's *The Seasons* (first collected edition, 1730):

> Whitening, the angry Billows rowl immense,
> And roar their Terrors, through the shuddering Soul
> Of feeble Man, amidst their Fury caught,
> And dash'd upon his Fate: Then, o'er the Cliff,
> Where dwells the *Sea-Mew*, unconfin'd, they fly,
> And, hurrying, swallow up the sterile Shore.
>
> (*Winter*, lines 167–172)

Francia exhibited a number of shipwreck scenes at the Royal Academy (1802, 1803, 1814, 1816), but his interest in the plight of shipwrecked mariners developed from the pictorial to the philanthropic after his return to Calais and in 1834 he was the prime mover behind the foundation of the Société Humaine, founded to organize an effective lifeboat service (Françoise Saulnier et Nelly Schmidt, *La Pêche et l'habitat à Calais depuis le XIIᵉ siècle, Le Courgain maritime*, Calais, Musée des Beaux Arts, 1980, p. 46).

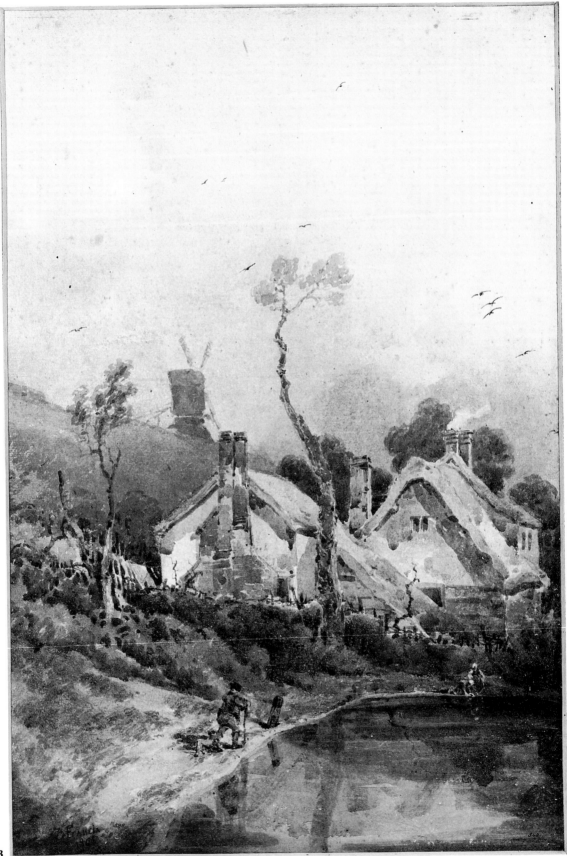

3
Cottages in a valley

Watercolour on card laid down; $17\frac{3}{8} \times 11\frac{7}{8}$ (43.9 × 30.1)
Signed and dated *L. Francia 1805* lower left
FA 588
CONDITION: Much faded but marginal strips suggest something of the original colour, slight foxing, horizontal ink marks from the mount along the top edge
PROV: Acquired by the original South Kensington Art Library and transferred to the Victoria and Albert Museum when the Dept of Prints and Drawings was created
EXH: Possibly RA 1805 (491); 'John Thirtle, 1777–1839', Norwich, Castle Museum, 1977 (L40)

This evidently very picturesque composition, with its studied grouping of cottages, etiolated tree and windmill is executed in the manner developed by the Sketching Club and manifest in Girtin's work of the late 1790s. Flat areas of thin wash are combined with nervous linear strokes for the depiction of trees and an overall build-up of texture. It is very interesting to compare this with the dry manner of painting and the open and naturalistic approach to subject evident in Francia's *Sketch from nature below Gravesend* of 1813 (**8**).

Francia exhibited five works at the Royal Academy in 1805. *Cottages in a valley* is close in technique to *A view from Long Pond, Hayes Green, Middlesex* (**32**), exhibited in that year. *Cottages in a valley* may be identifiable with *A view at Botwell near Hayes* (491). Francia gave his address that year as Wood End Green, Hayes, Middlesex so he was evidently living in the locality.

When he first exhibited at the Royal Academy in 1795 Francia was working as a drawing teacher for John Charles Barrow who ran a drawing school at Southwark. By 1805, however, he was running his own school and it seems quite likely that *Cottages in a valley* was executed as a model in picturesque landscape composition for his pupils. This view is given credence by the existence at the Museum of a heavily executed copy of Francia's work which slavishly follows the original in every detail (Victoria & Albert Museum 6777).

FIG. 50 (for comparison with CAT. **4**) Francia, *Mousehold Heath, Norwich*, watercolour, 1808, Yale Center for British Art, Paul Mellon Collection, $12\frac{1}{4} \times 9\frac{1}{4}$

FIG. 51 (for comparison with CAT. **4**) Bonington, *Two windmills at sunset*, watercolour, gum arabic and bodycolour, Musée du Louvre, Cabinet des Dessins, $6\frac{1}{4} \times 8\frac{5}{8}$

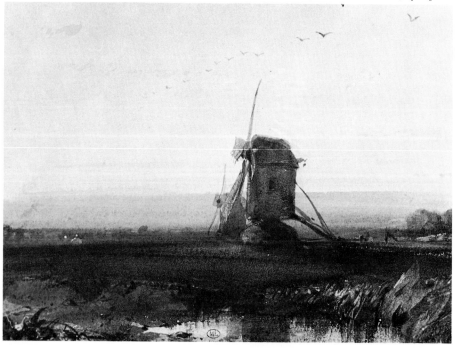

4
Heath scene with windmill

Watercolour on buff paper; 13⅝ × 19¾
(34.8 × 48.1)
3016-1876
(See also colour plate between pp. 96 and
97)
CONDITION: The work has been treated
ineffectually to bleach out foxing some
time in the past and there are two vertical
scratches down the left margin.
PROV: Bequeathed by William Smith in
1876 (see also **12**)
EXH: Possibly no. 63 at Society of Arts
Exhibition of Historical Watercolour
Paintings, 1861
LIT: Alfred W. Rich, *Watercolour Painting*,
1918, repr. facing p. 218; E.B. Lintott, *The
Art of Watercolour Painting*, 1926, repr.
facing p. 226

Although it is undated this is evidently an
early work of Francia. It is executed in the
dark, monochromatic colour range of the
era of the Brothers (see **1**) (fig. 46) and is
characterized by fluid washes superimposed
by a network of serpentine lines suggesting
paths, roads, the margin of the pool and
the divisions between fields. Lights are all
lifted out, though a patch of body colour is
used for the smoke which rises from the
farmstead, centre left.

Francia exhibited subjects from
Yorkshire at the Royal Academy in 1799
and subjects from Wales in 1800. *Heath
scene with windmill* could belong to either
group. The tonality of the watercolour is
dark but the sharp contrasts of light and
shade, the crispness of the execution and
the attention to prismatic light effects
remind us that Francia knew Cotman and
his work. This watercolour is not as
Cotmanesque as Francia's *Mousehold Heath,
Norwich* (Yale Center for British Art, Paul
Mellon Collection, B1977.14.4680) (fig. 50)
but there are, nevertheless, strong
similarities. A comparison with the study of
windmills by Bonington (Louvre, RF 1466)
(fig. 56) reveals the debt that Bonington
owed to his teacher, Francia, even after his
handling had attained an unprecedented
boldness and his colour taken on a
brilliance never found in the older artist's
work.

4

5
Landscape with an angler, Fonthill Abbey in the distance

Watercolour on white paper; 20⅝ × 16¾ (52.4 × 42.5)
Inscribed in paint lower right *L Francia 1804*
3017–1876
CONDITION: Overall fading; evidence of conservation lower left margin, vertical tear in top margin
PROV: Bequeathed by William Smith in 1876. For details of the Smith Bequest see **12**

Francia exhibited six works at the Royal Academy in 1804, but this was not among them. The view is a classic one and there are similar renderings by John Varley and by J.M.W. Turner who worked at Fonthill in 1800. Turner's view, engraved by T. Crostik and published in 1828 (V&A 29103.1), is in horizontal format but taken from almost the identical spot. Francia's vertical composition, however, owes much to the tradition of Gainsborough; it is a deliberately picturesque arrangement in which the strong central vertical established by the torso of the fisherman leads upwards, through the carefully judged leafless sapling which grows in isolation by the fence, to the distant tower of Beckford's Fonthill Abbey. This spaced vertical is counterbalanced by the deep scoop of the ground which, reinforced by the winding track, the fisherman's rod and the margin of the pool, creates two intersecting diagonals.

Francia retained his admiration of Gainsborough and included a number of soft-ground etchings after his drawings in *Studies of Landscapes . . . Imitated from the Originals by L. Francia* of 1810. The charcoal landscape studies of Gainsborough were a source of inspiration to Girtin, Turner and other young artists who studied in the evenings at Dr Monro's 'academy'. Francia's *Landscape with an angler* is an accomplished rendering of the motifs and compositional devices familiar to young English landscape artists in the first decades of the century. It is precisely what one might expect from an artist who was employed at the time as an assistant at Barrow's Drawing School.

The handling of pigment in this watercolour is typical of Francia's work of this period, as are the predominantly brown and dark-green tones. Dry dragged washes are overlaid with squiggly fluid lines suggesting cart tracks, sandbanks and other features. The foliage is treated in immense detail with small flecks of paint, and the loving observation of these tree-forms reminds us that, as is made evident in a number of pencil drawings, Francia was a keen observer of nature. One such pencil drawing is *L'Etang sous bois*, touched with sepia wash (Musée des Beaux Arts, Calais, 61–1–3 (14)) (fig. 52). The fisherman is treated boldly in **5**; the dash of his red waistcoat and the brilliant white of his shirt are prominent in the middle foreground. He brings to mind the work of John Sell Cotman, whom Francia would have known and whose drawings he lithographed.

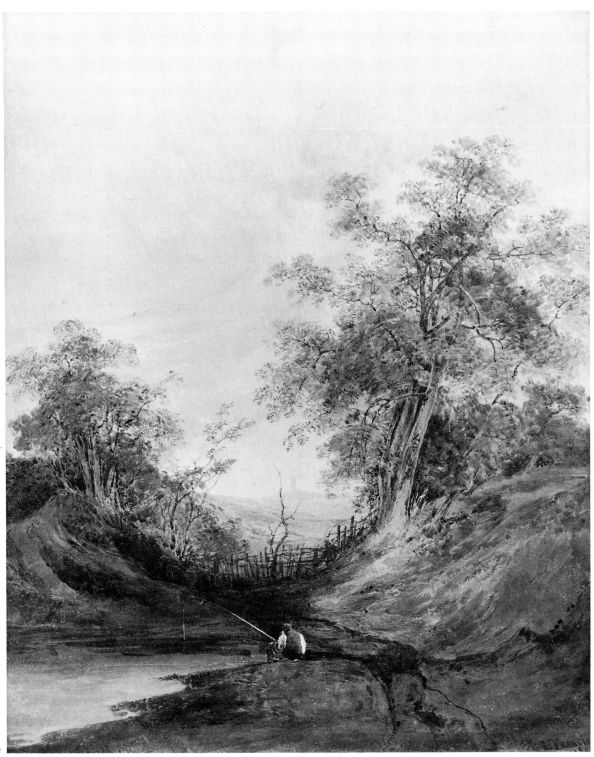

FIG. 52 (for comparison with CAT. **5**) Francia, *L'Etang sous bois*, pencil on cream paper with sepia wash, Calais Museum, $5\frac{7}{8} \times 4\frac{3}{8}$

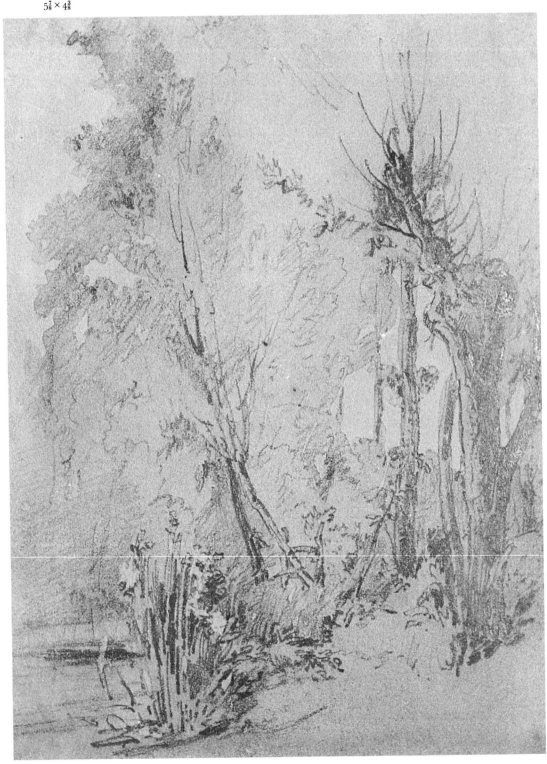

6
Interior of a church

Sepia and bodycolour on beige paper stuck
to the mount at the corners; 9¾ × 7¼
(24.8 × 18.5)
Signed with a monogram in pigment on
the font and below centre in ink *L Francia*.
Number *623* inscribed in ink lower left
E 5658–1910
CONDITION: The edges are scuffed and the
paper very worn in parts; there are three
small tears down the left-hand side
PROV: South Kensington Art Library,
transferred to Prints and Drawings from
Circulation Dept in 1910
EXH: RA 1804 (652) 'Two views of
interiors: no. 1 Winchester; no. 2 Christ's
Church, Hants'.
LIT: I. Williams, *Early English Watercolours*,
1952, p. 104

This watercolour treats a type of subject
commonplace in the work of Turner,
Girtin and the Varleys in the early years of
the nineteenth century. The dusty interior
of a medieval church with crumbling
masonry and rickety pews is illuminated by
a shaft of sunlight. This painting shows
Francia rather closer to Girtin and Turner
than to the Varleys. He has eschewed
antiquarian detail and even divested his
subject of much of the paraphernalia of the
Picturesque in order to concentrate upon
the broad surfaces of the interior with its
huge box pews and the sharp contrasts
between light and shade. A service is in
progress but the figures are given little
prominence. Nor is the architectural detail
brought to our attention; the font appears
merely as a great dark bulk of stone
breaking up the vista down the aisle.
　John Varley's watercolour of
Chillingham Church (Brighton Art
Gallery) (fig. 53) shows a very similar view
of an ecclesiastical interior; there is the
chancel arch, the light entering from a
window at the right-hand side, the high
pulpit and the font in the left foreground.
But there the similarity ends. Varley is
meticulously descriptive, offering a
symmetrical composition executed in flat
washes with methodically overlaid detail.
Francia does not merely represent the
interior but interprets it in terms of
architecture and light in the manner of
Turner in *The interior of Ely Cathedral* (1796,

6

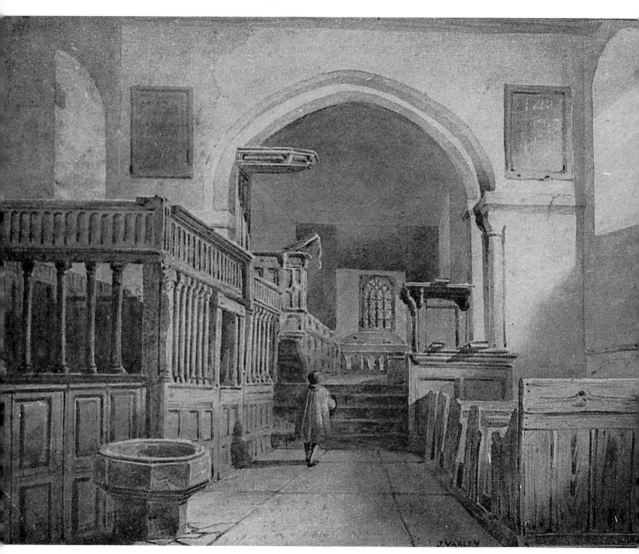

FIG. 53. (for comparison with CAT. **6**) John
Varley, *Chillingham Church*, watercolour,
Brighton Museum and Art Gallery,
$9\frac{1}{2} \times 13\frac{1}{2}$

Aberdeen Art Gallery). Using a vertical format he emphasizes the height of the church; the figures are reduced to illogically small proportions, lending weight and massiveness to the great wooden structure within the nave. The scene is viewed from an angle so that the eye meanders around and about to reach the west window. The treatment of a dramatically lit ecclesiastical interior during a service anticipates the grandeur and richness of Bonington's *The Church of St Ambrogio* (Wallace Collection, London, P.714) (fig. 67). In execution, *Interior of a church* shows a great affinity with Girtin; the paint is applied in fluid washes with speckled dabs and dragged dashes picking out texture and architectural features.

7
Fishing craft

Pencil, watercolour and gum on Whatman paper; 13¼ × 25⅛ (33.6 × 63.8)
The date 1806 is inscribed on the frame
FA 469
CONDITION: Faded
PROV: Acquired by the South Kensington Art Library and transferred to the Victoria and Albert Museum when the Dept of Prints and Drawings was established

This is an unsigned work which appears to be unfinished. The brown monochrome washes, the technically accurate details of the boats and the sweeping, lateral composition all confirm the traditional attribution to Francia and suggest that the work was executed early in his career. However, the figures are left unfinished and the composition is jumbled in contrast to the clarity of design which is normally a feature of Francia's work. The vertical wooden structure in the right middle ground is a capstan used for hauling fishing boats up the beach.

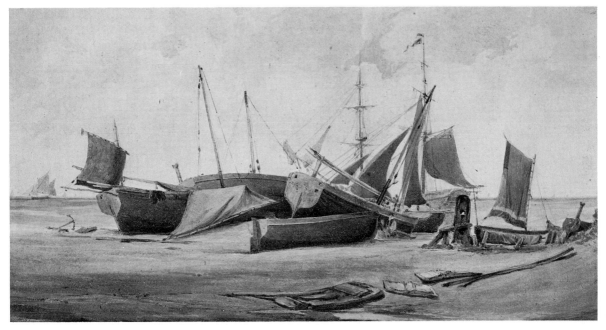

7

8

Sketch from nature below Gravesend

Watercolour on white card; 6¼ × 8¾
(15.8 × 22.3)
Signed and dated *L Francia 1813* with the L
and F in monogrammatic form
103–1894
CONDITION: In sound condition but some-
what faded
PROV: Given to the Museum by J.E. Taylor,
Esq. in 1894 (see also **9**)
EXH: RA 1813 (603)

This watercolour with its rich late-
afternoon lighting and its controlled but
broadly expressive handling demonstrates
that Francia was an innovative artist
independent of the brilliance of his pupil
Bonington and of his friend Thomas Girtin.
Few if any artists in England in 1813 could
have equalled the fresh and unhackneyed
vision and the delicacy of handling shown
by Francia in this view of the Thames. The
stillness of the late afternoon is suggested in

the sweeping brushstrokes of the water and
sky, whilst the vitality of the landscape is
conveyed by the energetic linear depiction
of farm buildings, church, windmill and
shipping. As with *Lambeth Palace and
Westminster Bridge* (**9**) there is very little
lifting out of lights but Francia reveals
himself to be innovative in his handling of
the land mass at the left, and particularly
in the foreground. Small vertical dashes of
pure colour: yellow, dark green and brown,
convey the colour and texture of the turf
and also, through their structure, suggest
the receding contours.

In Francia's later work, stippled,
granular effects combined with fluid
washes and broken linear tracing of
architectural features are his great strength.
It is interesting, therefore, to compare **8**
with *A Normandy village* (signed and dated
1832, Whitworth Art Gallery, University of
Manchester D67 1892 (fig 54) and to
observe that the essential characteristics are
already present in the 1813 watercolour.

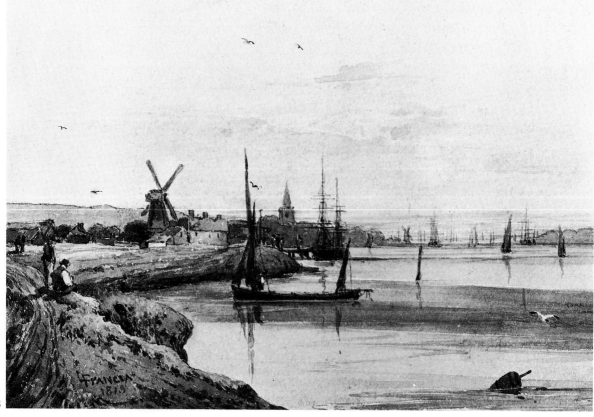

8

FIG. 54 (for comparison with CAT. **8**) Francia, *A
Normandy Village*, watercolour, 1832,
Whitworth Art Gallery, University of
Manchester, $6\frac{3}{8} \times 9\frac{3}{8}$

9

Lambeth Palace and Westminster Bridge

Pencil and watercolour on white card
5¾ × 8½ (14.5 × 21.6)
Inscribed on reverse in ink *Lambeth Palace
and Westminster Bridge* 64-1894
(See colour plate between pp. 96 and 97)
CONDITION: In good condition but faded,
particularly in the sky; marginal strip of
better-preserved colour on left
PROV: When this watercolour was
remounted in 1920 an inscription in pencil
was found on the back of the old card
backing to the watercolour: *lot 52 Francia
Lambeth Palace Christie's April 25th 1868*. The
catalogue of this sale does not reveal who
owned the drawing, but it was bought for
£2-10 by Smith. It was given to the
Museum by J.E. Taylor Esq. in 1894
LIT: I. Williams, *Early English Watercolours*,
1952, p. 104

This work belongs to Francia's London
period, which ended when he returned to
his native Calais in 1817. The atmospheric
effects culminating in the spectacular
rainstorm at the left, and the broad
handling, suggest a close affinity with
Girtin, whom Francia knew well at least
from 1799. Although this particular view of
the Thames does not appear to have been
engraved, it may be connected with the
series of riverside and shipping scenes that
Francia executed for W.B. and George
Cooke's *Views on the Thames* (1822). Francia
contributed four illustrations dated from
1814 to 1819; one of the subjects, *The Little
Belt breaking up at Battersea*, shows an event
that took place in 1811. The view in **9** was
painted by many artists, including Richard
Wilson (see W. Thornbury, *The Life of
J.M.W. Turner, RA*, 1862, p. 57), but
Francia shows himself at this relatively
early date remarkably free from the
constraints of the topographical tradition.
The composition certainly has some very
traditional elements, conceived as it is in
terms of receding planes with carefully
balanced and equally spaced features (the
barges, the spar, the seagull and so on),
but none of the architectural features is
transcribed in detail and the bridge
becomes a mysterious link with a world
swathed in rain clouds and unseen beyond
the picture space. The barge full of barrels

in the right foreground provides a solid and
stable point of reference. The celebrated
monuments of Lambeth Palace and the
dome of St Paul's (appearing in the haze
between the Palace's twin towers) are but
loosely evoked in comparison with the
foreground feature. A similar view taken
from a position closer to Lambeth is in the
Henry E. Huntington Art Gallery, San
Marino, Caifornia (59-55-530).

10

A dismantled man-of-war lying at anchor

Pencil and watercolour on buff wove paper
watermarked 1815; 9⅞ × 14½ (25.0 × 36.7)
49-1887
CONDITION: Badly faded; foxing damage has
been treated in various places and there
are extensive marks of restoration. Two
vertical fold marks at left
PROV: Purchased from Mr Parsons of 45
Brompton Road for £6 in 1887

This work was probably executed some
time between 1815 and 1817 when Francia
returned to Calais. It may be a view taken
somewhere along the lower reaches of the
Thames, a popular sketching ground for
London-based artists in the first two
decades of the century. The subject is a
two-decker man-of-war which is floating
high in the water, owing to its guns and
ballast having been removed. Tarpaulins
have been laid across the decks and a
string of washing hangs from the mast. The
sight of such a noble vessel reduced in this
way would probably have been a great
attraction in the neighbourhood. Hulks
were frequently used as prison ships,
especially during the Napoleonic wars. A
prison ship at Deptford is one of the
subjects drawn by Samuel Prout and
engraved by George Cooke in *Views of
London and its vicinity* (1826-32, pl. 45), and
the episode in Dickens's *Great Expectations*
(1860-1), where a convict escapes from a
prison ship on the Thames is well known.
It seems unlikely, however, that Francia's
man-of-war falls into this category, as a
ship used as a gaol would not have been
allowed to fall into such disrepair.
 Francia is concerned in this work with
creating what is essentially a single-feature
study. The dismantled vessel and its
reflection dominate the composition,

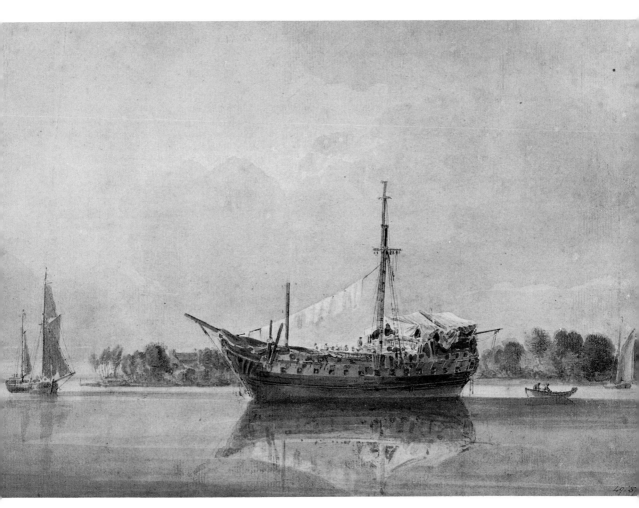

10

although the bank with its willow trees and thick undergrowth painted in tiny repeated linear strokes is sensitive and detailed, reminding us of a Rembrandt etching or a passage from Salomon Ruisdael. Although much faded and restored, the rich yellows along the bank and the gold woven into the details of the deck must have ensured that this was a delicious visual experience when freshly painted. It is interesting to notice how Francia has not avoided the use of relatively heavy pencil marks that show clearly through the paint and, in some places (e.g. the details at the prow around the waterline) are not painted over at all. The artist's viewpoint was probably a small boat and the extensive use of pencil may perhaps indicate that he drew the vessel and the basic lines of the composition on the spot in this instance and completed it on his return home.

11
A vessel and boats tied up alongside a wharf

Pencil and watercolour on Whatman paper laid down on card; $13\frac{3}{8} \times 9\frac{5}{8}$ (34.1 × 24.6)
15-1878
CONDITION: Very faded in the area of the sky, slightly damaged at lower edge
PROV: Palmer's sale, Christie's 24–26 Jan. 1878 (365) as Bonington, bt. Mr T.M. Whitehead and sold to the Museum for £6 plus £1 commission

This work was for a long time attributed to Bonington and it typifies the problems of attribution with early marine pieces by Francia and Bonington. The location is probably Calais – the boats are seen at low tide in a harbour between two piers – and the date must be around 1818–20. The handling of paint, with dry flat segments juxtaposed with more liquid washes for the sails, scraped-out lines of cords and rubbed areas where the light is reflected in the water, is very close to much of Bonington's work. This is not surprising, for it was on

works like this that the young Bonington modelled his style. Some slight details of execution, however, suggest that Francia rather than Bonington is the author. Notice, for example, the prevalence of curving and squiggly lines in the foreground. This is not generally a feature of Bonington's work but is very familiar in his teacher's. What makes it certainly the work of Francia rather than Bonington are the less immediately obvious but equally important characteristics of composition and design. The upright format is one that is much less frequently used by Bonington than by Francia; the empty foreground, the absence of carefully grouped figures and the arrangement of the forms all along one plane are features that are familiar in Francia's work but rare in Bonington's. However, the strongest evidence is much more difficult to convey. There is in Bonington's work a tension, a sort of vital, dramatic core – even in watercolours or oils depicting still, becalmed boats (as with, for example, the superb *Fishing boats in a calm*, Merseyside County Art Galleries, Sudley House) (fig. 55) – that makes one sense a source of endemic energy. In Francia, forms are more evenly represented, less reduced, altogether more descriptive than in Bonington's work. This constitutes the chief difference between them for, on grounds of handling, they frequently cannot be differentiated.

A vessel and boats tied up alongside a wharf can be compared with several other works by Francia that represent similar subjects in a comparable way: *Old Men O'War* (Yale Center for British Art, Paul Mellon collection (fig. 56), a watercolour at Birmingham which has been attributed to Bonington (*Fishing smacks in a French Harbour*, bequeathed by J. Leslie Wright to Birmingham City Art Gallery in 1944) (fig. 57); and a horizontal composition in the Ashmolean Museum, Oxford, entitled *A hulk* (uncatalogued).

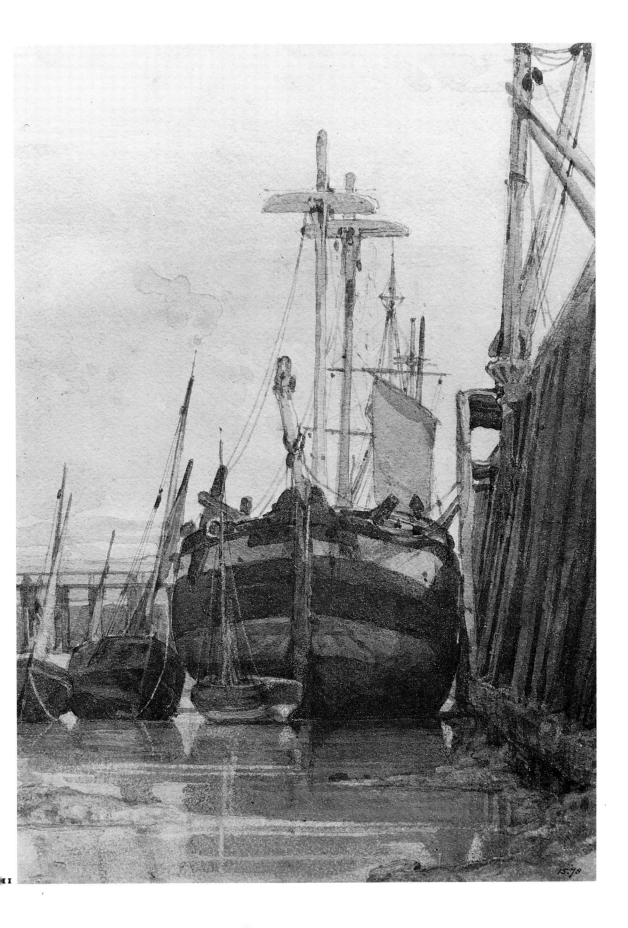

15.78

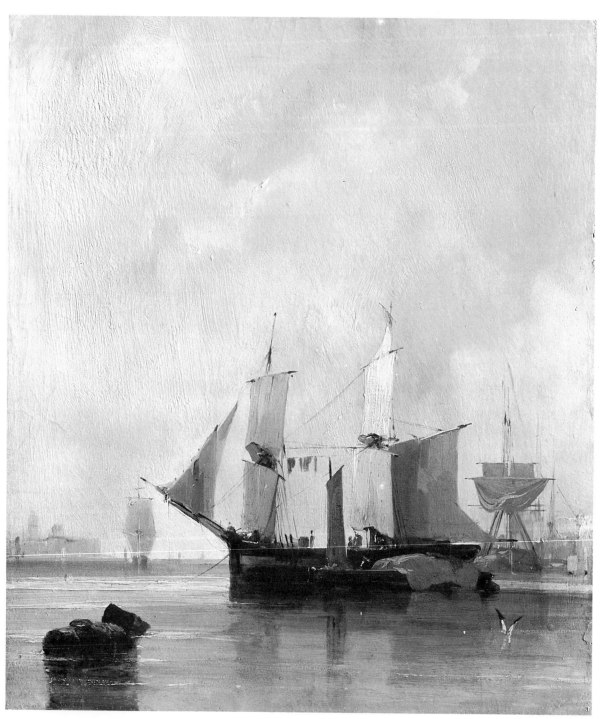

FIG. 55 (for comparison with CAT. **11**) Boning-
ton, *Fishing boats in a calm*, oil on board,
stuck on canvas. Merseyside County Art
Galleries, Sudley House, $14\frac{1}{8} \times 12\frac{1}{16}$

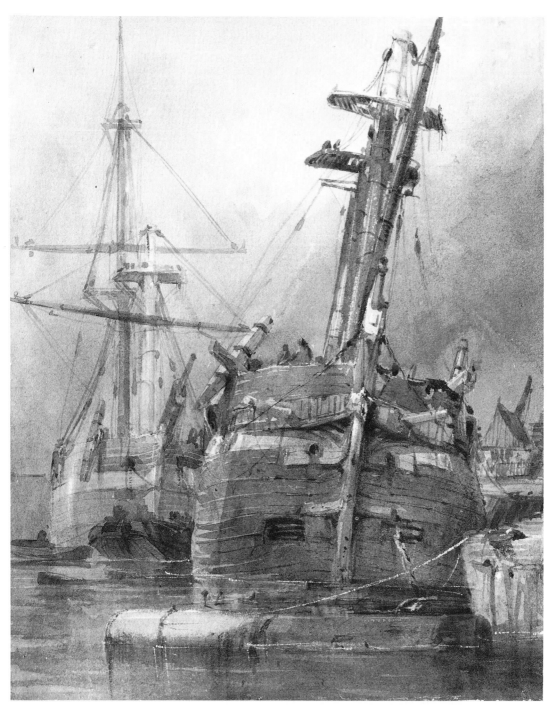

FIG. 56 (for comparison with CAT. **11**) Francia,
Old Men O'War, watercolour, Yale
Center for British Art, Paul Mellon
Collection, $9\frac{7}{8} \times 8$

FIG. 57 (for comparison with CAT. 11) Francia, *Fishing Smacks in a French harbour*, watercolour, by courtesy of Birmingham Museums and Art Gallery (as Bonington, P44'53)

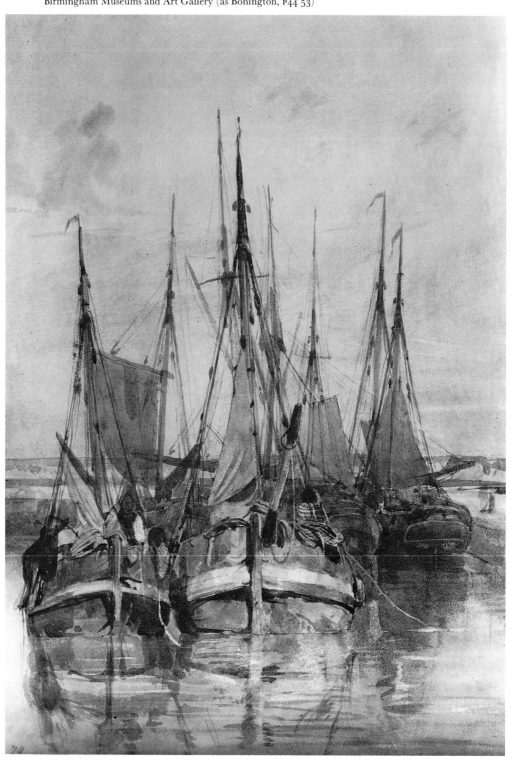

12
French coast with fishing luggers

Pencil, watercolour and bodycolour on white paper laid down on card; 6⅝ × 11¾ (17 × 29.8)
Signed lower left corner in indian ink *R.P. Bonington*; on reverse is written in pencil *Bonington* and in another hand instructions to framer: 1½ *margin* ... *Rupert Porter* (?)
3046–1876
CONDITION: considerably faded, especially sky, suggestions of original colour in margins at either side
PROV: This drawing came from the collection of one of the Museum's great benefactors, Mr William Smith. A letter from Mr Smith to Henry Cole preserved in the Museum and dated 20 May 1870 reveals that Mr Smith's collecting was seriously planned on historical lines to illustrate 'the history and progress' of watercolour art in England. In 1870 Mr Smith empowered Richard Redgrave to select whatever he thought necessary to complete the series already in the Museum. These works would be presented as a gift as soon as proper gallery space was provided for them. Redgrave chose 26 watercolours. On Mr Smith's death in

1876 a further 136 drawings entered the Museum from his collection, among them 3046–1876

There is an aquatint by Frank Short after this drawing (V&A E 2416-1919) which suggests that, before it faded, the sky was much more prominent in this work. Although it bears a signature, this drawing is not, in this writer's view, the work of Bonington. The composition is altogether too spread out for Bonington and the treatment too flat. The scene is evidently a view either on the south coast of England or the north coast of France; the subject matter is typical of the group of Anglo-French artists who drew inspiration from Louis Francia. It might be compared, for instance, with Newton Fielding's *Normandy coast scene* (V&A E991-1921, formerly attrib. Copley Fielding) (fig. 58), though this has a more dramatic sky. It could be the work of one of Francia's pupils, but seems more likely to be by the master himself. It is a very unmannered work; there is an ease and naturalness about the broad, slow, spread of the view dotted with fishing craft of varying shapes and sizes which implies an artist relaxed in a familiar relationship with his subject

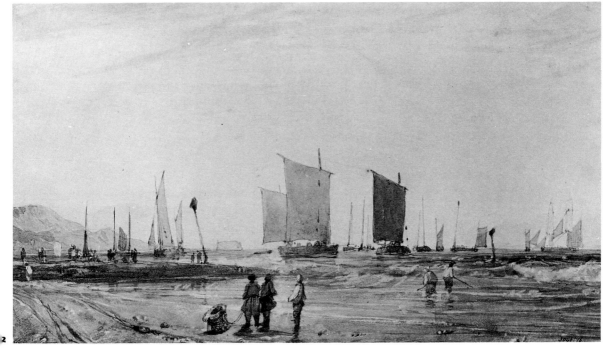

FIG. 58 (for comparison with CAT. **12**) Newton Fielding, *Normandy Coast Scene*, watercolour, Victoria & Albert Museum (as Copley Fielding, E991–1921), $4\frac{1}{2} \times 7\frac{3}{4}$

matter. The forms of the different boats and the fishing equipment are distinctive and self-explanatory, but in no way intrude on the lazy drift of the wide-angled view. The paint is dragged in uneven horizontal bands across the paper and the artist delights in the reflective but unevenly textured surfaces of the beach at low tide. The lights are lifted out and scratched out; the figures to the left in the distance are picked out in brilliant blue bodycolour. The masts are delicately etched in to create a floating mass of stabbing, receding verticals stretching to the horizon. In the left foreground, the uneven tracks of a wheeled vehicle meander away out of the picture. The handling of the paint and the motif of the cart tracks are strongly reminiscent of Jacob Van Ruisdael's beach and seaside scenes. He and Salomon

Ruisdael were a major source of inspiration for Francia. These features appear in Bonington's work but not in the same degree or with the same effect. Two other works by Francia in the Victoria & Albert Museum will serve as comparisons. In *Sketch from nature below Gravesend* (**8**) there is the same spread-out composition, the same delight in receding grouped vertical masts, the same delicate outlining of certain features (hillside on the horizon, ships' sails), the same receding cart-wheel ruts in the left-hand corner. *The Banks of a canal* (**15**) shows a different sort of scene, but again Francia is concerned with the fretwork of vertical masts against horizontally washed paint and establishes the spatial dimensions by use of a cart track in the left corner.

13
River with barges

Watercolour and bodycolour on buff paper laid down; 12½ × 23½ (31.7 × 59.6)
A strip 0.5 cm in width and 15 cm in height is cut from the upper left margin; signed on the rudder of the barge *L. Francia*; thumb mark in the centre foreground
375-1878
CONDITION: Blues faded
PROV: Given to the Museum by William Wyld through the agency of Mr Owen on 16 August 1878 (see **14**)

The provenance indicates a date for this watercolour some time between 1826 and 1828, and style and handling also support this. The costume of the woman in the foreground indicates that the location is in northern France or Flanders. Although this is not perhaps among Francia's most attractive compositions – his attempt to take a wide-angled view with focal points both to the left along the track and to the right along the canal does not completely succeed – it is a significant work on several counts. In the first place, it reveals Francia treating picturesque subject matter in a relatively unembroidered and literal way. In comparison with, say, *Cottages in a valley* of 1805 (**3**), the concern with a robust, direct translation and an interest in the environment as a whole is seen to take precedence in *River with barges* over the working up of a motif. Thus, in the 1805 watercolour, chimneys and roofs are blocked in with a mosaic of colours, their forms conveyed through our appreciation of the gnarled and bent tree-forms that surround them. In the later watercolour the objects – barges, cottages, trees – are individually examined and independently confronted by the artist who thus is able to incorporate them the more convincingly into a 'naturalistic' presentation, avoiding misty and half-suggested elements like the mill in the distance of the 1805 view.

In the second place, this watercolour is a work of great interest on account of the mixed techniques the artist employs. The sky is treated with broad horizontal washes, heavily streaked in the foreground. In the far left of the foreground and at the tops of the trees to the right of the composition, Francia employs a manner of dotting with rich colour visible even in a photograph, so that the foliage is outlined with a 'halo' of little dabs of blue which create a great sense of depth. In the centre background where the canal disappears from sight into shady trees, the pigment is heavily applied and smudged, whilst in the tangled foliage that surrounds the cottage at the right, the paint is scratched out to reveal the paper. The boats and the figures are depicted by a combination of lightly washed colour and precise outlines in paint.

14

A street scene with a bridge and boys fishing

Pencil and watercolour on paper laid down; $13\frac{3}{4} \times 19\frac{1}{2}$ (35.1 × 48.7) Signed and dated on the parapet of the bridge at the left *L. Francia 1827*
374–1878
CONDITION: Treated for mildew and foxing in 1932, but much of the damage remains and the colour is very faded; wide marginal strips indicate loss of colour; slight tear top left margin
PROV: This is one of two watercolours by Francia given to the Museum by William Wyld, through the agency of Mr Owen, in 1878 (see **13**). William Wyld was secretary to the British Consul in Calais from 1826–8, and this watercolour, dated 1827, may therefore have been given to Wyld by the artist himself. On the other hand, it may be one of the collection of Francia watercolours which, according to P.G. Hamerton, writing in Wyld's lifetime, were given to Wyld by Beau Brummell who lived in exile in Calais (P.G. Hamerton, 'William Wyld's sketches in Italy', *Portfolio*, VIII, 1877, p. 65)

On the basis of the architecture, the date and the provenance, we may assume the location to be a town in the Calais region, but it has yet to be identified. Two world wars fought in Normandy and the Pas de Calais have made it, in many cases, impossible to identify with certainty the locations of many town and village scenes. The boys on the bridge are engaged in *pêche à carreau*, using a large basket or trawl lowered on a pulley. This is a device more normally used in sea-fishing, but not unknown along canals in the area around Calais.

Francia is an extraordinarily versatile artist; even confining oneself to the examples of his *oeuvre* in the Museum, one discovers many different modes of handling paint and different approaches to subject matter. He is more varied than his pupil Bonington, if less technically brilliant and less original. He had the advantage of a secure training in late eighteenth-century watercolour techniques, acquiring an understanding of the craftmanship for which John Varley was renowned. But by establishing himself at a distance from the English school he avoided the affectation of Turner's followers or the emulation of oil effects that dominated English watercolourists from the late eighteen-twenties. That he knew and admired Turner is, however, evident from this watercolour which, with its freely yet emphatically defined architectural space, is reminiscent of Turner's *Oxford High Street* (exhibited 1810, Lloyd collection). The assurance of composition – in which all details like the stone buttresses of the bridge and the ruts in the road are co-ordinated to enhance the meandering recession – and the breadth of handling in this watercolour only came gradually to Francia. It is interesting to compare *A street scene with a bridge and boys fishing* with an unfinished view of Rochester Castle seen across the Medway executed by Francia in 1808 (*A south-east view of Rochester Castle, Kent*, Yale Center for British Art B1975.4.826) (fig. 59). A bridge and a boy appear prominently in the foreground of the latter work, but the arrangement of the buildings carefully articulated along the skyline, and the depiction of foreground detail, as well as the technique of tentatively drawn outlines filled in with colour, all detract from the powerful sense of design that characterizes the 1827 watercolour.

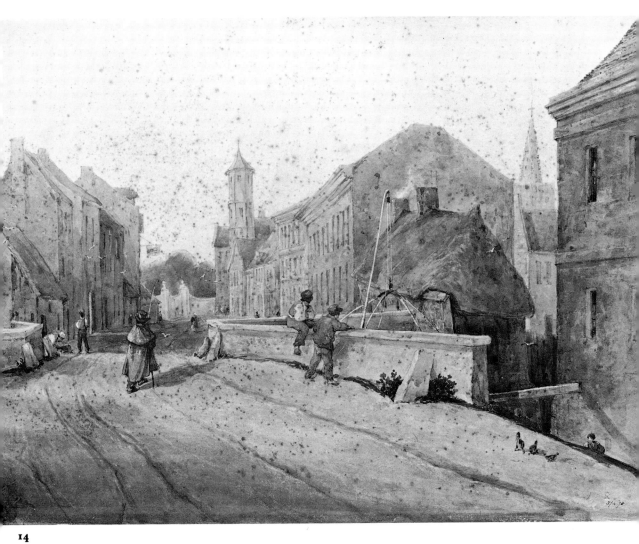

14

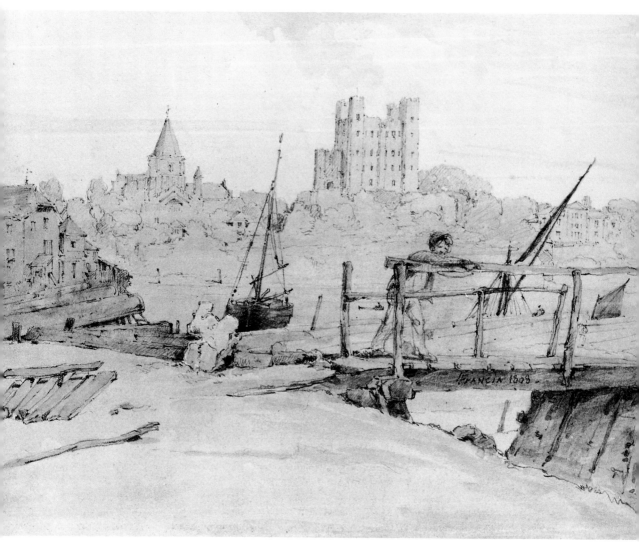

FIG. 59 (for comparison with CAT. **14**) Francia,
A south-east view of Rochester Castle, Kent,
pencil and wash, 1808, Yale Center
for British Art, Paul Mellon Collection,
$6\frac{1}{4} \times 8\frac{5}{8}$

15
The banks of a canal

Pencil, watercolour and bodycolour on white paper; $5\frac{3}{8} \times 8\frac{5}{8}$ (13.7 × 21.6)
Signed very faintly in paint lower left *L Francia*
P13–1923
CONDITION: The watercolour is fresh, the pencil mainly evident in the marking-out of the clouds; there is a vertical scratch in the right foreground
PROV: Bought at Sotheby's 22 March 1923 (31) anon sale

This watercolour was evidently executed after Francia's return to Calais in 1817. The subject is clearly somewhere in northern France, probably near Calais, which was surrounded in the early nineteenth century by a network of canals linking the port to other nearby towns (see J.F. Henry, *Essai historique, topographique et statistique sur l'arrondissement de Boulogne-sur-mer*, Boulogne, 1810, map opp. p. 154).

The detail in the landscape is difficult to explain (what are the wooden structures with vertical struts and a cross-beam, and what is the large shape appearing behind the trees on the right?), but it appears to relate to some kind of boat-building activity. There seems to be a lock, as the masts at the left-hand side must belong to boats at a lower level, and some men are climbing a ladder of which we only see the top portion. It may be that the wooden structures that lend such a distinctive flavour to the scene are something to do with the lock. Boat building has long been a major industry at Guisnes, six kilometres from Calais and linked with it by canal. This might be a possible location.

The free handling and rich variety of colour in *The banks of a canal* suggest that Francia may have painted the scene relatively late, perhaps towards the end of the 1820s. Certainly it seems to show the influence of his own pupil, Bonington. The low viewpoint with a mound in the centre foreground such as Bonington used in watercolours like *The château of the Duchesse de Berry* in the British Museum, the richly scumbled pigment and the contrasts between tranquil open spaces and compact areas of varied activity, are all reminiscent of the younger artist's work. The colour ranges from dark-blue foliage to light grey in the water, and is relieved by small areas of mauve, blue and an acid turquoise-green that Bonington also delighted to use. The 'receding' signature is also typical of Francia's later work.

Bonington

16

Paris from Père Lachaise

Pencil and watercolour on Whatman
paper; 11¼ × 8⅛ (28.4 × 20.5)
AL 5968
CONDITION: Sky much faded, strips of
brighter colour remain at margins
PROV: Acquired by the original South
Kensington Art Library and transferred to
the Victoria and Albert Museum when the
Dept of Prints and Drawings was created;
Spencer suggests it may have been lot 601
in the D.T. White sale, Christie's, 18 April
1868, bt. Wigsell, £1-18
EXH: 'Loan Exhibition of watercolour
drawings by deceased British Artists',
Manchester, Whitworth Institute, 1912
(302)
LIT: Spencer, no. 204

Bonington arrived in Paris in 1818 and
within a short time his parents joined him.
The family lived first at 22 rue des
Moulins, in the fashionable area of Paris
bordered by the Theatre des Bouffes, the
Comédie Française and the Palais Royale.
It was from this address that Bonington's
parents ran their tulle business. Nearby
was rue de la Paix where Mme Hulin, a
dealer who specialized in the sale of
modern French and British drawings and
engravings, had her shop. At that time it
was certainly possible to see the pleasant
tract of hillside acquired from the Jesuits
by the city of Paris in 1803 from the rue
des Moulins or, at least, from nearby. The
new cemetery established on that hillside
retained the name of Père Lachaise by
which the land had always been known.

The free and fluid handling of
Bonington's *View of Paris from Père Lachaise*,
with its liquid dabs of pigment, its
restrained overall colour scheme (even
allowing for fading this must always have
been primarily in the blue-grey register)
and its overlaid washes, suggests that it
may have been executed in the early 1820s,
say 1821 or 1822.

The form and the treatment of the tree
at the right of AL 5968 are not dissimilar
from the trees at the left in the *View of
Lillebonne* (**18**). On the other hand the
handling lacks the crispness and angularity
of dated 1824 watercolours. Père Lachaise
remained a location of interest to
Bonington and he refers to his 'Père La

Chaise drawings' in a letter to W.B. Cooke
dated 5 November 1827. (D&H, p. 79). A
watercolour of the same subject by
Bonington was no. 105 in the exhibition
R.P. Bonington and his Circle at the
Burlington Fine Arts Club, 1937 (Sir
Hickman Bacon, Bt.).

The Père Lachaise cemetery,
commanding fine views over Paris until the
chestnut trees which currently grow in
great profusion reached their maturity, was
a favourite tourist site even as early as
1816. The 1773 act of parliament led to
the closure of the putrid Cimetière des
Innocents and the gradual closure of all
the cemeteries inside the city. Montmartre
and Popincourt were among the new
cemeteries established at the turn of the
century and Marchant records 'un cimitière
plus imposant encore ... placé à Mont Louis,
sur le terrain de l'ancienne maison de Père
Lachaise'. The 1816 revised edition of his
popular guide to Paris refers to 'l'étendue de
ce lieu, les arbres dont il n'est pas encore
dépouillé, les ruines de ses anciens édifices, son
site élevé, le feuillage lugubre des ces cypres
ombrageant des tombeaux de toutes les
formes', and describes his favourite tombs
and epitaphs very much in the manner of
the modern tourist of today (F.M.
Marchant, *Le Nouveau Conducteur de l'Etranger
à Paris*, fifth edn. of *Le Conducteur* and first
edn. *Le Nouveau Conducteur*, Paris 1816, pp.
244-5). For today's visitor the cemetery
has the additional interest of having been
the site, in 1871, of the Paris Commune's
last stand.

Bonington was not alone in his choice of
this particular subject or, indeed, in his
taste for views in Paris and its environs. It
is important to remember that although
Girtin had established an innovatory
freedom of approach to townscape and
French scenery in his aquatints of 1803,
French artists were at work on Parisian
views before Bonington and Boys
established themselves. The Salon of 1817
contained a *Vue du cimetière du village de
Montmartre* (452) and, in all, 20 views of
Paris by eleven different artists including
Bouhot and Watelet were shown that year.
Père Lachaise became a popular subject in
the early 1820s; in 1824 views of the
cemetery were exhibited by Arbousse (29,
watercolour), Boisselier (187) and the
young Daubigny (2310). It is, however,

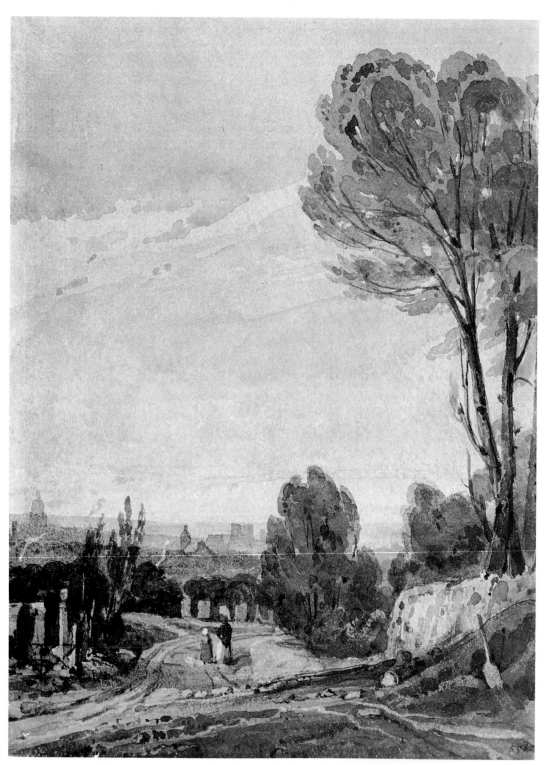

significant that all these views are cited as 'Vue au Père Lachaise', whereas Bonington's is very definitely a 'Vue de Père Lachaise', emphasizing the distant smoky city roofs and the ground falling away towards the skyline (University of Oxford, Dept of History of Art, salon subject index).

To paint his view, Bonington must have been standing nearly at the summit of the hill, roughly where a large memorial now stands to the victims, 'travailleurs municipaux de la ville de Paris', killed in the course of their duties. On the skyline of Bonington's watercolour it is possible to identify on the left the magnificent dome of the Panthéon, started by Soufflot and completed in 1789, and on the right the twin towers of Notre Dame.

17

17
The church of St Gilles, Abbeville

Watercolour on coarse white paper laid down; $9\frac{7}{8} \times 6\frac{7}{8}$ (25 × 17.4)
On the reverse is written in pencil *Church in Normandy/R.P. Bonington* and lower *no. 41*. There is a similar inscription at the bottom with the name spelt 'Bonnington'
P26–1928
(See also colour plate between pp. 96 and 97)
CONDITION: Two small tears at the lower edge have been repaired; faded
PROV: Given by Miss P. Woolner of 13 Campden Hill Road, Kensington in 1928. A letter in the Museum reveals that the attribution to Bonington was made by Miss Woolner's father who, we may guess, perhaps wrote the inscription on the back. The artist Thomas Woolner, who died in 1892, was a keen collector of drawings; sale catalogues of the latter part of the nineteenth century reveal that many works by British artists passed through his hands. Another of the artist's daughters, Miss Amy Woolner, published a *Life* of her father in 1917. Spencer records that Woolner owned a version of Bonington's *Don Quixote* (Spencer, no. 291)
EXH: 'Vroege engelse aquarellen', Utrecht, Centraal Museum and The Hague, Gemeentemuseum, 1955 (3); 'R.P. Bonington', Nottingham, The Castle Museum, 1965 (196); 'British watercolours 1750–1850', International Exhibitions Foundation, 1966–7 (7)
LIT: AS, p. 86 (as *Church in Normandy*); Spencer, no. 205; Spencer exh. no. 196; M. Cormack, 'The Bonington Exhibition', *Master Drawings*, iii, no. 3, 1965, p. 289

There seems no reason to doubt the attribution to Bonington. The subject, the conception and the handling all suggest a work of the early 1820s. As Bonington's first known sketching tour of Normandy and northern France took place in 1821, this work can be dated with some certainty to that year.

Similar close-up views of ecclesiastical buildings were executed by John Varley's pupils during the first decade of the nineteenth century and it is interesting to compare one of these, William Mulready's 1804 view of the west front of Kirkstall Abbey (V&A P49–1936) (fig. 60) with Bonington's view. Mulready's watercolour

FIG. 60 (for comparison with CAT. **17**) William Mulready, *The West front of Kirkstall Abbey*, watercolour, Victoria & Albert Museum, $15\frac{3}{4} \times 10\frac{3}{4}$

is more dramatic in lighting and in the low angle of vision. It is virtually a study of the Romanesque portal in isolation, overhung with Girtinesque foliage, and lacks any concern with setting or atmosphere. The paint is applied in broken areas and is finely textured. Bonington, on the other hand, whilst he also moves close in upon the building, stresses the rhythmic uniformity of architectural feature as well as the individuality of the belfry. He, like Mulready, who has a child picking flowers in the foreground, is concerned not merely with topography. The pecking chickens and broken fence in the foreground of his work help to establish a sense of particularity. But Bonington applies his paint much more broadly; the buttresses are depicted with broad flat washes stressing the solid geometry of the structure and the lights are rubbed out. The texture of the roof and the varied foreground terrain – although vividly conveyed – are not permitted to detract from this formal realization.

The ancient church of St Gilles already existed in some form in 1205, but was rebuilt and enlarged in 1485. It still stands in Abbeville, but has been substantially restored following severe damage in 1940. Bonington's view is taken from the south-east.

18
View of Lillebonne
Pencil, watercolour and chinese white on smooth buff paper laid down; $4\frac{5}{8} \times 7\frac{5}{8}$ (11.9 × 19.5)
116-1892
CONDITION: The paper is allowed to remain for large areas of the architecture, particularly the church steeple, but elsewhere the pigment is seriously faded and consequently almost monochrome. The margins are stained where the drawing has been under a mount
PROV: Bought for £12-12 from the Fine Art Society in 1892

When Bonington first exhibited at the salon in 1822, one of his contributions was *Vue prise à Lillebonne*, but it seems probable that this would have been a larger or, at least, a more imposing work than **18**. Number 81 in John Lewis Brown's sale, Paris 27 December 1834, was *Vue de Lillebonne; dessin de la seconde manière de l'auteur, d'une grande finesse de ton*. It was bought anonymously for £1-11-6. The history of **18** is not known, but it seems reasonable to suppose that this accomplished little watercolour is the work mentioned above. Spencer did not include it in her unpublished Ph.D. thesis nor in the Nottingham exhibition catalogue, but if

18

one allows for the very poor condition of this watercolour and for the uncertainties that surround any estimation of the artist's early watercolour style, the traditional attribution should be accepted.

Lillebonne was a site popular with artists travelling through the Seine Maritime. Cotman visited the town in 1817, and many other artists both French and British sought out this attractive small town ringed by steep hills and famous for its medieval castle, its large Roman theatre and its sixteenth-century church. The Fragonard brothers, Atthalin, Bourgeois and Isabey, are all known to have visited and sketched the town and Turner executed two watercolours and many sketches in the neighbourhood in 1832 (*Les Débuts du Romantisme*, Cherbourg, Musée des Beaux Arts, 1966, p. 19; A. Wilton, *The Life and Work of J.M.W. Turner*, London, 1979, cat. nos. 958, 959 ill. The Tancarville and Lillebonne sketchbook on which these views are based is in the British Museum, London (TB CCLIII))

The Roman theatre at Lillebonne, where Bonington positioned himself to take this view, had been partially excavated in the town centre in 1812 when the Département de la Seine Inférieure acquired the site. The excavations of 1812 uncovered only a small amount of the theatre. The first real archaeological examination of the site was begun around 1908, halted by the First World War, begun again in 1936-8 and left incomplete at the outbreak of the Second World War (I am indebted to M. François Bergot of Rouen for this information).

Cotman's visit of 1817 was made with the specific intention of visiting these Roman ruins. Although he particularly inquired of the theatre, he was directed to the castle which he drew and subsequently published in *Normandy* in 1822 (*John Sell Cotman: Drawings of Normandy in Norwich Castle Museum*, Norwich, 1975, 27, 28). Engelmann's lithograph after Fragonard's view of the castle appeared in 1820, and Bonington himself was responsible for a drawing of the castle which was lithographed in *Restes et Fragmens* of 1824. The theatre and the church have survived, but Bonington's view is now obscured by the mairie and the post office built in Place Félix Faure.

In 1820 Bonington travelled from Paris to Le Havre, passing through Mantes and Rouen (D&H, p. 43). Lillebonne would have been the obvious halt for him between Rouen and Le Havre, especially if he had already seen Fragonard's published view of the medieval castle and knew of the excavations which were currently arousing interest in the area between the old Roman port of Lillebonne (Juliobona) and the coast at Etretat (see P.J. Feret, *Notice sur Dieppe, Arques et quelques monumens circonvoisins*, Dieppe, 1824, pp. 2-6). If he executed a watercolour in 1820 but missed the opening of the Salon in April of that year, then the first opportunity he would have had to offer it for exhibition would have been in 1822 because the Salon was, at this time, only held every two years. The other work Bonington contributed to the 1822 exhibition was a view of Le Havre (unidentified). Both may, therefore, have been done in the summer of 1820 and the work in the Victoria & Albert Museum may be a study for the view exhibited at the Salon.

The Norwich Castle Museum owns two studies by, or attributed to, Cotman, which appear to be related to Roman remains at Lillebonne, but neither represents the theatre (*John Sell Cotman*, op. cit). Bonington's watercolour may well show repair work being carried out on the excavation, as the figure in the foreground is seated by a broken section of the perimeter wall, does not appear to be sketching, and seems to have no other reason for being there.

Whilst the development of Bonington's style from 1822 onwards can be charted with reasonable accuracy from dated watercolours with secure provenances, how the 18-year-old artist sketched and painted on one of his first tours is much more a matter of speculation. However, the detailed pencil drawing under the transparent washes of *View of Lillebonne*, the stylized representation of the texture of wooded hillsides and stone walls, the delicate drawing-in of tracery on the church tower, the bright patches of Chinese white and body colour, and the elegant curves of the trees, all point to the influence of Girtin and Francia (see, for example, Francia's 1813 *Sketch from nature below Gravesend* (**8**). The low viewpoint

selected by the artist to provide the framed vista of a Gothic monument rising from half-timbered cottages is absolutely consistent with Bonington's interest in picturesque travel at this time. It can be compared with Francia's 1804 *Landscape with an angler, Fonthill Abbey in the distance* (**5**) which employs the same sort of compositional devices and also includes a single figure in the foreground.

19
A cottage at Vimereux

Pencil and wash on white paper, probably a page from a sketchbook; $4\frac{7}{8} \times 5\frac{7}{8}$ mount size (11.7×15)
Inscribed in pencil lower left *Vimereux* and faintly top left *16*, indecipherable pencil inscription botton right corner
D2272–1885
CONDITION: There are a number of dirty marks down the side, possibly thumbprints
PROV: Purchased with D2273–1885 on one mount on 24 November 1885 from an anonymous seller

Vimereux (or Wimereux) was a small village four kilometres from Boulogne where Napoleon created a port in 1803. This drawing was, therefore, probably done during the early 1820s when Bonington made several visits to the north coast of France. Cottage subjects such as this were the stock in trade of Varley's pupils and associates, and Francia included several in his series of etchings and aquatints. *Studies in Landscape* . . ., published in 1810 (fig. 62). Newton Fielding who, like Bonington, lived and worked in France, sketched ruined cottages while travelling from Dieppe on a sketching tour along the coast in 1824 and found similar subjects the following year between Maintenon and Pierre (Newton Fielding's sketchbooks, The Castle Museum, Nottingham (fig. 61)).

With its expressive, varied hatching and its higgledy-piggledy lines, this cottage by Bonington is an attractive example of his briefest sketching technique. The incompleteness of the view, the manifestly speedy execution and the pencil medium all suggest that it was done before the motif. A note of caution, however, is called for since a similarly spontaneous-looking cottage view in the Yale Center is inscribed 'Drawn for Harriet A. Eliot in her presence, Paris, 1827' (Yale Center for British Art, B1977 14 4657) (fig. 63).

19

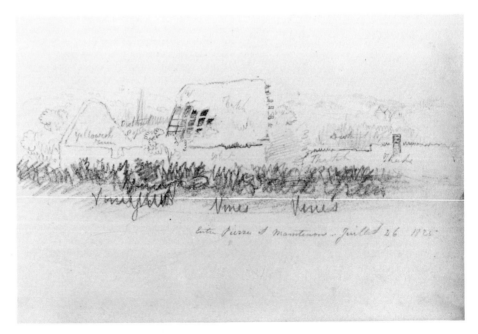

FIG. 61 (for comparison with CAT. **19**) Newton Fielding, page from a sketchbook, f.6 recto, inscribed *Entre Pierre et Maintenon juillet 26 1825*, the Castle Museum, Nottingham

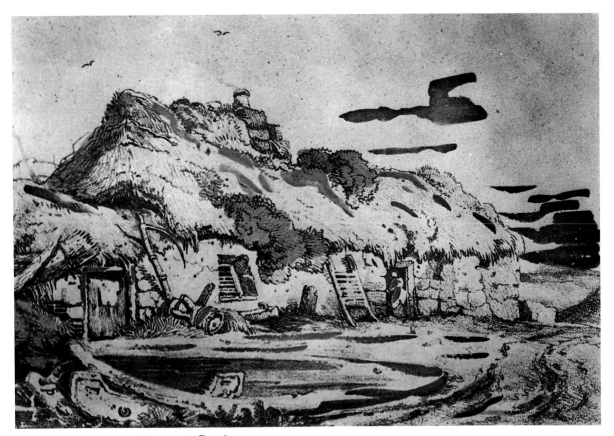

FIG. 62 (for comparison with CAT. **19**) Francia,
page from *Studies in Landscape* …, 1810

FIG. 63 (for comparison
with CAT. **19**)
Bonington, *Trees
and cottage by a river
pond*, pencil, 1827,
Yale Center for
British Art, Paul
Mellon Collection,
6¼ × 8

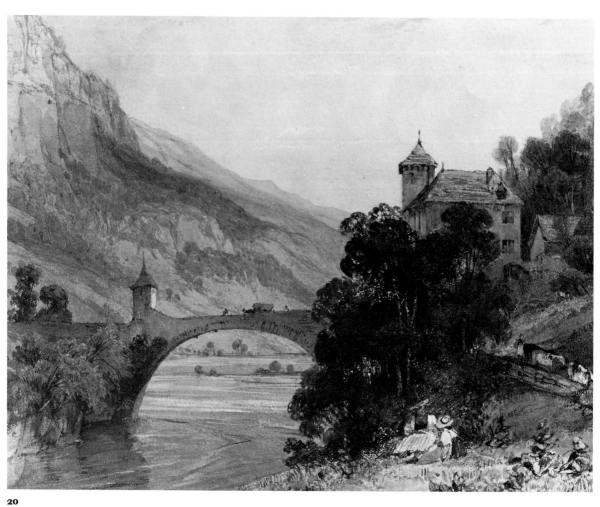

20

20
The bridge of St Maurice d'Agaune, Switzerland

Watercolour on Whatman paper watermarked 1823; 7⅜ × 9⅜ (18.5 × 23.7)
Inscribed in pencil on back in a hand other than the artist's *R.P. Bonington*
P27-1934
(See also colour plate between pp. 96 and 97)

CONDITION: In a fresh condition except for the sky which is faded

PROV: Bequeathed by Lady Powell in 1934; R.P. Bonington sale, Sotheby's June 1829 (197) *View in Switzerland*, bt. Monro, £3-10; Dr Thomas Monro's sale, Christie's 26 June 1833 (162) *A View in Switzerland, in colours*, bt. Colnaghi £4-12; Archdeacon Burney to his daughter Mrs Rosetta d'Arblay Wood who left it to her daughter Lady Powell (née Edith M. Burke Wood)

LIT: Victoria & Albert Museum, *Annual Review*, 1934, repr. pl. 14; Spencer, no. 235; A.S., p. 104; G. Reynolds, *A Concise History of Watercolours*, 1971, pl. 77.

A steel engraving entitled *Bridge over the Rhône at St Maurice* by W.J. Cooke was published in London by Colnaghi and in Paris by MM. Chaillon Potrelle, dated 20 March 1828 (V&A E467-1910). Spencer points out that a pencil sketch of this subject was lot 127 in the R.P. Bonington sale, Sotheby's 29 June 1829. Turner's very similar view of the bridge was engraved by R. Wallis and published in 1829 (V&A E5126-1906). Bonington refers to Cooke 'doing my bridge' in a letter to John Barnett dated 21 October 1827 (MS British Museum, London).

Bonington must have passed through St Maurice early in April 1826, on his way to Italy in the company of Baron Rivet. The town, on the site of the Roman Agaunum, was (and still is) famous for its fourteenth-century monastery, the most ancient in the Alps, where visitors could see the priceless liturgical objects and the library of medieval manuscripts. These would have been of interest to Bonington and his companion who, like all the members of Delacroix's circle at this time, were engrossed with troubadour art and its accoutrements. The ancient heraldic decorations in the town hall of St Maurice may also have attracted the travellers for

similar reasons. In 1825, Bonington and Delacroix had devoted much of their brief stay in London to studying and drawing medieval armour and Gothic tombs. If Bonington did visit the treasures at St Maurice the experience would undoubtedly have reinforced his already strong predilection for Romance motifs. Many drawings, as well as the well-known troubadour subjects in watercolour and oil, testify to this interest.

The colours of *St Maurice* are strong, with striking contrasts of tone, and there are highlights and twig formations scraped out in the clump of trees in the middle right ground and in the water. The drawing reveals a grasp of the structure of the hillside and an ability to create a sense of space and distance which are lacking in the much earlier view of Lillebonne (**18**). The paint is handled freely and crisply, particularly in the foreground where a little group of figures, their striped skirts and pyramidal forms characteristic of Bonington, sit in the rich Swiss meadow. The actual application of pigment in Bonington's watercolours is often so very stunning that, carried away by his virtuoso performance, one fails to notice that the conception of the subject is deeply rooted in a long-established tradition of landscape art. Here it is Gainsborough whose influence established the formal language through which the scene is communicated. The covered cart and figures crossing a bridge would not on their own be sufficient to justify invoking Gainsborough, even though they are the central pictorial motif and, as such, remind us of works like Gainsborough's *Mountain landscape with peasants crossing a bridge* (Washington, National Gallery of Art). But at the extreme right of Bonington's view is a little vignette of cows driven down a slope by a milkmaid that poignantly calls to mind those many Gainsborough chalk drawings that Girtin and his friends must have copied at Dr Monro's Academy. There were several Gainsborough-inspired subjects of this kind in Francia's *Studies from Landscape* ... of 1810, which Bonington must certainly have encountered, as well as actual 'imitations' of Gainsborough drawings (fig. 64).

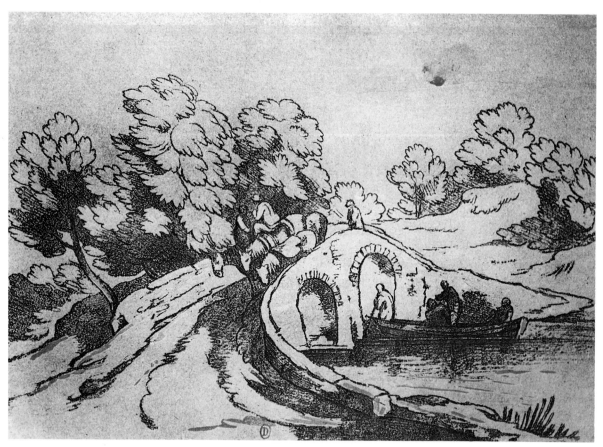

FIG. 64 (for comparison with CAT. **20**) Francia,
page from *Studies in Landscape* ..., 1810

21

The Corso Sant'Anastasia, Verona, with a view of the Palace of Prince Maffei

Watercolour and bodycolour on white
paper; 9¼ × 6⅛ (23.5 × 15.4)
Signed lower left in paint *RPB 1826*
3047-1876
(See also colour plate between pp. 96 and 97)
CONDITION: Slight stain centre top margin,
otherwise in excellent condition
PROV: Thomas Shotter Boys, Sotheby's 9
May 1850 (7): 'the magnificent and well-
known drawing in colours, probably the
finest of this lamented artist's productions';
bt. William Smith for £27; bequeathed by
William Smith to the Museum 1876 (see
also **12**)
EXH: Winter exhibition, Royal Academy,
London, 1873 (393); 'R. P. Bonington',
Nottingham Castle Museum, 1965 (219);
'Bonington: Un Romantique Anglais à
Paris', Paris, Musée Jacquemart-André, 1966
(54); 'Zwei Jahrhunderte Englische
Malerei, Britische Kunst und Europa
1680-1880', Munich, Haus der Kunst,
1979-80
LIT: Sir W. Armstrong, *Art in Great Britain
and Ireland*, 1909, repr. p. 262; D&H, repr.
facing p. 159; James Lane, 'Richard Parkes
Bonington', *Art Quarterly*, 1939, p. 148; AS,
p. 114, repr. pl. 132; M. Gobin, *R.P.
Bonington 1802-1828*, Paris, 1950, repr;
Spencer, no. 243; C. Peacock, *Richard
Parkes Bonington*, 1979, pl. xvi

A steel engraving by W. J. Cooke of 1830
was published in *The Gem* of 1830, in *The
Token* of 1833 and in *The Bouquet* of 1835
and 1836 (V&A E533-1910). The
engraving is based fairly precisely on **21**. A
drawing for this watercolour (lead pencil
on grey paper) was sold at Sotheby's 25
March 1920 (97). It came from the
Heseltine collection and measured 27 ×
19 cm. A reproduction of this drawing
appears facing p. 203 in Dubuisson and
Hughes. The Duke of Sutherland owned a
version in oil with a religious procession
passing along the Corso. This was lot 110
in Bonington's sale (Sotheby's 29-30 June
1829) and is now in the Yale Center for
British Art, the Paul Mellon collection
(2188) (fig. 65). It is referred to in a letter
from Bonington to Dominic Colnaghi,

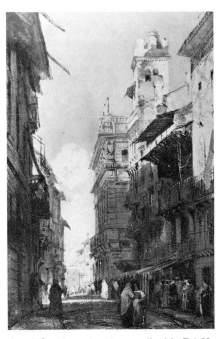

21

dated October 1827 (transcribed in D&H,
pp. 78-9, original unknown). Spencer
suggests that J.D. Harding's lithograph
(V&A E 445-1910) is based on a second
oil painting, now lost. This is possible, but
not probable, as the composition of the
lithographed view, dominated by a pile of
timber in the foreground, is very prosaic. It
could have been based on a pencil sketch
(now missing), lot 93 in Bonington's sale
(Sotheby's 29-30 June 1829). Birmingham
City Art Gallery has a copy attributed to
David Cox (no. 108-'19); this was
probably based on the watercolour which,
besides being in the same medium, would
have been relatively accessible in Boys's
collection. Christie's sold a watercolour
drawing attributed to Bonington on 6
December 1935 (3), *A Street in Verona*, 6 ×
4¼ in, ex Harper collection, 1851, bt.
Adams. It was seen by L.G. Duke and
Basil Long, who thought it was a copy
after the engraving.

Bonington and Baron Rivet spent at the
most two days in Verona on their visit to
Italy in 1826, arriving in the city on 18
April and moving on to Venice on 20
April. The degree of finish in this
watercolour suggests that it was executed
some time after the visit from the drawing
mentioned above and now lost. The oil

could have been done at the same time or later following the watercolour. The technique reveals Bonington at his most assured and brilliant; the washes are laid in unhesitatingly with no uneven edges where the paint has dried too quickly, the texture varies from the extremely smooth and liquid finish in the sky and the distant architecture to the dry and scumbled effect of the foreground. The architectural details are reduced to an impressionistic minimum and drawn in with a loaded brush with the greatest panache. Relatively large areas of

untreated paper are allowed to remain and flashes of vitality and brightness are conveyed by a restrained but calculated scraping off of pigment, as with the cord that hangs from the balcony at the right and the small relieving areas of white in the clothing of the figures in the foreground. Bonington treats the road surface in the foreground with a typically bold hand, changing suddenly the direction of his brush stroke, rubbing out and scratching.

The angle of vision is dramatic,

FIG. 65 (for comparison with CAT. **21**) Bonington, *Corso Sant'Anastasia, Verona, with a religious procession*, oil on panel, Yale Center for British Art, Paul Mellon Collection, 23½ × 17¼

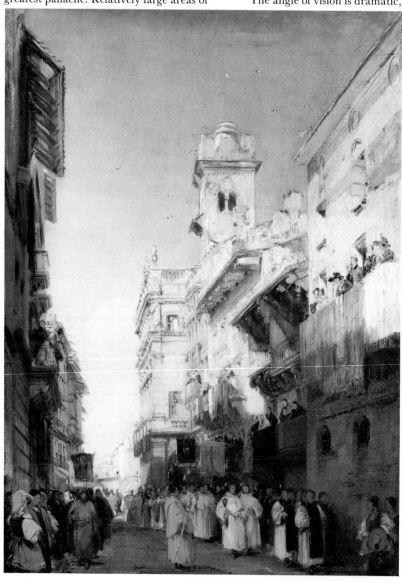

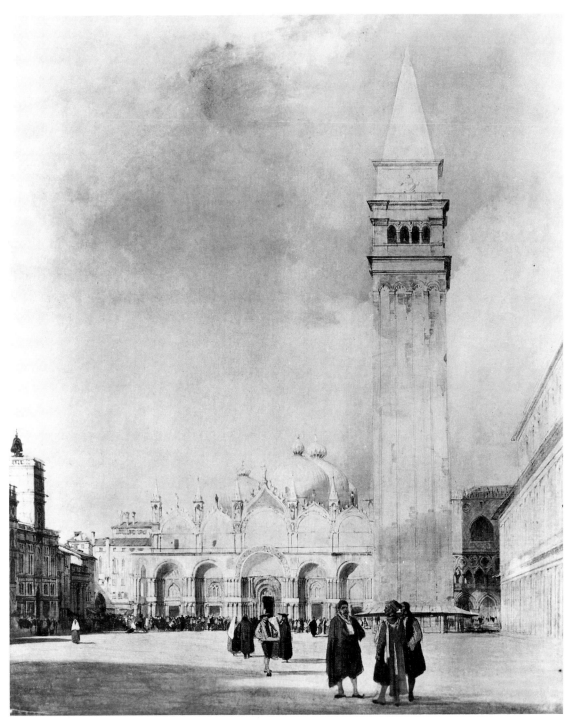

FIG. 66 (for comparison with CAT. 21) Bonington, *The Piazza San Marco*, oil on canvas, Wallace
Collection, London, $39\frac{1}{2} \times 32\frac{1}{8}$

FIG. 67 (for comparison with CAT. **21**) Bonington,
*The Interior of the Church of S. Ambrogio,
Milan*, watercolour, Wallace Collection,
London, $8\frac{5}{8} \times 11\frac{1}{4}$

emphasizing the asymmetrical and overhanging roofs and balconies of the narrow street, a main thoroughfare of this busy Italian town. It is a mark of Bonington's sensitivity, perceptiveness and originality of vision that he is able to achieve, at a later date and removed from the scene itself, such a vividly atmospheric representation of a place. It is this vitality and sense of atmosphere transforming topography that distinguishes his work from the more laboured efforts of some of his contemporaries. At the same time, he can be quite cavalier about accuracy in perspective and in the rendering of architectural detail. It is characteristic that Bonington chose to paint a street, suppressing the feature that blocks the vista so that the eye is forced to dwell on sharply projecting water spouts and the layered effect of unevenly arranged balconies. Thomas Shotter Boys would undoubtedly have made more of the terminating archway, emphasized the architectural features and more accurately defined the perspective.

A comparison between the watercolour (**21**) and the oil (fig. 65) reveals a number of important changes. In the oil painting the figures, instead of receding, are approaching the viewer, and they are clearly to be distinguished as clerics. In the watercolour they appear to be women clad in long skirts and shawls. The central figure in the oil is a church dignitary clad in brilliant red. Figures and banners are introduced at the left-hand side of the street in the oil version and the more prominently depicted balcony of the first house on the right from which people watch the procession is draped with

celebratory flags. In order not to distract attention from these events, Bonington has suppressed the overhanging eaves of houses which are shown in the watercolour. The looped cords that hang from the balcony at the right-hand side of the watercolour have been eliminated and the dimensions of the house altered to simplify the ground floor. The street is altogether darker and the whole effect is richer and more highly worked. This is not always the case with Bonington's oils; *The Piazza San Marco* of 1828, for example, is painted in thin clear 'washes' of oil paint (Wallace Collection, London, p. 375) (fig. 66). With its more exotic and colourful effects, the oil version of *Verona* approximates more closely than the watercolour to current French salon painting and the changes may, in fact, have resulted from the artist's desire to paint a subject picture likely to find an immediate purchaser. Religious processions were popular subject matter with Troubadour artists and with those who, depicting medieval French monuments, enlivened them and endowed them with an authentic atmosphere by introducing habited monks and processions of worshippers. Camille Roqueplan, whom Bonington knew as a student in Paris, became expert at this sort of subject and his works enjoyed great popularity in lithographed form. Bonington's interest in this sort of subject is also evident in another watercolour deriving from his Italian visit, the fine *The Church of Sant'Ambrogio, Milan* (Wallace Collection, London, P714) (fig. 67) in which a priest celebrates mass at the high altar before a congregation of the faithful.

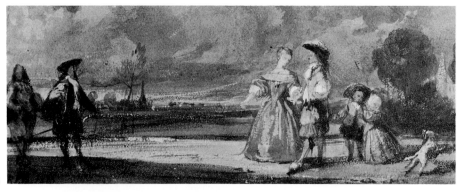

22

R. P. BONINGTON

22
The meeting

Watercolour, bodycolour and gum arabic on white paper $2\frac{1}{2} \times 5\frac{3}{4}$ (6.3 × 14.8)
Signed and dated lower left in paint *R.P.B. 1826*; inscribed in pencil on reverse *3 inches margin at each side $8\frac{1}{2} \times 12$*
P2 1980
(See also colour plate between pp. 96 and 97)
CONDITION: Fresh
PROV: Thomas McLean, his sale, Christie's 18 January 1908; M. Beurdeley, his sale, Galerie George Petit, 30 February 1920; Sotheby's 13 March 1980 (63) as *The Meeting of Louis XIV of France and Charles II of England*, bt. Victoria and Albert Museum
EXH: 'Exposition Centennale de l'Art Français', St Petersburg, 1912 (46)
LIT: A.S. p. 147

This tiny but beautifully executed and finely articulated composition showing the afternoon stroll of a family in Van Dyck costume is typical of the genre of Troubadour painting for which Bonington was greatly acclaimed at the time of his death in 1828. Richly coloured, imaginative excursions into the courtly past of the sixteenth and seventeenth centuries such as this were regarded by many as Bonington's greatest achievement. Although he by no means invented the *style Troubadour*, Bonington's work in this vein is more refined, more tender in mood and more subtle in execution that that of many of his contemporaries. He had many followers in this genre on both sides of the Channel.

Although this work is on such a small scale, Bonington has deftly and characteristically established a sense of space and depth through the positioning of the spire in the distance and the spire at the right. A lively narrative is conveyed with the counterbalance between the dignified rhythmic movement of the adult figures and the swift darting form of the dog. The scene has the feel of an episode from an historical novel, but it seems more likely to be imaginary. The group at the right is reminiscent of Rubens's portrait of himself with his second wife and his son walking in their garden (*c.* 1631), and the grouped figures generally echo works by Van Dyck and Rubens which Bonington is known to have studied in the Louvre (fig. 68). The sale following the death of Bonington's father (Christie's 23–24 May 1834) included a portfolio containing twenty-seven artist's prints after Rubens etc. (lot 1). Details are not given, but this may have been *Oeuvres de P.P. Rubens et de Van Dyck, ou recueil des principaux tableaux de ces deux illustres peintres, gravé par Schelte et Boetius de Bolswert, L.Vosterman, P.Pontius et autres ... artistes*, Amsterdam, 1808.

The execution of this watercolour reveals Bonington at his most versatile and brilliant. The handling of paint is full of zest. Plain areas of paper are permitted to remain in some areas of the sky and in the foreground. Tag-ends where a wash has been allowed to dry quickly between the left-hand figures and the tree create hard line and depth effects. Thumbmarks above the children's heads and in the centre of the sky create a textured effect which contrasts with the delicate calligraphy of the tree. The paint surface is scratched out in the lights of the centre foreground and Chinese white is applied with a dry brush on the church spire, in the clothing of the figures, on the dog's back and in the sky. The colouring is rich and brilliant with high points in the vivid pink dress of the woman and the sharp yellow of the girl's clothes. Gum has been applied in the foreground shadows and on the men's clothing.

FIG. 68 (for comparison with CAT. **22**) Bonington, sheet of studies after Old Masters, watercolour, Fondation Custodia (Coll. F. Lugt) Institut Néerlandais, Paris, largest $2\frac{1}{2} \times 3\frac{1}{2}$

23
Place du Molard, Geneva

Pencil, wash and Chinese white on grey
paper; 6⅞ × 6¼ (17.3 × 16.3) mountsize
Inscribed lower left in pencil *8* and top
right in pencil in Bonington's hand: *Place
du Mo[lard] Geneva*
E83-1943
CONDITION: Excellent
See also **34** and **35**, formerly attributed to
Bonington
PROV: Purchased from Agnew's in 1943
EXH: 'R.P. Bonington', Nottingham Castle
Museum, 1965 (66)
LIT: Henri Lemaître, *Le Paysage Anglais à
l'aquarelle 1760–1851*, Paris, 1955, p. 346; M.
Cormack, 'The Bonington Exhibition',
Master Drawings, iii, no. 3, 1965, p. 289;
Spencer, no. 85

This sketch is probably, as Spencer
suggests, the basis of a lost watercolour
lithographed by J.D. Harding in 1829
(V&A E456-1910; lithographed from a
drawing in the possession of P.F. Robinson
Esq^re, published August 1st 1829 by J.
Carpenter and Son, Old Bond Street,
printed by Hullmandel). The oil painting
of the same subject in the Museum (CA1
13) (**35**) is based on the lithograph and is
not by Bonington. The unfinished
watercolour sketch (P10-1956) (**34**) is not
by Bonington either and appears to be
based either on the lithograph or on the
oil. There seems, however, no doubt that
the drawing **23** is authentic. There were a
number of drawings of Switzerland in
Bonington's studio sale (Sotheby's 29-30
June 1829); lot 97 included a view of
Geneva.

The whole group of works provides an
interesting example of how lithographs
after drawings of picturesque and popular
places spawned copies which, particularly
in the case of an artist who is known to
have worked extensively in oil as well as in
watercolour, then became accepted as
different stages in the artist's working out
of a theme.

In the lithograph a strong shadow is cast
by the buildings to the left, the cart in the
left foreground is replaced by the figures of
a soldier, several women wearing hats and
a girl with a tray on her head. The
architecture is generally rendered with
greater clarity in the lithograph.

Bonington stopped in Geneva on his way
to Italy in April 1826. Everything about
this drawing suggests that it was done on
the spot; it has great immediacy and is
created in Bonington's most spontaneous
short-hand pencil manner with stubby
energetic pencil strokes and rich, bold
hatching. The name of the place was
recorded at the top corner of the drawing
for reference because it was Bonington's
habit to use such swift drawings as the
bases for finished watercolours. The
drawing combines economy with great
precision and it was this combination that
ensured the unhackneyed and authentic
feel of his watercolours. Notice, for
example, that despite the sketchy notation
of windows and doors, the clock is
conveyed in great detail, as is the precise
positioning of the line of washing, the
hanging lamp at the far left and the cart in
the left foreground.

Bonington's view shows the medieval
market hall in the Place du Molard, the
commercial centre of the town. The
wooden projecting roofs that can be seen at
ground-floor level were a feature of old
Geneva that began to disappear as the
medieval quarters of the town were rebuilt
and access opened up to the lake and the
river later in the century. The square was
the scene of a major event in the Geneva
revolution of 1846, by which time, as
contemporary views show, the line of
buildings depicted by Bonington had been
radically changed and a passageway
opened with archways supported on piers
(see P. Guichonnet, *Histoire de Genève . . .*,
Toulouse and Lausanne, 1974, pp. 98-9,
289, ill. opp. p. 320).

24
River scene – sunset

Oil on millboard; 10¾ × 12¾ (27.3 × 32.5)
FA 1
CONDITION: Good
PROV: George Cooke; John Sheepshanks,
bequeathed by him to the Museum in 1857
EXH: Aldeburgh Festival, 1954 (10); 'R.P.
Bonington', Nottingham Castle Museum,
1965 (257); 'Naissance de l'Impressionisme',
Bordeaux Musée des Beaux-Arts, 1974;
'Impressionism', RA, 1974
LIT: Spencer, exh. no. 257

The history of this picture provides an
interesting demonstration of how artists
and collectors cherished Bonington's works
during the period immediately following
his death and how tightly knit was the
community of landscape artists during the
early nineteenth century. George Cooke
(1781–1834) was an engraver who is
remembered particularly for his work on
J.M.W. Turner's *Views of the South Coast of
England* (1814), Hakewill's *Picturesque Tour
of Italy*, illustrated by Turner in 1820, and
many other similar enterprises. George
Cooke undoubtedly played an important
part in disseminating Turnerian vision
among the artists of his generation. It is,
therefore, interesting to observe that Cooke
possessed an example of Bonington's work
that reveals the artist's evident admiration
for Turner.

George Cooke's son, E.W. Cooke,
himself an engraver and watercolourist,
was friendly with Thomas Shotter Boys.
His diary, which survives in manuscript
with a descendant of the Cooke family,
provides a fascinating glimpse into the
daily life, aspirations and interests of this
group of artists of Bonington's generation.
River scene – sunset is in all likelihood the
'beautiful little picture' that E.W. Cooke
records Joseph West presenting to his
father on 1 February 1830. George Cooke
was, his son tells us, delighted, and Boys,
who was present, 'promised him a drawing
by the same artist' (E.W. Cooke's diary, 1
February 1830, private collection,
transcript in the possession of Mr John
Munday to whom I am grateful for
access).

Three years later E.W. Cooke called on
Bonington's father and saw 'the fine Exhn.
of his son's drawings' (diary, 25 August

1833) and in 1834 he accompanied Joseph
Nash to the Prince of Wales' Hotel to see
John Lewis Brown's collection of Bonington
watercolours. '*Truly splendid and surprising
works of art!!!!*', he declared in his diary,
'nothing in art so much affected me before'
(diary, 10 April 1834). It was on this
occasion that E.W. Cooke had what he
describes as the '*surprising luck*' to meet Mr
Sheepshanks, the Leeds woollen
manufacturer and patron of contemporary
British Artists. Sheepshanks commissioned
an oil painting and invited him to Hastings
for a few days. John Lewis Brown, a
Bordeaux businessman, was evidently in
London for the sale of Bonington's work at
Christie's which took place on 21 May
1834, but it is fascinating to see that, like
Sir George Beaumont, John Lewis Brown
travelled with his most precious works of
art. The greater part of Mr Brown's
collection was sold in Paris later that same
year (Hotel de MM. les Commissaires-
priseurs, Place de la Bourse, 2, 27
December 1834); the remainder went
through the same sale room on 17–18 April
1837. Brown was evidently still in London
in July because E.W. Cooke records
meeting two Wylds (William and his
brother?) at the British Institution and
taking them to see Mr Lewis Brown's
'superb collection of Bonnington's (*sic*)
drawings' (diary, 4 July 1834). The Cooke
family was evidently much devoted to
Bonington's work, for there is mention in
E.W. Cooke's diary for 16 January 1835 of
a sketch in oils which 'coz Bill' lent him to
copy. *River scene – sunset* is the only work by
Bonington in the Sheepshanks bequest. It
seems likely that, having failed to acquire a
satisfactory Bonington at Christie's sale in
1834, Sheepshanks used his influence to
purchase one privately. E.W. Cooke
would, doubtless, have told him of his
father's 'beautiful little picture'.

There is evidently a considerable debt to
J.M.W. Turner in *River scene – sunset*, with
its pool of light and its low ball of wintry
sun emphasized late in the painting's
execution by a crisp vertical dab of paint.
The frond-like bushes, the reflection of the
sun and of the foliage in the still water are
also reminiscent of some of Turner's
Thames scenes of the early 1820s. Yet the
dry, dragged brushloads of paint and the
flourish which the flexible wrist creates at

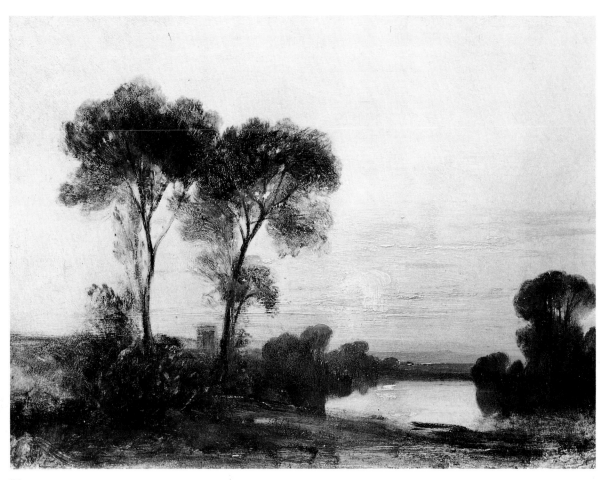

24

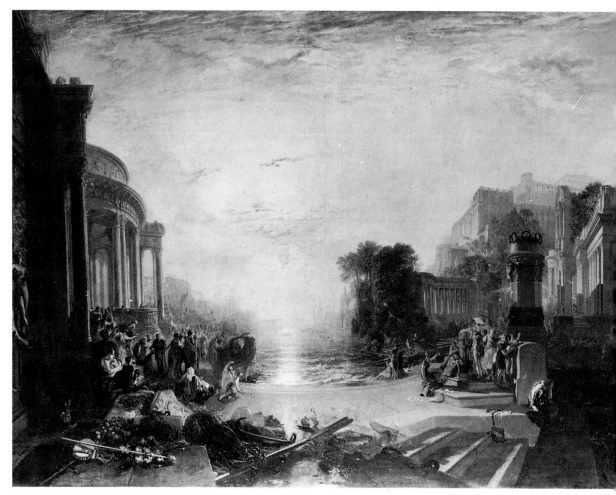

FIG. 69 (for comparison with CAT. **24**) J.M.W.
Turner, *The Decline of the Carthaginian
Empire*, Tate Gallery, London, $67\frac{1}{2} \times 95$

the left-hand corner, are entirely in Bonington's manner. There seems little doubt that Bonington, who visited London in 1825 in the company of Alexandre Colin, arriving by early June, acquired an intimate knowledge of works by Turner. The visitors from France would undoubtedly have been interested in Turner's *Harbour of Dieppe (changement de domicile)* (Frick Collection, New York), hanging in the Royal Academy that year. A closer relationship between Bonington's *River scene – sunset* and Turner's work may, however, be seen by comparing the former with Turner's historical subjects and landscapes of a few years earlier. *Landscape: composition of Tivoli* of 1817 (private collection), and *The Decline of the Carthaginian Empire* (RA 1817, Tate Gallery, London, Turner Bequest) (fig. 69), exploit the dramatic effects of looking directly into the sun, although both are, of course, very detailed and highly finished in comparison with Bonington's oil (both are

reproduced by A. Wilton in *The Life and Work of J.M.W. Turner*, 1979). *The Decline of the Carthaginian Empire* remained in the artist's possession and could, therefore, have been seen by Bonington and Colin. Turner appears to have been in London between May and July 1825 (see J. Gage, *Collected Correspondence of J.M.W. Turner*, Oxford, 1980, p. 95). *River scene – sunset* is clearly based on a French location, but it is interesting to observe how readily Bonington was able to adapt the dry, chiaroscuro manner of this oil study to the brilliant scenery of Italy which he visited in 1826. *A view of Lerici* from Sir Thomas Lawrence's collection, sold at Sotheby's in 1980, possesses the same expressive brushwork, the same feathery trees, still water and vague distant architectural forms as *River scene – sunset*, but the artist's palette has been lightened to encompass a high range of tonality (Sotheby's, London 12 March 1980, 122).

The precise nature of the relationship

FIG. 70 (for comparison with CAT. **24**) Paul Huet, *Paysage nocturne*, sepia, Calais Museum, $5\frac{1}{2} \times 7\frac{5}{8}$

between Bonington and the French landscape artist Paul Huet is also a question that can be raised in connection with *River Scene – sunset*. Huet was certainly a great admirer of Bonington as well as one of his close acquaintances. Indeed, it was Huet who said that Bonington talked incessantly of Turner (*Paul Huet (1803–1869) d'après Ses Notes, Sa correspondance, Ses Contemporains. Documents recueillis par son fils et précédés d'une Notice Biographique*, Paris, 1911, pp. 21, 96). Huet's watercolours suggest that he had studied Bonington, but as few of them are dated it is difficult to know whether Bonington influenced Huet or vice versa. There are, moreover, freely handled sketches in oil and watercolour by Huet which Miquel has dated to the very early eighteen-twenties. If this dating is correct then it would seem that works such as. Huet's *Paysage Nocturne* (Calais Museum) (fig. 70) may well have inspired Bonington to the much broader application of the oil medium that distinguished his work very strikingly from Turner's (Version in oil on panel, 45.2 × 68.2 reproduced vol. II, p. 198 of P. Miquel, *Le Paysage français au XIX^e Siècle, 1824–74, L'Ecole de la Nature*, Maurs-la-Jolie, 1975).

FIG. 71 (for comparison with CAT. **25**) Bonington, *The Seine near Mantes*, oil on canvas, Wallace Collection, London, 12¼ × 18⅛

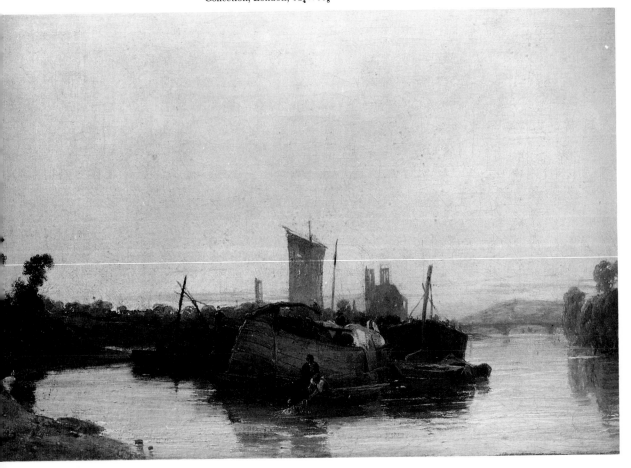

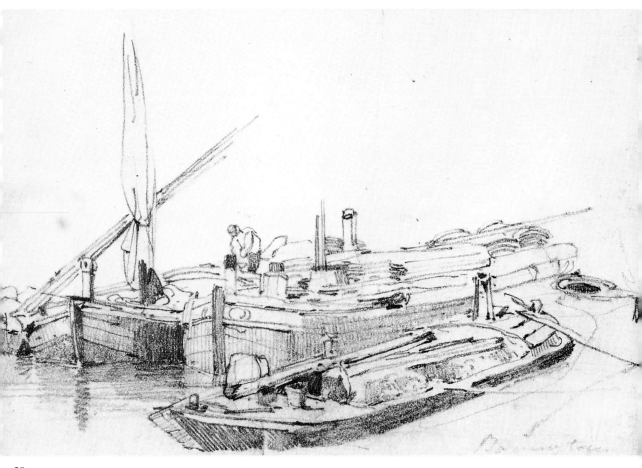

25

25
Fishing vessels tied up

Pencil and wash on white paper, probably
a page from a sketchbook; $4\frac{3}{8} \times 7$
(11.3×18)
Inscribed in pencil bottom right in a hand
other than the artist's *Bonington* and top left
41
D 2273–1885
CONDITION: Scorch marks at left and a
certain amount of smudging and/or dirt
especially at margins
PROV: Purchased with D2272–1185 (on one
mount) 24 November 1885 for seven
shillings and sixpence from an anonymous
seller.

This and the drawing of Vimereux (**19**) are
typical of Bonington's quick open-air pencil
sketches. The subject matter compares with
that in a number of the artist's finished

watercolour and oil views of rivers and
ports. See, for example, *The Seine near
Mantes* (Wallace Collection P339) (fig. 71).
The difference between this drawing and
Bonington's use of similar motifs in his
finished work lies in the angle of vision.
Bonington, for all his natural effects of
sunshine and fresh air, is essentially a
draughtsman and a formalist rather than a
plein-air naturalist. On-the-spot drawings
such as this are used as visual records of
compositional ideas and technical details.
Thus, the angle which allows us, in this
drawing, to look down into the boats from
the quayside, is invariably replaced in the
finished work by a distanced and lower
viewpoint. Bonington's innate sense of the
formal qualities of groups of objects is,
however, very evident in these little
spontaneous jottings. Notice the way in
which an oar propped against the quay on

the right balances the leaning mast at the
left, and the visual fascination with the
irregular arrangement of regular forms –
the hulls unevenly lined up, and the clutter
inside the even curves of the boats' sides.
Bonington, having been trained by
Francia, must have been more familiar
with this subject matter than with any
other. The older artist, however, often
favoured a more casual angle of vision, as
in his *River with barges* (**13**), where we look
down from a bridge at two boats.

Bonington handles his pencil, normally a
soft lead pencil, with splendid staccato
effects. The variation in tone from thick
heavy blackness to the lightest suggestion,
and from the vigorous hatching of the
foreground barge to the gentle shading of
the water, makes this an exciting and vital
example of Bonington's sketching practice.

FIG. 72 (for comparison with CAT. **26**) Bonington, *A Fishmarket at Boulogne*, watercolour, Musée du
Louvre, Cabinet de Dessins, $6\frac{1}{4} \times 9\frac{3}{8}$

26

Fisherfolk on the beach

Pencil and watercolour on white paper laid down on card; $4\frac{3}{8} \times 8\frac{1}{8}$ (11.1×20.5)

P 15-1943

CONDITION: Pencil underdrawing is visible through sail and rigging at left; lower right-hand corner damaged

PROV: Christie's 16 November 1934 (9), property Rt Hon. Lady Northcote decd.; H.J. Chetwood FRIBA; given to the Museum in accordance with his wishes 1943

This slight sketch of a mother with a baby and a small boy seated at low tide near a harbour wall is executed with Bonington's customary panache. The sky is rendered with large sweeping brushstrokes, the figures are drawn in with rapid, fine brushlines and filled in with flat colour and stripes (for the woman's apron), creating the slabby, angular quality so characteristic of Bonington's figures in paint. The background and the beach are swiftly built up with dry, dragged strokes of paint. Although the sketch is slight and rapidly executed, the placing of the forms reveals that instinctive feel for spatial relationships which is one of Bonington's greatest strengths as an artist. The white sail at the left, the white caps of mother and baby, the flat white shirt back of the boy and the bright patch of sky behind the sail at the right form a series of bright material features in rhythmic contrast to the darker breakwater and beach and the ephemeral changing sky and sharply cast shadows.

Bonington frequently placed groups of figures like these in the foreground of his beach scenes. They are the descendants of the elegant sailors who heave on ropes and tidy tackle in the foreground of Vernet's sea-pieces. Although they certainly provide local colour and picturesque interest they are, as this sketch shows, regarded by Bonington as just one part of the structure of the landscape with which he is concerned, rather than as a narrative appendage. Occasionally, notably in the *Fishmarket at Boulogne* (fig. 72) which he painted in oil and in watercolour (Yale Center for British Art; Louvre, Paris) the figures become the dominant motif and the ships, beach and harbour assume an inferior role.

26

27
The Pool from Adelaide Hotel, London Bridge

Watercolour on white paper laid down;
9¾ × 13⅜ (23.6 × 33.8)
Signed in paint bottom left *W. Wyld* and inscribed bottom right *London*. Pencilled on reverse along top edge *The Thames from the Adelaide Hotel*
563-1882
(See colour plate between pp. 96 and 97)
CONDITION: Overall fading, especially sky area; damage in lower right corner where the paper is thin after tearing when removed from a mount on to which it has been stuck at some time
PROV: Bequeathed by Mr John Jones in 1882, one of a collection of 105 oils and 19 watercolours left to the South Kensington Museum

The new London Bridge was opened on 1 August 1831 and so Wyld's undated watercolour probably dates from around 1832-3. The technique also suggests a date early in the artist's career. Thin transparent washes of paint are overlaid with painted detail which is particularly evident in the wharf and the boats in the foreground. This manner is typical of Francia and Bonington and quite different from the thick, textured paint Wyld employed from the late 1830s (see, for example, *The Falls of Tivoli*, **28**). The wooden end of the brush has been used to scratch out the horizontal lines of reflection in the water on the right and both the sun (scarcely visible in a photograph) and its reflection are heavily and extensively scraped out. It seems likely that Wyld had in mind Turner's Claudian predilection for river scenes in which the spectator looks straight into the sun when it is low in the sky. The industrial hustle and bustle of this working river scene are not unlike the sort of effects achieved in Turner's view of Newcastle. The inaccurate perspective and the pencil grid which is visible beneath the paint surface of the foreground buildings also support the supposition that this is the work of the young Wyld.

The area that Wyld chose to depict in this work is one that became dear to Whistler later in the century. But although Wyld makes much of the hazy light in which the sun appears through smoke and mist, and enjoys the grand but brutal architecture of Fresh Wharf, his drawing contains many topographical omissions and inaccuracies. Indeed, it seems impossible that it could have been painted on the spot or even with the assistance of detailed sketches, and must have been done largely from memory, perhaps after Wyld – who lived in France – had returned home.

The Adelaide Hotel stands at the north end of London Bridge (the original hotel has recently been rebuilt). Thus, if the inscription on the reverse of the drawing is correct, Wyld is looking down-river and the more or less correctly transcribed horizon confirms this. Nonetheless, on the right bank are visible a number of silhouettes that belong up-river and could not be seen from that position (the monument and a church tower that looks like St Bride's) while the church tower that is visible above Fresh Wharf closely resembles Southwark Cathedral, which is situated at the south end of the bridge. There are (or were) several other churches at the north end of the bridge – St Magnus Martyr, St Mary-at-Hill and St George's Botolph Lane – but none of them have or had towers of this type. Moreover, the Tower of London which should be readily visible, is nowhere to be seen.

Bonington showed interest in industrialized landscapes and working scenes (see, for example, *Bridge Builders at Rouen*, an early work in the Fitzwilliam Museum, Cambridge; Spencer, nos. 207, 208) and it is interesting to notice that he executed a watercolour of the Pool of London when he visited London in 1825 (Spencer, p.257). This is now missing, but was in the Lewis Brown sale of 17 April 1837 where it was described as 'Vue de vieux pont de Londres: sur le devant un grand nombre de Batimens garnissent ce dessin . . .'. The scene is described as 'plein de vapeurs qui couvrent ordinairement la Tamise.'

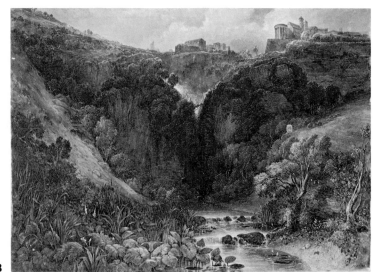

28

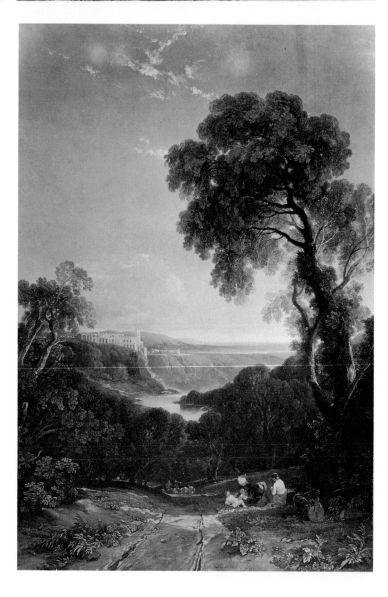

28

The Falls of Tivoli

Watercolour and bodycolour on cream
paper laid down; 13⅛ × 18 (33.3 × 45.7)
Signed and dated William Wyld 1839
1287–1886
(See also colour plate between pp. 96 and
97)
CONDITION: Slightly damaged at edges by
mount; slight tear now stuck down centre
top edge, horizontal pencil line ruled across
top margin
PROV: Purchased by the Museum in 1886
for £22

Tivoli is one of the most time-honoured
subjects in the repertoire of landscape
artists from the seventeenth century
onwards. British and French artists
studying in Rome during the eighteenth
century would make excursions to Tivoli
and the many views exhibited in the Salon
and the Royal Academy during the later
years of the eighteenth century testify to
the popularity of this beautiful villa and its
enchanting gardens. Wyld would have
visited Tivoli in 1833 when he was staying
in Rome. His view is unusual, insofar as,
whilst retaining a glimpse of the villa itself
up on its rocky prominence, he chooses to
concentrate on a close-up depiction of the
wild and Sublime aspects of the landscape
rather than its soothing and more
cultivated charms.

It is instructive in this respect to
compare Wyld's *The Falls of Tivoli* with the
view of Tivoli painted by W.J. Muller in
the same year (signed and dated November
1839, Walker Art Gallery, Liverpool) (fig.
73). Muller takes a distant view looking
across and down to Tivoli. His format is
upright and the entire composition with its
framing trees and pastoral foreground
figures is a well-wrought pastiche of
Claude's lyrical landscapes. A quick wash
drawing by Wyld in the Whitworth Art
Gallery, Manchester, presents the same

view of Tivoli as Muller chose, but from a
somewhat closer position (Whitworth Art
Gallery, University of Manchester, D68,
1926) (fig. 74). This drawing includes
figures in the right foreground (absent in
the Victoria & Albert Museum view),
but also suggests the strong interest in
foreground vegetation which Wyld
developed in his finished view. The
relationship between the Whitworth
drawing and 1287–1886 suggests that Wyld
gathered on-the-spot documentation from
which he subsequently worked up a highly
finished exhibition piece. Another view of
Tivoli by Wyld from a similar position to
that used for 1287–1886 was lot 168 at
Sotheby's, 17 October 1968.

The centre of Wyld's picture is occupied
by the great black chasm in the rocks
down which water plunges, leaving a froth
of white spray among the vegetation at the
top. The vision of this severe and
threatening drop reminds us of such classic
interpretations of Sublime landscape as
James Ward's *Gordale Scar* (1811–15, Tate
Gallery, London). Yet the foreground is
occupied not by wild bulls but foliage and
wild flowers – waterlilies, harebells and
cyclamen – all depicted with a minute
attention to detail worthy of John Linnell
or Francis Danby in their work of this
period.

Wyld appears to have particularly
enjoyed dramatic views of richly fertile
locations in which outcrops of rock are
interspersed with thick undergrowth, trees
and a wide range of botanic specimens. His
view of *Mont St Michel* (Louvre, Paris) is a
painting of this type. The artist has in both
cases produced a very highly wrought
painting in which transparent washes are
discarded in favour of dryly worked and
teased paint surfaces, and tepid northern
colours are replaced by sometimes
startlingly strong combinations where body
colour is employed to great effect. The
foam from the waterfall and the foreground
water is boldly and broadly scraped out.
For all the tempestuous quality of the
subject and the obsessive application of
paint, this is still a very carefully controlled
work. The white boulder on the right
shoulder of the hill is calculated to help the
spectator define proportions and distance
and the plants are observed and studied
with great attention to botanical accuracy.

FIG. 73 (for comparison with CAT. **28**) W.J.
Muller, *Tivoli*, oil on canvas, 1839,
Walker Art Gallery, Liverpool, 72⅛ × 50¼

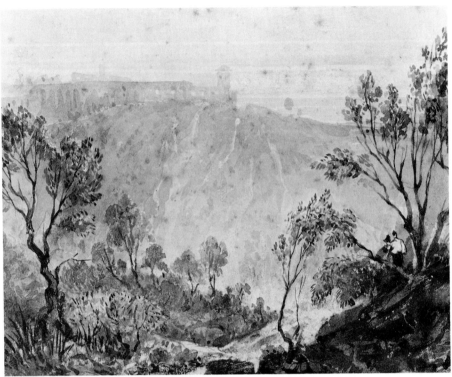

FIG. 74 (for comparison with CAT. **28**) Wyld,
 Tivoli, sepia, Whitworth Art Gallery,
 University of Manchester, $4\frac{1}{4} \times 5\frac{1}{8}$

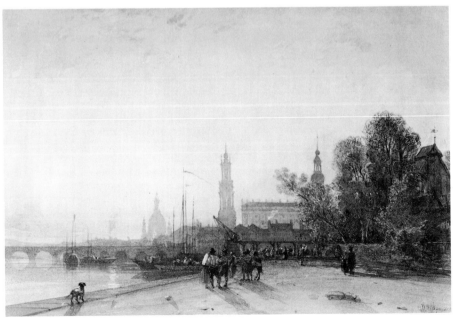

29

29
View of Dresden by sunset

Watercolour and bodycolour with gum
arabic on thin cream paper laid down;
$6\frac{7}{8} \times 10\frac{5}{8}$ (17.5 × 26.8)
Signed in paint lower right and inscribed
W. Wyld Dresden 1475–1869
(See also colour plate between pp. 96 and
97)
CONDITION: The sky is faded and brown
and there is no indication of what the
original colour must have been like
PROV: This work was one of a large group
of works – 186 oils, 177 watercolours and a
large number of gems, drawings, prints and
other items – selected by the Museum from
the collection of the Revd Chauncey Hare
Townshend, according to the terms of his
bequest of 1868. Townshend was a poet,
traveller and amateur artist. His
watercolours and drawings recording his
travels and those parts of his collection not
chosen by the Museum are now in the
Wisbech and Fenland Museum, Wisbech.
A *Vue de Dresde* in watercolour was lot 8 in
Wyld's studio sale, Paris, Hotel Drouot
30–31 May 1890, but no details are given
EXH: RA 1852 (10); Liverpool Academy
1852 (34)

Dresden was not a popular place with
artists in the first half of the nineteenth
century. Thomas Shotter Boys visited the
city in the early 1840s but he was probably
more familiar with Prussia than most of his
contemporary landscapists as his sister
Mary lived there with her husband,
William John Cooke. Between 1796 and
1861 any number of views along the Rhine
were exhibited at the salon, but only one
view of Dresden (E. Desplechin, *Vue prise
dans les environs de Dresde*, dessin, no. 1924,
salon subject index, Dept of History of Art,
University of Oxford). Wyld probably
visited the city in the late eighteen-forties,
as he exhibited a *View near Dresden*
(*Morning*) at the Liverpool Academy in
1850 (no. 326).

Wyld's view of Dresden shows the left
bank of the Elbe looking upstream. On the
left is the Augustus Bridge; behind it are
silhouetted (from left to right) the
Protestant Frauenkirche by G. Baehr
(destroyed in the war), the tower and nave
of the Catholic Palace Church by Chiaveri
and, behind the trees, the tower of Dresden
Schloss (I am grateful to Gertraute
Lippold of the Staatliche
Kunstsammlungen, Dresden, for
elucidating the topography of this work.)

Wyld's fidelity to 'la manière anglaise', as
taught by Francia and Bonington, is very
evident in this watercolour despite the
location in Eastern Europe, well beyond
the geographical boundaries that
circumscribe the work of the older artists.
The crispness of the paint application, the
grouping of the figures in their brightly
coloured clothing, the long shadows cast by
the sun and the massing of interesting
features at one side of the composition
while the other side is left open, are all
characteristic of this 'school'. Thin
translucent washes are overlaid with body
colour and gum for the depiction of the
figures. The light area on the dog's back is
scraped out and the trees at the right are
painted with a spiky dry brush. Wyld
developed this technique into something
approaching Pre-Raphaelite meticulousness
in his later work. In the centre area the
paint is blotted to achieve a dry velvety
texture. The choice of evening light in
which the major architectural forms are
seen as vague and distant silhouettes and in
which the figures cast long shadows against
the setting sun reveal Wyld's debt to
Turner.

Following the example of Boys in his
Paris watercolours (fig. 75) (V&A AL 5848;
D1588–1907; 456–1882), Wyld exploits
man-made and man-centred details like the
crane which, dead centre, dominates the
figures and cuts across the main lines of the
composition. The open and vacant
foreground and the long receding line of
the harbour's edge serve to draw attention
to the centre of activity. The wintry light
and the grey tones of the architecture are
relieved by splashes of red and the vivid
acid-green which Wyld specially
favoured.

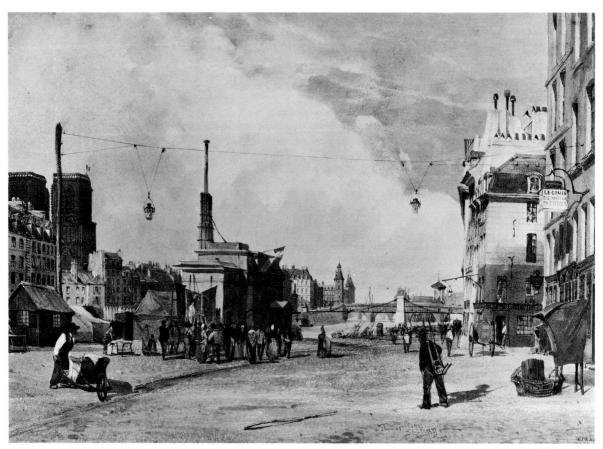

FIG 75. (for comparison with CAT. **29**) Thomas
Shotter Boys, *Quai de la Grève et le Port au
Blé, Paris*, watercolour, 1837, Victoria &
Albert Museum, 11¼ × 15⅞

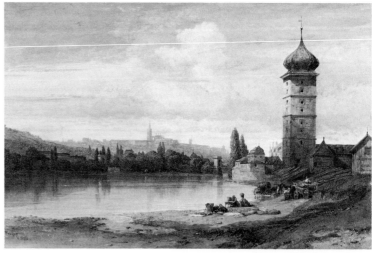

30

30
A view of Prague

Watercolour on white paper laid down;
13 × 20 (33.1 × 50.65)
Signed in paint lower left and inscribed
Prague W.Wyld
D115-1905
(See also colour plate between pp. 96 and
97)
CONDITION: Slight tear right edge and two
slight tears top edge; sky faded, marginal
strips indicate original colour, glue marks,
moderately foxed
PROV: Christie's 16 July 1904 (51) anon.
sale, bt. Agnew's; purchased from Agnew's
annual watercolour exhibition February
1905 (115) for £21 on the recommendation
of Sir William Richmond and H.M.
Cundall

There were five views of Prague exhibited
at the Salon between 1841 and 1863 (1841,
Mathieu 1414; 1855 Thienon 4045; 1857
Mathieu 1862; 1861 Karsen 1708; 1863
Thienon 1776; salon subject index. Dept of
History of Art, University of Oxford).
Although there is no record of Wyld
having exhibited this particular view either
in Paris or in London, it was probably
executed in the early fifties or even in the
very late forties, perhaps on the same trip
to Eastern Europe that took him to
Dresden (**29**). Architectural evidence
suggests a date around this time and the
handling of the medium is very similar to
that in the view of Dresden that Wyld
exhibited in 1852 (**29**). Wyld painted a
similar view of Prague in oil on canvas.
This was with the Trafalgar Galleries in
1965 (*The Victorian Painter Abroad*).
 Wyld's watercolour shows the panoramic
view of the south of Prague castle
(Hradčany) from the right bank of the
River Vltava. In the right foreground is
Sitkovsky's mill; the Renaissance water-
tower with its impressive Baroque cupola
still survives. On the other side of the river
can be seen the Malá Strana (Little Town)
with its Baroque church of St Nicholas.
One end of the suspension bridge, replaced
at the turn of the century, is visible. The
skyline is dominated by Hradčany and the
silhouette of the Gothic cathedral of St
Guy, seen here before its completion at the
end of the nineteenth century. The view
remains substantially the same today,
although the river is now canalized and
bordered by houses (I am grateful to Dr
Zdeněk Pillǎr, Deputy Director of the
National Gallery, Prague, for information.)
 A View of Prague anticipates the virtuoso
but wooden topographical studies that
Wyld executed towards the end of his very
long life (he died in 1889), but still
possesses much of the vitality which
characterizes his early work. At first glance
the landscape suggests the conventions of
eighteenth-century Wilsonian landscape
with its calm contours, great central
glimmering expanse of water and the very
large feature of a domed tower at the right.
But a closer look reveals a fascination with
foreground texture, a use of colour -
particularly a sharp acid-green and the use
of blue-and-white-striped clothing - that
are quite unlike anything executed in the
eighteenth century and remind us of
Bonington. The painting of a tiny but
clearly present figure in Chinese white on
the opposite bank not only provides the
sense of scale in terms of distance, but also
establishes an essential point of reference in
the scale of colour and tone.

31
The Tuileries Gardens, Paris

Watercolour and bodycolour on white
paper; 21 × 34½ (53.3 × 87.6)
Signed in paint lower left and inscribed
W.Wyld 1858 Paris 94-1896
CONDITION: In excellent condition, the
colours very fresh; the paint stops slightly
short of the mount at the lower edge
PROV: Purchased by the Museum for £40
from Mrs O'Brien of 2, Russell Street,
Bath. Correspondence preserved in the
Museum reveals only that she received it
from her father who had allegedly bought
it 30 years earlier for £100

Although it compares in subject matter
with lithographs in the popular journal of
the period, *L'Illustration*, this work does not
appear to have been engraved or used as
an illustration. However, a similar view of
the Tuileries is plate 17 in a volume of
lithographs by and after Wyld, *Monumens et
Rues de Paris* (1839, V&A E5808-1903).
The large size and high degree of finish
suggest that the watercolour was specially
executed either as an exhibition piece or
for a private patron.

Wyld lived permanently in France, although he retained his British nationality, and he spent much of his life in Paris. Indeed, this work was executed only three years after Wyld had exhibited at the Salon as a member of the French school and won a gold medal for his contribution.

This view of the Tuileries gardens from the Bassin Ronde, looking towards the Arc de Triomphe, must have been very familiar to Wyld. Construction of the Arc, which had begun in 1806 and been abandoned under the Restoration, had been completed between 1832 and 1836. Even before the completion of this landmark, the vista down the gardens had always been one of the most admired and cherished views of Paris. 'C'est surtout au coucher du soleil, dans les beaux jours d'été, que cette perspective est admirable', wrote Marchant in his popular guide to Paris. 'Son coup d'oeil n'est pas moins ravissant, lorsque descendant des hauteurs de la barrière de l'Etoile, on aperçoit au fond de cette allée le palais d'un grand roi.' (F.M. Marchant, *Le Nouveau Conducteur de l'Etranger à Paris*, Paris, 1816, p. 145; this guidebook went into 11 edns. between 1816 and 1851.) By the time Wyld painted this view in 1858 it was one of the standard tourist sights visited by the ever-increasing crowds of English tourists. Unlike many other Parisian gardens (particularly the Bagatelle and Parc Monceau), the Tuileries were never modified to accord with the taste for *le jardin anglais*. The problem of saving the old-style gardens was debated at length in Paris in 1855 (see Paul de Wint, *Essais historiques sur les Jardins*, Paris, 1855). The orange trees in boxes, which were an important feature of the gardens and which are readily visible in Wyld's painting, are no longer there, and the statues have been moved to other parts of the gardens. The large group second from the right and the first group that is visible on the left in Wyld's watercolour may now be seen alongside Ave. Général Lemmonier, facing the Louvre. Otherwise the view remains very much the same today.

This is a work which, even more than others, needs to be seen in the original. Wyld achieves a remarkably rich and naturalistic effect for such a highly worked watercolour. The flat, pale-green paint of the orange-tree boxes provides a carefully articulated contrast to the textured and mottled areas of variegated greens in the trees. The white of the water in the fountains and of the birds that perch on the basin of the foreground fountain and fly over the pool is scraped out. But there is a tendency in these large-scale later works for Wyld to use Chinese white to create highlights. The sky is rubbed and flecked, creating a virtuoso marbled effect akin to that in some of Copley Fielding's big exhibition watercolours. The great strength and originality of this work lies, however, mainly in the treatment of the figures, who range from the detailed family group relaxing over a book in the right foreground to the distant throng of strollers on the far side of the pool. The distant figures are conveyed by blobs and dashes of pure colour; the foreground figures are treated in greater detail but still very impressionistically and without any loss of vitality.

Wyld's evident delight in Second Empire finery and social life anticipates the concern of Manet and his young followers by some five years (Manet's *Musique aux Tuileries*, National Gallery, London, was painted in 1862), whilst the overall mood of the painting, with its larger-than-life curtain of trees beneath which the gods and goddesses of classical antiquity stonily gaze down upon a thronging mass of fashionable society, recalls the park scenes of Fragonard and Hubert Robert. Wyld had travelled extensively in the East and it is, therefore, interesting to note that he has introduced into the shadows beneath the orange tree in the lower left corner, next to his signature, an Arab who is quizzically observed by a small child with a hoop. A number of studies executed in Algeria were in Wyld's studio sale and one of these, a sheet of three washed drawings of Arabs, is preserved in the Fondation Custodia, Paris (cat. no. 7727(3)) (fig. 76). Wyld's studio sale took place in his atelier in Paris on 30 May 1890 and at Hotel Drouot on 30–31 May 1890).

FIG. 76 (for comparison with CAT. **31**) Wyld, *A seated Arab*, watercolour, Fondation Custodia (Coll. F. Lugt), Institut Néerlandais, Paris, $2\frac{7}{8} \times 3\frac{7}{8}$

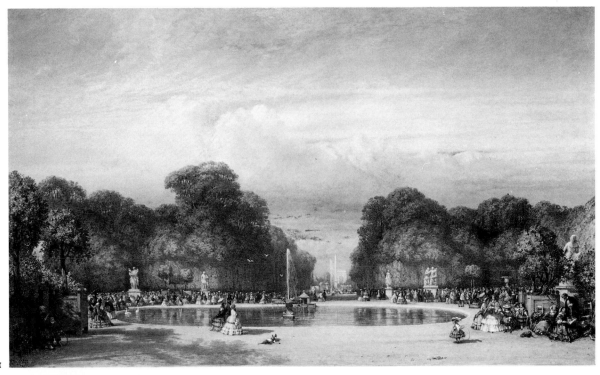

31

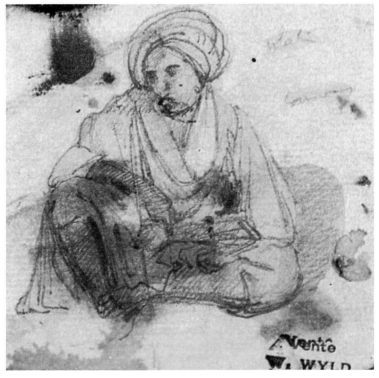

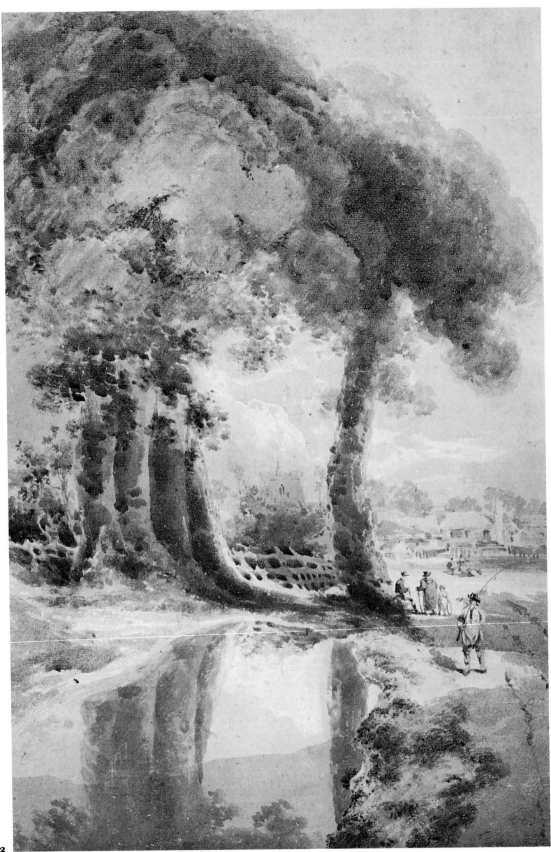

32
A view from Long Pond, Hayes Green, Middlesex

Pencil and watercolour on coarse white paper; $17\frac{1}{4} \times 11\frac{5}{8}$ (44.4 × 29.5)
Inscribed on back of mount in a later hand
Hayes Middlesex Francia
P21-1968
PROV: Herbert Powell, bought by the
Museum from his collection with the aid of
the National Art Collections Fund
EXH: Tate Gallery 1931; Norwich Castle
Museum, 1931; Usher Art Gallery,
Lincoln, 1932; Laing Gallery, Newcastle-
upon-Tyne, 1932; Edinburgh National
Gallery of Scotland 1932; Kircaldy 1933;
Bankfield Museum, Halifax 1933; Ferens
Art Gallery, Hull, 1933
LIT: *Catalogue of the Herbert Powell Collection*,
1931, no. 57, repr. p. 41 of second edn

Francia exhibited a subject with this title
at the Royal Academy in 1805 (495). By
that date he had been exhibiting at the RA
for ten years. The uncertainty of execution
in **32**, especially if it is compared with
other early known and signed works by
Francia (see **3** and **5**) clearly indicates the
hand of a pupil. The pigment is applied in
the Sketching Club manner of building up
a mosaic of flat areas of colour, with the
paper surface remaining untouched for the
lights (as in the patch of sunlight on the
left of the lake). The treatment of the
foliage is, however, very heavy and muddy
when compared with Girtin's and Francia's
signed work and the faint outline in pencil
of a sheep on the far side of the pool is
further evidence that this is not Francia's
own work. Watercolour teachers of the
period set their pupils to copy their work
and this has led to much confusion in
identifying paintings (as, for example, in
the case of Cotman). That Francia was no
exception can be seen by examining a view
near Hayes, executed in 1805, alongside a
pupil's copy of the work.

33
A Deal or Hastings lugger and boats

Pencil and watercolour on white paper laid
down; $12\frac{1}{2} \times 8\frac{7}{8}$ (31.8 × 22.4)
627-1877
(See colour plate between pp. 96 and 97)
CONDITION: Faded
PROV: Samuel Redgrave, his sale Christie's
23-24 March 1877 (291), bought by the
Museum for £3-0-0
EXH: 'Vroege engelse aquarellen', Utrecht,
Centraal Museum and The Hague,
Gemeentemuseum, 1955 (22)

Technically this watercolour depends upon
Francia's methods of marine painting in
granular flat washes and scraped-out lights,
but the uninteresting composition, the lack
of co-ordination between the parts and the
ineptitude in applying the pigment in some
areas (for example, the figure of the man
leaning against the boat is transparent)
indicate that this must be the work of an
imitator or, more probably, a pupil. It is
worth noting that both **32** and **33** come
from distinguished Victorian collections of
British art.

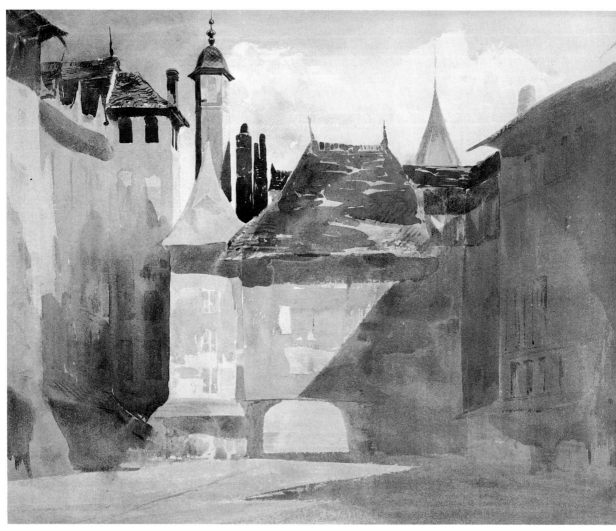

34

34
Place du Molard, Geneva

Watercolour, unfinished: $9\frac{7}{8} \times 13\frac{1}{4}$
(25.0×33.6)
PIO–1956
CONDITION: Good
PROV: Given by Mr Philip Hargreen in
1956

This rudimentary sketch is based on J.D.
Harding's lithograph after Bonington's
Place du Molard (see **23**).

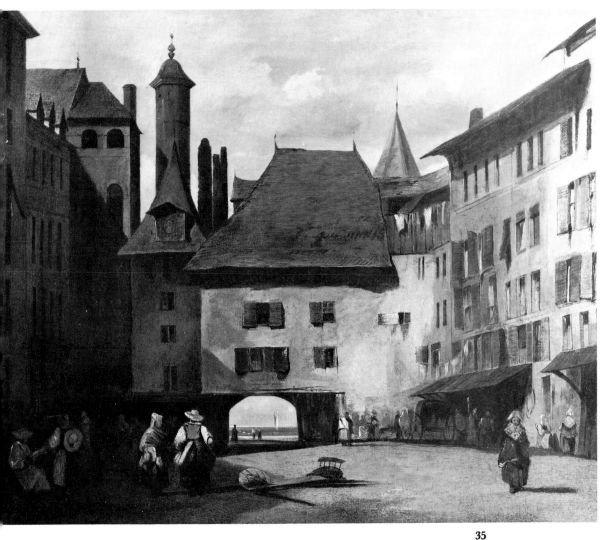

35

**35
Place du Molard, Geneva**

Oil on canvas; $24\frac{3}{4} \times 29\frac{7}{8}$ (62.9 × 75.7)
Signed *Bonington*
CAI 13
CONDITION: Good
PROV: Bequeathed to the Museum by C.A.
Ionides
LIT: AS, p. 112; ill. p. 121; Spencer, no. 421

The painting is heavy and crude, the colour undistinguished and the details of the figures and equipment lack coherence. This work is undoubtedly a copy of J.D. Harding's lithograph after Bonington's *Place du Molard* (see **23**).

ABBREVIATIONS

Spencer Marion Spencer, 'Richard Parkes Bonington (1802–1828). A
 Reassessment of the character and development of his art',
 unpublished Ph.D. thesis, University of Nottingham, 1963.

Spencer exh. *R.P. Bonington 1802–1828*, exhibition catalogue, Castle
 Museum and Art Gallery, Nottingham, 1965.

D&H A. Dubuisson and C.E. Hughes, *Richard Parkes Bonington: his Life
 and Work*, 1924.

AS The Hon. Andrew Shirley, *Bonington*, 1941.

Main exhibitions of Bonington's work

London, Great Russell Street, August 1833, '130 subjects chiefly sketches, the property of Richard Bonington'.

Paris, A. Sambon, 7 Square de Messine, 24 mai–10 juin 1932, 'Exposition d'œuvres inédites de Richard Parkes Bonington et de Sir David Wilkie'.

Paris, M. Gobin, 1936, 'Peintures, aquarelles et dessins de R.P. Bonington'.

London, Burlington Fine Arts Club, 1937, 'R.P. Bonington and his Circle'.

New London, Lyman Allyn Museum, 2 December 1942–3 January 1943, 'An Exhibition of the works of Richard Parkes Bonington'.

Boston, Museum of Fine Arts, 21 March–28 April 1946, 'An Exhibition of Paintings, Drawings and Prints by J.M.W. Turner, John Constable, R.P. Bonington'.

Calais, Musée des Beaux-Arts, 29 juillet–17 septembre 1961, 'L'Aquarelle Romantique en France et en Angleterre'.

London, Agnew's, 26 February–17 March 1962, 'R.P. Bonington'.

Bordeaux, Musée de Bordeaux, 17 mai–30 septembre 1963, 'Delacroix, ses maîtres, ses amis, ses élèves'.

Nottingham, The Castle Museum and Art Gallery, 1965, 'R.P. Bonington, 1802–1828'.

Paris, Musée Jacquemart-André, 1966, 'Bonington: un Romantique anglais à Paris'.

Cherbourg, Musée des Beaux-Arts, 1966, 'Bonington: Les Débuts du romantisme en Angleterre et en Normandie'.

Major public collections

CONTAINING WORKS BY FRANCIA, BONINGTON AND WYLD

Francia's work has tended to attract individual rather than institutional buyers in the sales of the present century. Nevertheless, outside the Victoria and Albert Museum, the most interesting collection of Francia's work is to be found in the British Museum; it includes pencil sketches on the Thames, elaborate views of Ramsgate and Calais, and a fine early work of 1809 (*Transports returning from Spain, February 1809, beating into St Helen's Roads*). In the provinces the Whitworth Art Gallery, University of Manchester; Birmingham City Art Gallery (where there is a fine view of Mont St Michel); and the Cecil Higgins Museum and Art Gallery, Bedford, as well as the Castle Museum, Nottingham and the Ashmolean Museum, Oxford, can offer the visitor the opportunity of examining a range of work by Francia. In the United States, the Yale Center for British Art, New Haven, Connecticut, owns a substantial collection of Francia watercolours, and interesting examples (including a large copy by Francia of Bonington's *On the Coast of Picardy*, now in the Wallace Collection) are to be found in the Huntington Museum and Art Gallery, San Marino, California. Not surprisingly there are rich holdings of Francia watercolours in French museums, particularly at Calais, St Omer and in the Musée Carnavalet in Paris, where a series of interesting late views of Paris are located.

Many art galleries and museums have at least one work attributed to Bonington. But serious students should address themselves to the British Museum in London where, in addition to a sketchbook and many pencil drawings, there is a collection of watercolours including the fine and frequently reproduced view of the Château of the Duchesse de Berry at Rosny and the view in Paris of the Institut from the Quai. The Wallace Collection in Manchester Square houses the single most distinguished and substantial collection of works by Bonington. It includes oils and watercolours, landscapes and historical-genre subjects. There is always a selection on show and the visitor can benefit from viewing these works alongside paintings of the French school by members of Bonington's generation. In the provinces, fine watercolours and oils by Bonington can be seen at the Laing Art Gallery, Newcastle upon Tyne; the Walker Art Gallery, Liverpool; Manchester City Art Gallery and Birmingham City Art Gallery (which owns a view of Paris annotated in a contemporary hand to the effect that it is the artist's last work). There are also rich holdings of Bonington's work in Paris, in the Cabinet des Dessins of the Louvre; in the collection of Fritz Lugt at the Institut Néerlandais and in the Bibliothèque Nationale.

William Wyld was a prolific artist, and as a result of the relatively modest prices asked for watercolours by Wyld, many works by this artist have entered private collections of recent years. There are, nevertheless, substantial numbers of watercolours and drawings by Wyld to be found in public collections. Apart from the royal family, Wyld's British patrons were by and large northern industrialists, therefore the best places to see his work are the Laing Art Gallery, Newcastle upon Tyne; the Whitworth Art Gallery, University of Manchester; and Manchester City Art Gallery. In London, the British Museum owns two elaborate watercolour views. As Wyld lived for the greater part of his life in France his work is also to be found in French collections. However, the relatively small size of the holdings in the Institut Néerlandais in Paris, in the Bibliothèque Nationale, and in the museums of Boulogne-sur-Mer, Calais and Rouen, suggests that many of Wyld's works in northern French museums must have been destroyed, as is the case with his *Vue du Port de Gènes prise des hauteurs d'Albano*, which 'disappeared' from the Musée de la Chartreuse, Douai during the 1914–18 war. There are also undoubtedly many surviving works by Wyld unlocated in collections both public and private in provincial France.

Sales of Bonington's works

NOTE: These entries are reproduced as they appear in the original catalogues, without any correction of inconsistencies of spelling or punctuation.

SALE FOLLOWING BONINGTON'S DEATH

(From a priced copy in the Victoria & Albert Museum.)

Catalogue of the Pictures, Original Sketches, and Drawings of the late much admired and lamented artist, R.P. Bonington; which will be sold by auction, by Mr Sotheby and Son, Wellington Street, Strand, on Monday, June the 29th, 1829, and following Day, at Twelve O'clock.

To be viewed on Tuesday the 23rd, to the time of sale.
Catalogues, price 1/s without which no person will be admitted.

FIRST DAY'S SALE.

Oil Sketches.

	£	s.	d.	
Lot 1. A Sketch in oil, view in the Mediterranean; a ditto, Coast Scene, St Valerie . . . 2	2	4	0	Roberts
2. A ditto, ditto; A ditto, View near Genoa, by a pupil 2	2	4	0	Barnet
3. A ditto, View of the Castle of Erici, on the Mediterranean, *very fine* 1	13	13	0	Heath
4. Ditto, Coast Views, on one pannel . . 2	4	16	0	Colnaghi
5. Ditto, Italian Buildings 1	2	12	0	Tiffin
6. Ditto of Trees near Florence 1	11	11	0	Jones
7. Ditto of Francis I and his Sister . . . 1	2	5	0	Triphook
*** This was a favourite subject with the late R.P. Bonington: he painted several pictures from this sketch.				

Pencil Sketches.

	£	s.	d.	
8. Spirited sketches of Coast Scenery, Shipping, &c. 13	3	3	0	Hinxman
9. Ditto ditto ditto . . . 8	2	12	0	Colnaghi
10. Ditto ditto ditto . . . 9	2	12	0	,,
11. Ditto ditto, *one of which is tinted* . . 9	3	0	0	Hixon
12. Ditto ditto, *and figures* . . . 11	2	12	0	Colnaghi
13. Ditto ditto 11	4	4	0	Bourne
14. Ditto ditto, Ancient Armour, *some tinted* . 8	3	0	0	Colnaghi
15. Ditto ditto, Ancient Armour, from Dr Meyrick's Collection . 6	2	16	0	,,
16. Spirited Sketches of Ancient Armour, from Dr Meyrick's Collection 13	3	8	0	Triphook
17. Ditto ditto, Tombs in Westminster Abbey, &c. . . 5	5	2	6	Colnaghi
18. Ditto ditto, Tombs in Normandy, &c., *some tinted* . . 13	3	5	0	,,
19. Ditto ditto, Ancient Costumes and Gothic Architecture . . 12	2	18	0	Hull
20. Spirited Sketches, *some tinted* . . . 16	4	0	0	Burnet,? or Barnet
21. Ditto ditto, Ancient Costume, &c., *some tinted* 22	2	16	6	Moltino

Oil Sketches (continued).

		£	s.	d.	
22. Coast Scenes, on one pannel . . .	2	3	0	0	Stanfield
23. View in Switzerland, on canvas . . .	1	5	0	0	Colnaghi
24. View of Fort Rouge, Calais	1	5	10	0	Seguier
25. A spirited Sketch of a Land Storm, with a Waggon in the Foreground . . .	1	15	10	0	Tiffin
26. View in Venice, with the Church of St George, *very fine*	1	12	12	0	Moltino
27. Spirited Sketches, in distemper, after *Titian* and *Giorgione*	6	10	0	0	,,
28. Rural Landscape, with Cattle, painted on canvass	1	2	12	0	Colnaghi
29. Coast Scene, on canvas	1	3	3	0	Triphook
30. A Beautiful Sketch of Henry the Fourth's Bedchamber: The King is Sitting in an Arm Chair at the Window, *on canvass*	1	10	10	0	Cattley
31. A pleasing Landscape, with Figures, on canvas	1	3	5	0	Hixon
32. Sketch of the Agony of our Saviour, on pannel	1		11	0	,,
33. A masterly and spirited Landscape, on pannel	1	7	12	0	Tiffin

Water-coloured Drawings.

34. The Vaults of the Cathedral at Basle . .	1	2	12	0	Colnaghi
35. View of the Cathedral of Rouen . .	1	7	0	0	,,
36. View of the Coast at Calais . . .	1	7	10	0	,,
37. Views, Lake of Thoun and Mont Blanc .	2	8	10	0	Tiffin
38. Porch of an Ancient Convent at Beauvais .	1	8	0	0	Cattley
39. Coast Scenes, View of La Férté, &c. .	2	13	0	0	Townshend
40. Street Views, Calais, &c. . . .	2	13	0	0	Mills
41. Sketches of Shipping	3	6	6	0	Roberts
42. Picturesque Sketch of Ancient Buildings at Beauvais	1	14	0	0	Colnaghi
43. View of the Pont des Arts, Paris . .	1	1	6	0	,,
44. View of the Church of Rouen . .	1	9	9	0	Moltino
45. A spirited Sketch, View of a Machine for driving Piles	1	7	10	0	Roles
46. View of the Havre	1	8	0	0	Monro

Water-coloured Drawings, framed and glazed.

47. View on the French Coast . . .	1	4	18	0	Colnaghi
48. Beautifully highly-finished Architectural Drawing	1	4	12	0	,,
49. Ditto, Interior of Henry the Fourth's Bedchamber	1	9	9	0	Roles
50. View of Venice	1	9	5	0	Moltino
51. View of the Ecole des Arts, Paris, in Pencil and Chalk, very spirited .	1	26	10	0	Colnaghi
52. A Beautiful highly-finished Water-coloured Drawing, Entrance to the Port of Havre, with Fishing Boats, &c.	1	9	9	0	Pinney
53. View on the French Coast, in Seppia . .	1	2	2	0	Bourne
54. Ditto ditto, in colours . . .	1	6	10	0	Cattley

Oil Sketches (continued).

		£	s.	d.	
55. INTERIOR OF AN ITALIAN COURT YARD . .	1	3	5	0	Hinxman
56. INTERIOR OF HENRY THE FOURTH'S BED-CHAMBER	1	10	10	0	Colnaghi
57. VIEW ON THE GRAND CANAL, VENICE . .	1	13	0	0	Tiffin
58. DITTO DITTO DITTO	1	8	0	0	Utterson
59. STUDIES OF TREES, NEAR ROUEN, HIGHLY COLOURED	1	10	10	0	Moltino
60. VIEW OF A SEA PORT, WITH SHIPPING . .	1	12	12	0	Townshend
61. INTERIOR OF A CATHEDRAL	1	3	0	0	Colnaghi
62. VIEW IN THE ENVIRONS OF FLORENCE . .	1	8	18	6	Cattley
63. SKETCH OF A SWISS PEASANT GIRL . . .	1	2	5	0	Tiffin

Pencil Sketches (continued).

		£	s.	d.	
64. Spirited Sketches from antient Tombs, *some tinted*.	14	2	2	0	Utterson
65. Coast Scenery, with Shipping . .	3	2	10	0	Blackford
66. Ditto ditto	10	1	15	0	Colnaghi
67. Ditto ditto	5	4	0	0	Hull
68. Ditto ditto, Views of Calais . .	7	5	5	0	Cox
69. Figures and Animals, various . .	9	2	18	0	Vine
70. Antient Buildings in France, &c. . .	5	4	6	0	Blackford
80. [*sic*] Sketches in Switzerland, &c. . .	8	4	4	0	Tiffin
81. Ditto ditto	8	2	8	0	Roberts
82. Ditto ditto	8	4	10	0	Wharncliffe
83. Sketches of Antient Monuments, *some tinted* .	19	1	14	0	Chambers
84. Sketches of Heads from Nature . .	10	5	7	6	Lansdowne
85. Ditto ditto ditto . .	9	3	3	0	Greville
86. Ditto ditto ditto . .	17	3	12	0	?
87. Sketches of Views in Florence, &c. . .	6	6	6	0	Cawdor
88. Ditto of THE RIALTO AND EQUESTRIAN FIGURE AT VENICE, VERY FINE . .	2	7	10	0	Colnaghi
89. Ditto View of Bologna, &c. . .	4	5	17	6	Seguier
90. Ditto VIEW OF VENICE FROM THE LITTLE PLACE OF ST. MARK . . .	1	3	5	0	Cawdor
91. Ditto VIEW OF THE GRAND CANAL AT VENICE, *slightly tinted* . .	1	6	15	0	Hinxman
*** The original Sketch for Mr Carpenter's Picture.					
92. Ditto VIEW OF THE LITTLE PLACE OF ST MARK	1	11	11	0	Cawdor
*** The original Sketch of Mr. Vernon's Picture.					
93. Ditto VIEW OF THE PALACE OF COUNT MAFFEI, AT VERONA . .	1	11	11	0	Seguier
94. Spirited Water-coloured View of Jumieges .	1	5	15	6	Moltino
95. L'ABBAYE ST ARMAND, ON BLUE PAPER, *in chalk and body colour*	1	17	0	0	Mills
96. Tinted Sketch of an Italian Monk . .	1	2	2	0	Roles
97. SKETCHES OF BIRDS, IN BLACK AND WHITE CHALK, VERY SPIRITED . . .	4	6	10	0	Mills

Drawings

			£	s.	d.	
96*.	Subjects, the Storm and the Sylph, *finished in Seppia*	2	1	13	0	Lansdowne
97*.	Sketches, View of Geneva, &c. . . .	7	4	16	0	Wharncliffe
98*.	Coloured Sketches, Swiss Costume . .	2	4	4	0	Roberts
99*.	Finished coloured Drawing, View in Venice, with Shipping	1	6	15	0	Moltino
100*.	Chalk Sketches of Horses, Figures, &c. &c. .	7	7	0	0	Blanchford
100**	Sketches, Views in Verona, &c., *copied from Bonington* . . .	6	1	11	0	Griffiths
98.	Coloured Sketch of a Venetian Costume, after Bellini	1	1	13	0	Grave
99.	Sketches of Females, in coloured chalk . .	2	6	10	0	Townshend
100.	Ditto ditto	3	3	15	0	Irby

Oil Paintings.

			£	s.	d.	
101.	Sketch, interior of an Abbey	1	5	15	6	Colnaghi
102.	Don Quixote in his Study	1	10	10	0	Triphook
103.	Highly coloured Landscape, View in the Gardens of Boboli, at Florence . . .	1	7	0	0	Tiffin
104.	VIEW ON THE GRAND CANAL, VENICE . .	1	16	5	0	Colnaghi
105.	VIEW OF THE RIALTO AT VENICE, *framed* .	1	19	0	0	Townshend
106.	A LARGE LANDSCAPE VIEW IN FRANCE .	1	23	2	0	Cattley
107.	A SCENE FROM THE MERCHANT OF VENICE .	1	9	0	0	Dawkins
108.	A CONVERSATION, WITH FIGURES IN THE VENETIAN COSTUME OF THE 16TH CENTURY .	1	56	0	0	Townshend
109.	VIEW ON THE COAST OF NORMANDY, WITH FIGURES AND CATTLE, framed . .	1	48	0	0	,,
110.	A HIGHLY FINISHED VIEW OF THE PALACE OF COUNT MAFFEI, AT VERONA, WITH RELIGIOUS PROCESSION, A SPLENDID SPECIMEN OF THE TALENTS OF THE ARTIST . . .	1	73	10	0	Marquis of Stafford
			851	4	6	

SECOND DAY'S SALE.

Oil Sketches (continued).

			£	s.	d.	
111.	Studies (two) of Heads, by *a pupil of Mr Bonington*	1	1	0	0	Rumbold
112.	Ditto of Two Females, by *Bonington* . .	1	1	13	0	Hixon
113.	Ditto of Figures, after *P. Verones*, by *ditto*	1	1	18	0	Hinxman
114.	Sketch of the Ruins of a Church at St Omer, *ditto*	1	2	8	0	Byng
115.	Ditto of the French Coast, with Figures, *ditto*	1	4	0	0	Lord Townshend
116.	Ditto of Dieppe Harbour, with Shipping, *ditto*	1	4	6	0	Colnaghi
117.	Ditto, Interior of a Church, *ditto* . .	1	6	10	0	Burney
118.	Sketch, Coast Scene, View of La Ferté, with Figures, by *Bonington*	1	3	15	0	Knapp
119.	Studies of Grecian Costumes, two Figures on one canvass, *ditto*	1	20	0	0	Lord Townshend
120.	Studies of Swiss Costume, ditto, ditto ditto	1	5	10	0	Roberts

Pencil Sketches (continued)

			£	s.	d.	
121.	Studies of Antient Costume, *from Dutch Pictures*, &c.	18	1	18	0	Roberts
122.	Ditto ditto ditto . . .	14	2	8	0	Stanfield
123.	Ditto of Building and Coast Scenery, &c. .	6	4	4	0	Lord Cawdor
124.	Ditto of Views in Switzerland, France, &c. .	5	3	18	0	Thane
125.	Ditto, Views of Honfleur, &c., *very fine* .	2	6	10	0	Seguier
126.	Ditto, View of the Bridge of Louis XVI, and Gothic Tomb	2	4	4	0	Colnaghi
127.	Ditto, Bridge of St. Maurice, and Cottages in Switzerland	3	4	15	0	,,
128.	Ditto, of Gothic Architecture . . .	7	3	15	0	Hull
129.	Ditto of the Town Hall of Ypres, &c. . .	5	5	5	0	Colnaghi

Coloured Drawings.

			£	s.	d.	
130.	An upright Drawing of Craft . . .	1	8	5	0	,,
131.	Ditto ditto Fishing Vessels . .	1	7	17	0	Boone
132.	Ditto ditto ditto . . .	1	8	8	0	,,
133.	VIEW OF THE GARDENS OF BOBOLI, NEAR FLORENCE.	1	13	0	0	Colnaghi
134.	DITTO ON THE FRENCH COAST . .	1	10	10	0	Seguier
135.	PROCESSIONS OF CATHOLIC CLERGY, AND STUDIES FROM VANDYKE . . .	2	5	15	0	Lord Lansdowne
136.	Studies of Shipping	2	4	8	0	Hall
137.	Ditto of Old Buildings, and Swiss Costume .	2	7	15	0	Moltino
138.	Ditto, Views in Switzerland . . .	2	8	5	0	Colnaghi
139.	Ditto Ditto in Beauvais . .	2	6	15	0	Monro
140.	DITTO DITTO MONT BLANC, AND COAST SCENE	2	7	0	0	,,

Pencil Sketches, Views in Italy.

			£	s.	d.	
141.	CITY OF FLORENCE AND GARDENS OF BOBOLI, &c.	4	2	8	0	Hinxman
142.	City of Genoa, and Environs . . .	6	2	0		Byng
143.	Views of Venice, &c.	8	7	17	6	Lord Lansdowne
144.	Views of the Ducal Palace, Venice, &c. .	2	5	7	6	Colnaghi
145.	View of St Mark, St George, Venice, &c. .	4	6	10	0	Lord Lansdowne
146.	Views in Venice, the Ducal Palace, &c. .	3	5	0	0	,, ,,
147.	Ditto ditto ditto, and the Greek Church	2	9	10	0	,, ,,
148.	Ditto ditto, on the Grand Canal, &c. .	3	4	16	0	Colnaghi
149.	A STREET VIEW IN VERONA . . .	1	7	15	0	Lord Cawdor
150.	DITTO, THE MARKET PLACE AT VERONA, ON TINTED PAPER, HEIGHTENED BY WHITE CHALK	1	13	13	0	Lord Lansdowne
151.	Views of Venice, Genoa, &c. . .	3	6	6	0	,, ,,
152.	CASTLE OF FERRARA, AND TOMB AT VERONA .	2	6	15	0	,, ,,
153.	THE CHURCH OF ST MARK AT VENICE, AN UPRIGHT SKETCH, LARGE . . .	1	14	0	0	Colnaghi
154.	THE PALACE OF ST MARK, VENICE, ON COLOURED PAPER, TOUCHED IN WHITE .	1	6	12	0	Lord Lansdowne
155.	THE GRAND CANAL, WITH A DISTANT VIEW OF THE RIALTO, VENICE	1	14	14	0	,, ,,
156.	VIEW OF VENICE	1	6	10	0	Lord Cawdor

Oil sketches (continued).

		£	s.	d.		
157.	SPIRITED SKETCH OF A FRESH BREEZE . .	1	13	13	0	Lord Townshend
158.	DITTO, ON THE COAST NEAR GENOA . .	1	17	0	0	,, ,,
159.	DITTO, PART OF GENOA AND THE BAY .	1	31	0	0	Rogers
160.	DITTO, VIEW OF THE ENVIRONS OF GENOA .	1	11	0	0	Sir T. Lawrence
161.	DITTO, VIEW IN VENICE . . .	1	23	2	0	Hinxman
162.	An upright View of the Church of St Mark, at Venice, *unfinished*	1	18	0	0	Cattley
163.	A Study, Portrait of a Lady . . .	1	6	0	0	Triphook
164.	View of the Port of Havre, with Shipping .	1	2	15	0	,,
165.	A spirited Sketch of a Storm with Shipwreck	1	4	0	0	Tiffin
166.	Portrait of Old Cordier, of Rouen, mending his Net	1	3	7	0	Colnaghi
167.	Interior of a Room	1	14	0	0	Colnaghi

Pencil Sketches (continued).

			£	s.	d.	
168.	Sketches of Costume, &c., *some tinted* .	13	2	0	0	Colnaghi
169.	Ditto, and Studies from Italian Masters .	9	5	15	6	Lord Lansdowne
170.	Ditto ditto	8	2	2	0	Barnet
171.	Ditto ditto	13	2	12	0	Roberts
172.	Ditto of Greek Costume . . .	4	2	12	0	,,
173.	Sketches, Views in Italy . . .	8	3	0	0	Triphook
174.	Sketches, *coloured*, of Coast Scenery, and Part of the Port of Havre	2	11	0	0	Monro
175.	DITTO, FINISHED ON TINTED PAPER, OF A GOTHIC CHURCH AT ROUEN . .	1	6	10	0	Lord Lansdowne
176.	Ditto, Specimen of Antient Architecture .	2	9	0	0	,, ,,
177.	DITTO, TOWN HALL OF ST OMER . .	1	7	0	0	Monro
178.	DITTO, GOTHIC SCREEN OF A CATHEDRAL, *touched with white*	1	5	18	0	Triphook
179.	Ditto, Town Hall at Ypres, and Gothic Fountain at Rouen	2	6	6	0	Colnaghi
180.	Views in Switzerland, an Ancient Chest, &c.	5	6	0	0	Monro
181.	VIEW OF ROUEN, *on tinted paper* . .	1	6	0	0	Carpenter
182.	DITTO OF CALAIS, in Seppia . . .	1	3	15	0	Hastings
183.	DITTO OF FORT ROUGE, CALAIS, *on coloured paper, touched with white* . . .	1	5	15	0	Colnaghi
184.	Archway, *on tinted paper, touched with white* .	2	6	0	0	Thane
185.	Antient Buildings in France . . .	12	13	0	0	Lord Lansdowne
186.	DITTO, HOTEL AT DIEPPE, AND GOTHIC PORCH AT ROUEN	2	9	5	0	Colnaghi
187.	ANTIENT BUILDINGS	2	6	12	6	Utterson
188.	DITTO GATEWAYS	2	8	0	0	Lord Lansdowne
189.	PALAIS DE JUSTICE AT ROUEN, *fine* . .	1	8	18	6	,, ,,
190.	VIEW OF ABBEVILLE, ON COLOURED PAPER, *touched with white, and coloured* . .	1	20	0	0	Lord Townshend
191.	THE ABBEY OF ST AMAN, *highly finished in colour*	1	24	3	0	Lord Lansdowne

Framed and Glazed Drawings, varia.

			£	s.	d.	
192.	Holy Family, after *Titian, highly finished in colour*	1	2	2	0	Hull
193.	A Subject from Italian History, *highly finished in colour*	1	6	10	0	,,
194.	Views in Switzerland, in one frame . .	2	5	15	0	Colnaghi

		£	s.	d.		
195.	VIEW OF THE CHURCH OF ST MARK, AT VENICE, *water colour, no frame* .	I	21	10	0	Colnaghi
196.	DITTO OF THE DUCAL PALACE, VENICE, *in water colour, no frame* . . .	I	19	0	0	Seguier
197.	VIEW IN SWITZERLAND, *coloured, no frame* .	I	3	10	0	Monro
198.	VIEW OF A WATER-FALL IN SWITZERLAND, *coloured, no frame* . . .	I	4	0	0	,,
199.	MOUNTAINOUS VIEW IN SWITZERLAND, *coloured no frame*	I	6	10	0	Hull
200.	VIEW OF LA FERTÉ, *coloured, no frame* . .	I	6	10	0	,,
201.	DITTO OF PARIS, *on tinted paper touched with white* (THE LAST PRODUCTION OF BONINGTON) [See Lot 54, p. 180], *no frame* . . .	I	24	0	0	Seguier
202.	DITTO IN ITALY, *highly finished in colours, no frame*	I	8	0	0	Moltino
203.	DITTO OF THE PALACE OF THE TUILLERIES, *highly finished in colours, no frame* . .	I	16	0	0	Seguier
204.	DITTO, STUDIES OF TREES, *highly finished in colours, no frame*	I	5	10	0	Tiffen
205.	DITTO OF PARIS AND TUILERIES, *highly finished in colours, no frame* . .	I	12	0	0	Colnaghi
206.	DITTO, RIVER SCENE, *highly finished in colours, no frame*	I	9	0	0	Cattley
207.	DITTO, INTERIOR OF A CHURCH AT MILAN, *highly finished in colours, no frame* .	I	11	11	0	Hull
208.	DITTO, FRUIT AND FLOWER PIECE, *in coloured chalk, framed*	I	7	0	0	,,
209.	DITTO OF THE PONT ROYAL, *highly finished in colours, framed*	I	18	18	0	Laurence
210.	DITTO, HENRY IV IN HIS BED-CHAMBER, *highly finished in colours, framed* . .	I	15	0	0	Lord Lansdowne

Oil Paintings (continued).

		£	s.	d.		
211.	VIEW OF THE PORT OF HAVRE . .	I	35	0	0	Lord Townshend
212.	DITTO, INTERIOR OF A CHURCH AT MILAN .	I	32	11	0	,, ,,
213.	DITTO, ENVIRONS OF FLORENCE . .	I	32	6	6	Glynn
214.	DITTO, BRIDGE OF RIALTO . . .	I	30	9	0	Moltino
215.	DITTO, DUCAL PALACE, VENICE . .	I	18	10	0	Glynn
216.	DITTO OF THE RIALTO . . .	I	22	1	0	Barnet
217.	DITTO OF A CASTLE IN THE MEDITERRANEAN	I	30	9	0	Laurence
218.	DITTO ON THE GRAND CANAL, VENICE . .	I	52	10	0	Townshend
219.	DITTO ON THE COAST, WITH FISHERMEN, &C., *framed*	I	14	0	0	Colnaghi
220.	DITTO OF VENICE, *a finished picture, framed* .	I	53	11	0	Townshend
221.	A CABINET PICTURE, MOTHER AND CHILD AT PRAYER, *in carved frame* . . .	I	105	0	0	Seguier
222.	A HIGHLY FINISHED PICTURE, FROM SIR W. SCOTT'S NOVEL OF QUENTIN DURWARD, *framed*	I	94	10	0	Bone
223.	PICTURE OF HENRY, KING OF FRANCE, RECEIVING THE SPANISH AMBASSADOR, *in gilt ornamented frame* . . .	I	84	0	0	Colnaghi

*** This picture was exhibited at the Royal Academy in the year 1828.

Miscellaneous.

			£	s.	d.	
224.	A Sword, Pistol, Steel Breast-Plate, and various Pieces of Antient Leather, &c. . .		1	5	0	Pickersgill
225.	A Suit of Steel Armour, *not quite perfect* . .		4	12	0	Stanfield
226.	A French Carved Frame, *fresh in gold*, 53–40 . 1		2	16	0	Triphook
227.	Ditto *ditto* 63½–44 . 1		2	14	0	Colnaghi
228.	Parcel of odd Plates, Histoire de l'Art par Les Monumens		1	14	0	Pickersgill
229.	A Gilt Frame, in 4 compartments . . .		1	1	0	Sotheby
230.	Ditto in 5 ditto		2	2	0	,,
231.	Ditto in 4 ditto		1	11	0	Hull
232.	Ditto in 4 ditto			18	0	Sotheby
233.	Ditto in 5 ditto		1	3	0	,,
234.	Ditto 27 inches by 21, *glazed* . .			16	0	Lansdowne
235.	Ditto 24 inches by 17, *ditto* . .			11	0	Sotheby
236.	Ditto 17 inches by 14, *ditto* . .			12	0	,,
237.	Ditto in 4 compartments, each 26 × 18, *glazed*		1	5	0	Colnaghi
	Ditto			9	6	Brown
	Total . . .		2296	6	0	

Colnaghi was by far the largest buyer, with 47 lots, two of which were frames. Lord Lansdowne came next with 21 lots, one of which was a gilt frame. His purchases included 68 items, the most important of which were probably the 'drawing highly finished in colours,' lot 210, Henry IV in his Bed-chamber, costing £15, and The Abbey of St Aman, lot 191, 'pencil, highly finished in colour,' costing 23 guineas.

SALE FOLLOWING THE DEATH OF BONINGTON'S FATHER.

A Catalogue of the Collection of Exquisite Pictures, Water-Colour Drawings, and Sketches of that celebrated painter, the late Richard P. Bonington, Collected by, and the Property of, his Father; Consisting of the celebrated Picture of Henry III of France receiving the Spanish Envoy; a scene from Quentin Durward; the Rialto at Venice, a charming picture; a View on the Seine, &c.: among the Water-Colour Drawings are some Historical Subjects, Sea Views, and Coast Scenes with Shipping; Views in Paris, Rouen, Abbeville, Dives, Honfleur, and other Towns of France and Italy: the Sketches comprise Views in Normandy and other parts of France, in Pencil and Chalks; two beautiful Views in Venice, and some characteristic Studies of French Figures: The whole forming a beautiful display of the brilliant talents of this extraordinary Painter: Which will be Sold by Auction, by Messrs. Christie, Manson, and Christie, at their Great Room, King Street, St James's Square, on Friday, May the 23rd, 1834, and following day, at one o'clock precisely.

May be viewed two Days preceding, and Catalogues had at Messrs. Christie, Manson, and Christie's Offices, King Street, St James's Square.

Loose Leaf insertea.

The two following Pictures are the Property of a Person of Rank, and will be sold after Mr Bonington's Pictures on Saturday, May 24, 1834.

Bonington 1. A VIEW OF BEACHY HEAD FROM THE SHORE.

Ditto 2. A VIEW OF THE BAY OF GENOA, *a brilliant and very capital little picture.*

FIRST DAY'S SALE.

Prints.

Lot 1. A portfolio containing twenty-seven artist's prints after Rubens, &c.

 2. Thirteen academy figures.

 3. Lord Byron, after Phillips; Francis I.; and thirty-three portraits of kings, &c.

 4. Twenty-two Foreign and English topography.

 5. The Surprise, after Maes, and thirteen more illustrations, &c.

 6. Sixteen French lithographic of views and figures.

 7. Philippo Lippi, and Les Enfans surpris par l'orage, after De la Roche, mezzotinto.

 8. Turner's marine views, plates 1 and 2, *India proofs.*

 9. Cumberland's designs, and Ackerman's and Rodwell's drawing books.

 10. Cook's views in Suffolk, Part I.

 11. Turner and Girtin's river scenery.

Works of the Late R.P. Bonington.

Sketches.

Lot 12. Six pen and ink sketches of figures, in one frame.

 13. The Storm, a vignette in bistre.

 14. View of the Lake of Brienne, with figures, in sepia.

 15. View on the French coast, and a river-scene in black chalk, and a view of Salinette, in pencil.

 16. Six slight studies of boats, &c., in black lead.

 17. Six ditto.

 18. French cottages on the bank of a river, in black and red chalk, and a coast-scene.

 19. Six small views of Calais and Forte la Rouge, in chalk and pencil.

 20. Ten studies of vessels and boats, in pencil.

 21. Six small sketches, with shipping, at Caen, Trouville, Rouen, &c., in pencil.

 22. Eight small studies of vessels and boats, in pencil.

 23. A heath-scene, in bistre.

 24. Seven sketches of figures, in pen and ink.

 25. Five studies of pea fowls.

 26. View of the town of Berne, with figures, bistre.

 27. Ann Page and Slender, vignette in bistre.

 28. An English landscape, in bistre.

 29. Prospero and Ariel, sepia.

Lot 30. A view on the Thames.
 31. A rough sea off a coast, with boats in the distance.
 32. View of Lillebonne, sepia.
 33. View of the entrance of La Havre, with boats and figures.
 34. Views of the churches of St Ouen, Jumieges, Lillebonne, and one other in Nor-
 mandy, pencil sketches.
 35. View of the quay at Havre, ad one at Honfleur, in pencil.
 36. View in the harbour of La Ferté, with a cutter and other vessels, in black lead on
 yellow paper.
 37. An owl, in black lead.
 38. La Chapelle de St Hay at Bruges, – *a beautiful pencil Sketch.*

Pencil Sketches.
Lot 39. Four pencil sketches of Landscapes.
 40. Four ditto.
 41. Four ditto, a view of Salinette, &c.
 42. Four pencil sketches of French peasants.
 43. Five ditto of French fishermen, &c.
 44. Five ditto of Swiss peasants, &c.
 45. The wreck, – a sketch in pencil and Indian ink.
 46. An academy figure, in black and white chalk on gray paper.
 47. Study of a figure in the picture of 'the Lute,' and one other in black chalk.
 48. A female figure, – an academy study in black and white chalk on drab paper.
 49. View of the windmill at Montmartre, in black chalk.
 50. Part of the Palais de Justice at Rouen, in black lead on drab paper, and one other.
 51. A sketch of French fishermen, in black and white chalk on drab paper.
 52. Ditto of French peasant girls, in red and white chalk.
 53. View of the church at Dives, at Louviers, and one other, sketches in pencil.
 54. View of the Abbey at Graville, buildings at Dives, and one other – pencil sketches.
 55. A subject from Quentin Durward, in black lead.
 56. A sea-shore, with a wave breaking in among some piles, black and white chalk
 on drab paper.
 57. A sketch of figures of French sailors, in black and red chalk.
 58. A sea-shore, with a cart and figures, in black and white chalk on blue paper.
 59. Grotesque ornaments of a house at Beauvais, and two architectural ornaments of
 a church at Caen.
 60. View of an old house at Caen, and of a church-tower at Gisors.
 61. Views of Salinette and Honfleur, and one other, pencil sketches.
 62. A pair of river-scenes, in black lead on drab paper, and one other.
 63. Views of Vache Noire, Trouville, and Ourticham [?Ouistreham], in black lead.
 64. Five studies of French peasants, in black lead.
 65. Five ditto.
 66. Two of French fishing boys, in black chalk on drab paper.
 67. Two ditto, in black and red chalk.
 68. Five small studies of French peasants, in black lead.
 69. View of the valley and church of Unterlaken, and a river-scene, on drab paper.
 70. View of a tower near Unterlake, a river-scene, and a cat's head, on gray paper.
 71. View of the Grand Canal and Rialto at Venice, with vessels and figures, in black
 lead.
 72. A pair of coast views, in black and white chalk on drab paper.
 73. Three studies of sea-shores, with shipping, on drab and blue paper.
 74. VIEW OF THE GRAND CANAL AND THE RIALTO AT VENICE, in black lead, heigh-
 tened with white, – *very carefully finished.*
 75. VIEW ON THE GRAND CANAL AT VENICE, with boats and figures, – *a beautiful*
 drawing in black lead.

 End of the First Day's Sale.

Second Day's Sale.

Drawings in Water Colours.

Lot 76. Study of a subject from the history of the Medici.
- 77. A man in a punt angling.
- 78. The companion, – *small*.
- 79. A view at the mouth of a French river, with boats and figures.
- 80. Sketch of a lady in Spanish dress.
- 81. View of the harbour of Honfleur, with boats and figures.
- 82. French fishing boats, with figures at a jetty.
- 83. A road-scene, with trees, – *upright*.
- 84. View near Dover, with boats.
- 85. View of Mont Valérien, from the road to St Cloud, – *small*.
- 86. A Sea-piece, with boats and figures on a pier-head.
- 87. View of the village and harbour of La Ferté, with the trunk of a tree in the foreground.
- 88. A harbour scene, with a ship moored near a stone jetty.
- 89. View of the village of La Ferté, with figures landing from a boat.
- 90. Old houses at Canterbury.
- 91. Entrance to a chateau.
- 92. View of the harbour of Honfleur, with vessels and figures in the foreground.
- 93. Casks and still life.
- 94. Portrait of a lady, in crayons.
- 95. Fishing boats, with figures, at a pier.
- 96. View at Honfleur.
- 97. View of the cathedral and town of Rouen, from the river; twilight.
- 98. View on the coast near Boulogne, with figures raising stone.
- 99. An Italian landscape, with figures dancing.
- 100. A sea-shore, with a fishing boat and buildings in the distance; evening.
- 101. French fishing boats in harbour.
- 102. View of Rouen from the river, *with capital sunny effect*.
- 103. View in a valley in Switzerland, with mountainous distance, and figures making hay in the foreground.
- 104. The gateway of a cloister.
- 105. A French river-scene, with a fishing boat, – *small upright*.
- 106. A study of two Swiss peasant girls, and one of horses and minute figures.
- 107. Two studies of French fishing boys, – *full of character*.
- 108. View on the Pont des Arts at Paris, *with capital effect of evening sun*.
- 109. Peasants with a cart and a grey horse halting at the door of a village inn, – *admirably coloured in the manner of Isaac Ostade*.
- 110. View on the coast near Dunkirk, with fishing boats and figures on the beach preparing to go out, – *with rich effect of evening sun*.
- 111. View of Versailles from the gardens, a sketch.
- 112. A water-mill at Charenton, with trees on the bank of a river, – *treated with great effect*.
- 113. View of the Cathedral of Dives, with a religious procession entering the gateway, – *a capital drawing*.
- 114. View of a Street, with the Cathedral of Abbeville, and numerous market figures, with a powerful effect of afternoon sun, – *a grand drawing*.
- 115. A subject from the Arabian Nights; a Persian princess on an ottoman, with an attendant at her feet, – *a capital finished drawing*.
- 116. A view on the coast, with a fishing boat drawn up on the shore, and fishermen, – *illumined with a brilliant effect of evening sun*.
- 117. View of the Institute at Paris, with figures, – *a capital drawing*.
- 118. A knight in armour, with a lady and a fortune-teller, – *full of character*.
- 119. A Knight attended by two Pages, at a table covered with yellow drapery, – *a capital drawing*.

Lot 120. INTERIOR OF A CHURCH, with knights at their devotions, and three figures kneeling at the door, – *very rich in colour and effect; the companion.*

121. Henry VIII. with Wolsey receiving a Spanish envoy in armour, – *a brilliant little drawing.*

122. The remonstrance; an old woman admonishing two children.

123. A SCENE FROM THE ANTIQUARY, – *a beautiful drawing.*

124. View of the Pont des Arts, at Paris.

125. A sea-shore, with a fishing vessel drawn up on the beach and a ship in the distance, some figures to the left, – *a capital drawing.*

126. A RIVER-SCENE, WITH DUTCH FISHING BOATS moored near a jetty, – *a brilliant and beautiful specimen.*

127. View on the coast near Calais, with numerous fishing boats and figures, – *with beautiful effect of evening sun.*

128. A LANDSCAPE, WITH A WAGGON descending a hill in a storm, – *this drawing has always been considered one of his finest productions.*

Pictures.

Lot 129. Fishing smacks at anchor, a sketch.

130. A sea-shore, with cliffs and buildings.

131. A harbour with vessels, sun-set.

132. View near Venice, with vessels, sun-set, *a very clever slight sketch.*

133. A river-scene, with a wooden jetty and children in a boat.

134. View of the canal and the church of St Maria Maggiore, at Venice.

135. Portrait of a Venetian girl in a yellow dress.

136. View of the cathedral and town of Rouen, from the opposite side of the river, with admirable effet of sun-set, a sketch.

137. View on the Seine near Rouen, with vessels and figures.

138. A view near Newhaven, with Beachy Head in the distance, and figures in the foreground, – *very powerfully painted.*

139. View of Rouen from the opposite side of the river, with blocks of stone under some trees on the quay.

140. A sea shore with cliffs, and a brig aground, and a man with two horses in the foreground.

141. View of the Pont des Arts from the quay of the Louvre, – *a capital sketch.*

142. Fishermen with a donkey on a flat shore, a village in the distance.

143. A view on the Seine, with barges, – *beautiful effect of morning.*

144. A sea piece, with a schooner and a man-of-war in the distance; *upright.*

145. VIEW OF THE RIALTO AT VENICE, with vessels, gondolas, and figure, – *a beautifully clear picture.*

146. A SUBJECT FROM QUENTIN DURWARD, – *drawn with admirable character.*

147. VIEW ON THE SEINE, with a barge and figures near a group of trees on the bank; evening scene, – *a beautiful picture.*

148. VIEW OF THE GRAND CANAL AT VENICE, looking up to the Rialto, with vessels and figures, – *an exquisite picture.*

149. HENRY III. OF FRANCE RECEIVING THE SPANISH ENVOY, – *the celebrated picture.*

FINIS.

SALE FOLLOWING THE DEATH OF BONINGTON'S MOTHER

Catalogue of a Collection of Original Sketches, in pen and ink, and pencil; Highly Finished Drawings, in water colours and sepia; and Cabinet Pictures, of that much admired and lamented Artist, R.P. Bonington, the property of the late Mr Bonington, Sen. Also, some beautiful Water-Colour Drawings, by Distinguished Artists, which will be sold by auction by Mr Leigh Sotheby, at his house, 3, Wellington Street, Strand, on Saturday, the 10th of February, 1838, at twelve o'clock.

Conditions of sale . . .

ADVERTISEMENT

The present collection of the works of the late admirable artist, R.P. BONINGTON, is to be sold by order of the relatives of his deceased Parents, by whom the various specimens in it were selected, as reminiscences of the highly gifted talent of their son, previous to the sale of his productions, which took place in Wellington Street in 1829.

The admirers of this truly distinguished Artist will here find much to gratify them, while the collectors of his works will be enabled to add some beautiful specimens to their cabinets.

The collection contains many specimens of his early works, which, though not possessing the same depth of feeling and beauty of his later productions, are well worthy a place in the portfolio and cabinet of the collector. Among these, some few will be recognized as having been, within a few years, offered for sale by auction, by order of the late MRS BONINGTON. This circumstance is alluded to, in consequence of many copies of his works appearing at the same sale, which tended much to the injury of this lamented artist.

In this Catalogue will be found, a collection of Copies made by the late MR BONINGTON, from the productions of his son. These are marked as such, and are now brought forward with the view of showing the great mechanical talent of the copyist, and the surpassing beauty and power of the original.

Wellington Street, Feb. 1, 1838.

CATALOGUE

Sketches and Studies, in Pen and Ink, Pencil and Colours

Lot 1. Peter the Hermit preaching to the Crusaders, sketched by R.P. Bonington, when fourteen years and a half old; also five other sketches of Battle Pieces and Shipping, *pen and ink.* 6

 2. A district Map of Nottingham, *drawn at an early age,* for the Election Committee in the Whig interest, *very interesting and curious,* and two smaller Maps. 3

 3. Early designs and sketches, *pencil, pen and ink, and colours.* 9

 4. Academical Studies, *pencil.* 9

 5. Two Designs for Pictures, and other Sketches, *pencil,* &c. 11

 6. Sketches and Studies, *pencil.* 13

 7. Landscapes, *pencil, sepia,* &c. 13

 8. Venetian and other Costume, *pencil, spirited.* 10

 9. Studies of Figures, *pen and ink, spirited.* 5

 10. A sheet having thereon very many studies of Female Figures, Heads, &c. *very spirited, pen and ink.* 1

 11. Studies for Shylock, and Female Figures, on two sheets, *very spirited, pen and ink.* 2

 12. Portrait of a Lady, in three positions, *pen and ink.* 3

 13. Sketches of Female Heads, Heads of Monkies, &c. *pen and ink,* very spirited. 8

 14. Two Designs for Pictures, *sepia;* Gateway, *pencil,* and Ancient Armour, *chalk.* 4

 15. A Study for a Picture, *colours,* and Sketch of Calais. 2

 16. Vessels at the Wharf, and Study for a Landscape. 2

 17. AN ALBUM, containing upwards of NINETY ORIGINAL DRAWINGS, STUDIES and SKETCHES, in CHALK and PENCIL, *all by the late R.P. Bonington.*

 *** This is a very interesting volume, in which the admirers of this admirable artist will find the original sketches of many subjects from which his finished drawings were made.

FINISHED DRAWINGS, IN SEPIA, MOUNTED WITH GLASS

Lot 18. Robinson Crusoe, *interesting as being the artist's first design, drawn at a very early age.*
19. Christ casting out the Money Changers, *an original design, at an early age.*
20. Queen Catherine, *design from Shakespeare.*
21. Another Design from Shakespeare.
22. The Finding of Gessner's Tomb.
23. Storm coming on.
24. St Valery.
25. Landscape, with Sheep in the foreground.
26. Dieppe Harbour.
27. View on the Rhine [wrongly described].
28. Sea View, with Fishing Boats in the foreground.
29. View on the Seine, Rouen in the distance.
30. View on the Seine.
31. Fort Rouge, Calais.
32. The DROWNED FISHERMAN.
33. LANDSCAPE, with Female Figures in the foreground, and Abbeville in the distance.
34. A Study from Shakespeare.
35. STUDY FOR A PICTURE, two figures, Venetian Costume.
36. MARY DE MEDICIS and LOUIS THE THIRTEENTH.
37. FAUST and MEPHISTOPHILES.
38. Sea Shore, *sketch in chalk.*
39. A Landscape, with Water, *pencil.*
40. Sea Shore, with Fishing Boats and Figures in the foreground.

FINISHED DRAWINGS IN WATER COLOURS

Some with Glasses, and others framed and glazed

Lot 42. Scene from one of Sir Walter Scott's Novels.
43. An Interior, comprising a Family Party with many Figures, *an early drawing.*
44. View near the Harbour of Boulogne, with Figures raising stones, *an early drawing.*
45. Sea View, with Figures and Fishing Boats in the foreground, *an early drawing.*
46. Sea Shore, with many Figures in the foreground, and Shipping coming in and going out, *an early drawing.*
47. View of St Valery, on the French Coast, with Boats and Figures in the foreground, *an early drawing.*
48. View of the Harbour at Harfleur, with Vessels and Figures, *an early drawing.*
49. View on the Soane, *unfinished.*
50. View of Paris, *unfinished.*
51. View in Switzerland.
52. View of Havre.
53. View of Rouen.
54. COAST SCENE, with SMUGGLERS landing the Goods.
 *** This was the last drawing made by the artist. [See Lot 201, page 172].
55. VIEW IN PARIS, with many Figures.
 *** The late Mrs Bonington was offered one hundred guineas for this specimen of her son's highly gifted talents.
56. VIEW OF VENICE, with Shipping in the foreground.
57. READING THE BIBLE.
 *** It was from this drawing the Artist made his large picture.
58. LOUIS XI, ISABELLE DE CROYE, and QUINTIN DURWARD, from Sir Walter Scott.
59.*View on the Seine, *in coloured chalks.*

59. Two SCRAP BOOKS, containing ONE HUNDRED AND FIFTEEN ENGRAVINGS IN LITHOGRAPHY, from the WORKS OF R.P. BONINGTON, comprising those drawn on stone by himself in Paris – those published by Harding and others.

Lot 60. PORTRAIT OF NAPOLEON, an admirably executed miniature, in colours, by LE-
 COUR.
 *** This portrait was taken immediately after the return of Napoleon from
 Elba, and is highly characteristic.

WATER COLOUR DRAWINGS BY VARIOUS ARTISTS

		Lot	
Grenier	. . .	61.	A Soldier on the Look out, and Turk and Attendant, *both sepia.*
Charlet	. . .	62.	A Study, and a Battle Scene, by Gudin, *both sepia.*
Joly	. . .	63.	Two Sketches, *in sepia;* a Sketch, by Larom, and another.
Cox D.	. . .	64.	View on the Dorset Coast.
Mornier [? Monnier]	.	65.	Shipping.
Boys	. . .	66.	View on the French Coast.
Holland	. . .	67.	View on the Medway.
Isabey	. . .	68.	Shipping, St Michael's Mount in the distance.
Parke	. . .	69.	Shipping.
Stone	. . .	70.	Juliet.
Stothard	. . .	71.	The Monk.
Buchard	. . .	72.	Rebecca.
Prout	. . .	73.	View on the Rhine.
Brockedon	. . .	74.	View of Philadelphia.
Barrett	. . .	75.	Classical Landscape.
Varley	. . .	76.	Pont Mer, Glass Lynn.
Boys	. . .	77.	View near Rouen.
Isabey	. . .	78.	Shipping.
Linton	. . .	79.	Classical Composition.
Holland	. . .	80	Woody Dell.
Phillips	. . .	81.	Mountain Scenery.
Dibdin	. . .	82.	View of Damascus.
Brockedon	. . .	83.	View of Syria.
Bentley	. . .	84.	Landscape Scenery.
Cooke, Elder	.	85.	View on the Kentish Coast.
Bentley	. . .	86.	Looking towards Folkestone, near Dover.
Parke	. . .	87.	Shipping.

COPIES FROM THE DRAWINGS OF R. P. BONINGTON MADE BY THE LATE MR BONINGTON,
SENIOR

Lot 88. Three Figures in chalk, and three small drawings in colours.
 88.*Boats near a Pier, with Figures looking out, and Bay of Naples [wrongly de-
 scribed].
 89. Sea View, with Figures and Fishing Boats in the foreground, *copy of No. 45.*
 89.*View near Boulogne, with Figures raising Stone, *copy of No. 44.*
 90. View of St Valery, *copy of No. 47.*
 90.*Sea View, Storm blowing up.
 91. Sea Shore, with Fishing Boats and Figures, *copy of No. 28.*
 91.*The Drowned Fisherman, *copy of No. 32.*
 92. Sea Shore, with Fishing Boats and Figures, *copy of No. 46.*
 93. Dieppe Harbour, *copy of No. 26.*
 94. Sea View, with Boats and Figures.
 95. Coast Scene, with Smugglers, *copy of No. 54.*
 96. Louis XI, &c. from Sir Walter Scott's Novel of Quentin Durward, *copy of No. 58.*

SKETCHES AND FINISHED PAINTINGS IN OIL BY R.P. BONINGTON

Lot 97. Two copies from French Historical Subjects, *very early specimen.*
 98. The Holy Maid of Kent, *sketched* 1818.
 99. A Composition, *early specimen.*
 100. Jephtha and his Daughter, *unfinished.*
 101. A Copy after Fetti.
 102. A Sketch for a Picture.
 103. Another Sketch.
 104. Design from Macbeth.
 105. Portrait of a Foreigner playing the Violincello.
 106. Another Portrait.
 108. Two Portraits of Venetians, *studies.*
 109. A Female in Venetian Costume, *a study.*
 110. The Artist with his Portfolio.
 111. The Finding of Gessner's Tomb.
 112. A Composition.
 113. The Water Mill.
 114. Elizabeth and the Virgin Mary, after Rubens.
 115. A Landscape, *unfinished.*
 116. A Portrait, study after nature.
 117. The Raising of Lazarus, *after Rembrandt.*
 118. An Interior, with many Figures.
 *** This picture was painted in March 1818. It may be considered as one of the earliest of the Artist's productions in oil. It has great merit.
 119. A small Landscape.
 120. Sea View, two Figures in the foreground regarding the Body of the Drowned Sailor.
 121. Lago Maggiore.
 122. A View in Piedmont, Switzerland.
 123. A LANDSCAPE, with Figures in the foreground, Peveril [?Pevensey] Castle in the mid-distance, and Beechy Head in the background.
 124. A VIEW OF VENICE, with Vessels in the foreground.
 125. PORTRAIT OF A FAVOURITE DOG, *not varnished.*
 126. VIEW IN SWITZERLAND, River Scene, with Bridge, Buildings and Figures.
 127. VIEW ON THE SEINE, with Boats.
 128. QUENTIN DURWARD. The original from which the large picture was taken.
 128.*An Outline in pencil for a Picture, *on canvas.*
 DRAWINGS AND PAINTINGS, BY THE LATE MR BONINGTON, SENIOR.
 129. Two Portraits, and three others.
 130. Four Landscapes, *in colours,* and two, *in indian ink.*
 131. Six small Landscapes, *in colours.*
 132. Two Landscapes, *in oil.*
 133. Another.
 134. Study of Fruit.

————

 135. A Group of Cupids, by Boucher.

————

 136. The Colour Box, formerly the property of R.P. Bonington, containing many colours, brushes, and other necessary implements for drawing.
 137. Two boxes with various coloured chalks.
 138. Two drawing boards.
 139. Sundry frames for pictures.
 140. Others.

FINIS.

Select bibliography

ADHÉMAR, J., 'Les Lithographies de paysage en France à l'époque romantique', *Archives de l'Art français*, 19, 1935-7.

BLANC, C., *Histoire des Peintres de toutes les Ecoles*, 'L'Ecole Anglaise', by M.W. Burger, Paris, 1872.

BORDEAUX, MUSÉE DE BORDEAUX, *Delacroix, ses maîtres, ses amis, ses élèves*, 17 mai-30 septembre 1963.

BOUVENNE, A., *Catalogue de l'Oeuvre gravé et lithographié de R.P. Bonington*, Paris, 1873.

CALLOW, W., *William Callow, An Autobiography*, ed. H.M. Cundall, 1908.

CALTON, R.B., *Annals and Legends of Calais*, 1852.

CHERBOURG, MUSÉE DES BEAUX-ARTS, *Bonington: les débuts du romantisme en Angleterre et en Normandie*, 1966.

COHN, M.B., *Wash and gouache: A Study of the Development of the Materials of Watercolour*, The Center for Conservation and Technical Studies, Fogg Art Museum and the Foundation of the American Institute for Conservation, 1977.

CUNNINGHAM, A., *The Lives of the Most Eminent British Painters, Sculptors and Architects*, 1829-32.

CURTIS, A., *L'Oeuvre gravé et lithographié de R.P. Bonington*, Paris, 1939.

DELESTRE, J.B., *Gros et ses ouvrages ou memoires historiques sur la vie et les travaux de ce célèbre artiste*, Paris, 1845.

DORBEC, P., *L'Art du paysage en France*, Paris, 1925.

DORBEC, P., 'Les paysagistes anglais en France', *Gazette des Beaux-Arts*, 1912.

DUBUISSON, A., 'L'influence de Bonington et de l'école anglaise sur la peinture de paysage en France', *Walpole Society*, 1912-13.

DUBUISSON, A. and HUGHES, C.E., *Richard Parkes Bonington: his Life and Work*, 1924.

EDWARDS, R., 'Richard Parkes Bonington and his Circle', *Burlington Magazine*, 1937.

FERGUSON, S. fils, *Histoire du Tulle et des Dentelles Mécaniques en Angleterre*, Paris, 1862.

FRY, R., 'Bonington and French Art', *Burlington Magazine*, 1927.

GAUDIBERT, P., 'Aquarellistes anglais à Paris', *Bulletin du Musée Carnavalet*, 1957.

GIRTIN, T., and LOSHAK, J., *The Art of Thomas Girtin*, 1954.

GOBIN, M., *R.P. Bonington 1802-1828*, Paris, 1950.

GUILLEMARD, DR, 'Girtin's sketching club', *Connoisseur*, 1922.

HAMERTON, P.G., 'W. Wyld's sketches in Italy', *Portfolio*, 1877.

HAMERTON, P.G., 'A sketchbook by Bonington in the British Museum', *Portfolio*, 1881.

HARDIE, M., *Watercolour Painting in Britain*, ii, 1967.

HUET, P., *Paul Huet d'après ses Notes, sa Corréspondance, ses contemporains. Documents recuellis par son fils et précédés d'une Notice biographique*, Paris, 1911.

HUGHES, C.E., 'Notes on Bonington's parents', *Walpole Society*, 1913-14.

INGAMELLS, J., *Richard Parkes Bonington*, 1979.

LE BEAU, E., *Notice sur Louis Francia* (1842).

LEMAITRE, H., *Le Paysage Anglais à l'aquarelle 1760-1851*, Paris, 1955.

LODGE, S., 'French artists visiting England 1815-1830, unpublished Ph.D. thesis, London University, Courtauld Institute of Art, 1966.

LONDON, AGNEW'S, *R.P. Bonington*, 26 February-17 March 1962.

LONDON, BURLINGTON FINE ARTS CLUB, *R.P. Bonington and his Circle*, 1937.

MANTZ, P., 'Bonington', *Gazette des Beaux-Arts*, 1876.

MARGUERY, M., *Notes sur R.P. Bonington*, Paris, 1931.

MELLORS, R., 'Richard Parkes Bonington', *Transactions of the Thoroton Society*, 1909.

MILLER, A., 'English watercolours and the rise of French regional Landscape 1815–1835', unpublished MA report, London University, Courtauld Institute of Art, 1978.

MULARD, N., *Calais au temps de la Dentelle*, Calais, 1963.

NEW LONDON, LYMAN ALLYN MUSEUM, *The Works of Richard Parkes Bonington*, 2 December 1942–3 January 1943.

NOEL, M., 'Le Centenaire de Bonington, 1801–1828' (*sic*), *Le Figaro*, 18 octobre 1928.

NOON, P.J., 'Bonington and Boys: some unpublished documents at Yale', *Burlington Magazine*, 1981.

NORWICH, THE CASTLE MUSEUM, *A Decade of English Naturalism 1810–1820*, 1969–70, introd. J. Gage.

NOTTINGHAM, CASTLE MUSEUM AND ART GALLERY, *R.P. Bonington 1802–1828*, 1965.

PARIS, MUSÉE CARNAVALET, *Dessins Parisiens des XIXe et XXe siècles*, 16 juin–31 octobre 1976.

PARIS, MUSÉE CARNAVALET, *Paris Romantique*, juin – juillet 1957.

PARIS, MUSÉE JACQUEMART-ANDRÉ, *Bonington: Un Romantique anglais à Paris*, 1966.

PEACOCK, C., *Richard Parkes Bonington*, 1979.

POINTON, M., *The Bonington Circle: English Watercolour and Anglo-French Landscape*, Brighton, 1985.

RACE, S., *Notes on the Boningtons*, Nottingham, 1950.

ROGET, J.L., *A History of the 'Old Watercolour' Society*, 1891.

ROSENTHAL, L., *La Peinture Romantique: essai sur l'évolution de la peinture française de 1815 à 1830*, Paris 1900.

ROUNDELL, J., *Thomas Shotter Boys 1803–1874*, 1974.

RYLEY, S. W., *The Itinerant, or Memoirs of an actor, 1808–1827*.

SANDILANDS, G. S., *Famous Watercolur Painters: Richard Parkes Bonington*, 1929.

SHIRLEY, A., *Bonington*, 1941.

SILVESTRE, T., *Histoire des Artistes vivants . . . études d'après nature*, Paris 1856.

SPENCER, M., 'Richard Parkes Bonington (1802–1828): A Reassessment of the Character and Development of his Art', unpublished Ph.D. thesis, University of Nottingham, 1963.

VION, A., *La vie calaisienne sous le Consulat et l'Empire*, Calais, 1972.

WILTON, A., *British Watercolours 1750–1850*, Oxford 1977.

Index